FIFTY PLACES TO PLAY GOLF

BEFORE YOU DIE

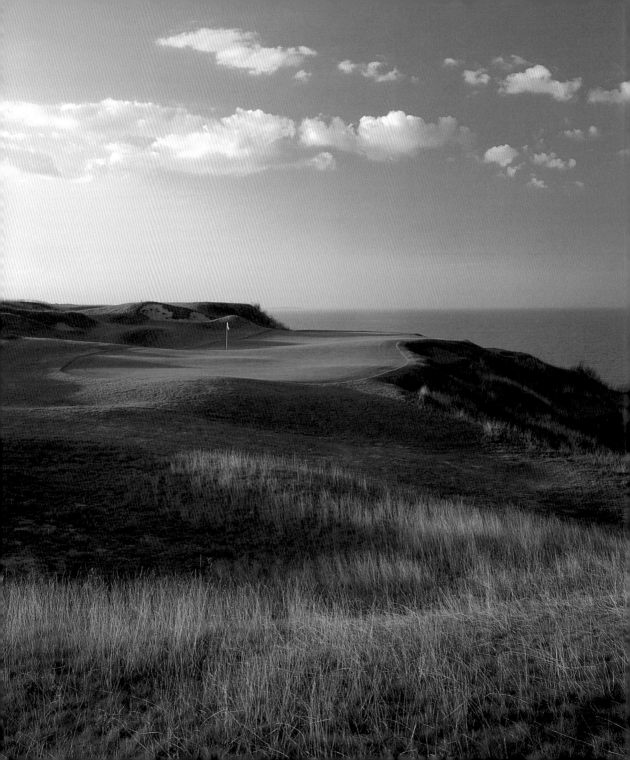

FIFTY PLACES TO
PLAY GOLF
BEFORE YOU DIE

Golf Experts Share the
World's Greatest Destinations

Chris Santella

FOREWORD BY MARK O'MEARA

STEWART, TABORI & CHANG

NEW YORK

To Deidre, Cassidy Rose, and Annabel Blossom,
who've been unwaveringly patient and generous with their time
so I might pursue my dream of writing books.

❧

ALSO BY THE AUTHOR
Fifty Places to Fly Fish Before You Die:
Fly-Fishing Experts Share
the World's Greatest Destinations

Contents

ACKNOWLEDGMENTS

This book would not have been possible without the generous assistance of the expert golfers who shared their time and experiences to help bring these fifty great golf venues to life. To these men and women I offer the most heartfelt thanks. I would especially like to thank Brian McCallen, James Levine, Matthew Harris, and John Strawn, who offered encouragement and made many introductions on my behalf. (Many years ago, Brian was willing to entertain the notions of a little-published writer, and his generosity of spirit and guidance still mean a great deal to me.) A special thanks should be extended to Tom Bracken, who introduced me to this silly game when I went to work for him at Pro Golf Discount in Norwalk, Connecticut, in 1980. I also want to acknowledge the fine efforts of my agent, Stephanie Kip Rostan, my editor Jennifer Levesque, assistant editor Dervla Kelly, designer Paul Wagner, and copyeditor Don Kennison, who helped bring the book into being. Since I first picked up a golf club when I was sixteen years old, I've made many fine golfing friends, a few of whom I can still defeat on occasion. This group includes Howard Kyser, Peter "Jimi" Clough, Mike McDonough, Ken Matsumoto, Jeff Sang, Kurt Norton, Jerry Stein, Dave Sinise, Ed O'Brien, Don Ryder, Lee Galban, Andy Waugh, Dave Tegeler, Chris Bittenbender, Chris Lande, Scott Stevens, Sloan Morris, and Keith Carlson. I look forward to many more days on the links with these friends, as well as the new friends one often makes on the first tee. These companions all understand that there's no performance on the first eighteen holes that cannot be made a bit better by a brief stop at the nineteenth hole. Finally, I'd like to thank my mother and father for encouraging me to try new hobbies—like golf and fly fishing—when I was young!

FOREWORD

As a twenty-five-year veteran of the PGA Tour, I've been fortunate to play golf on many fine courses all over the world, from California to Dubai, and most places in between. In the course of many rounds and countless miles, I've learned that there are a number of characteristics that distinguish a great golf experience: The beauty of the natural surroundings, the strategic elements of a course's design and the challenging shots it demands, the chance to walk the same fairway that legendary players have walked in the past, and the companionship of those that accompany you on your round, whether they be old pals or strangers. (Odds are pretty good they won't be strangers by the end of the round!)

For *Fifty Places to Play Golf Before You Die*, Chris Santella has interviewed golf course architects, superintendents, developers, teachers, touring players, and golf writers in order to compile a list of some of the world's best golf venues. Some of the courses included are those that you probably know; some you probably have never heard of. The diversity of perspectives that these individuals bring to the question "What makes a golf course a place to play before you die?" illustrates just how many different ways people can appreciate the golf experience. Chris has done a great job of bringing these places to life.

Golf has been a very special part of my life since I was thirteen years old. I've made a living playing golf, but I've also made many dear friends and have shared many happy fairway moments with both my son and my dad. *Fifty Places to Play Golf Before You Die* celebrates the intimate relationship many of us—tour champion or weekend hacker—have with the game.

—MARK O'MEARA

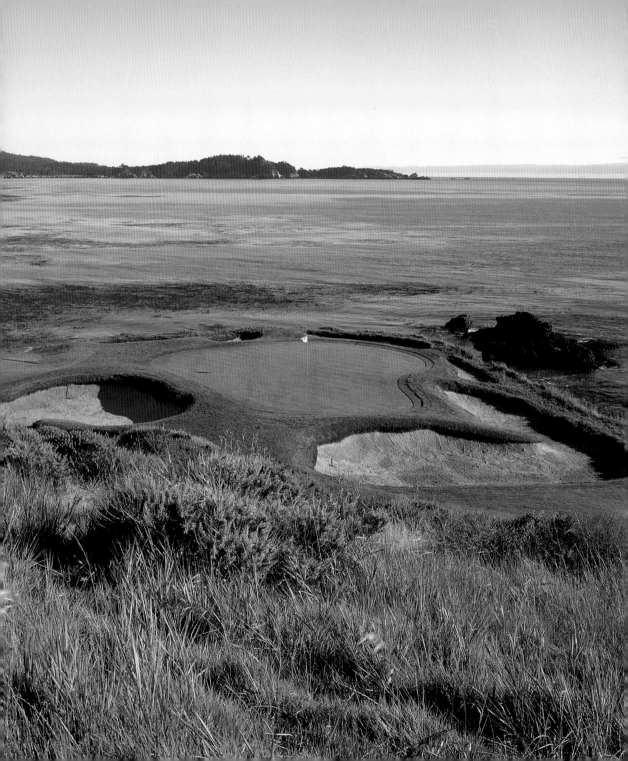

INTRODUCTION

My golf experience has been shaped by countless rounds on the municipal links of America—fairways that are often sunburned in the summer, sodden in the winter, and mowed whenever the greenkeeping team gets around to it; greens that are not always as trimmed as the fairways on the private course a few blocks away; surly starters who reign over the first tee as if they were initiating the final round at the Masters. I've loved every minute of it.

OPPOSITE:
Though barely
100 yards, the
seventh at
Pebble Beach is
one of golf's
great one- shot
challenges.

Most golfers I know enjoy any chance to get out on the course, whatever course might await them. The pastime of golf is about getting outside, spending time with friends, enjoying the special feeling that comes when square contact is made with the ball . . . and, perhaps, exploiting the chance to lord a friendly bet or two over a steady playing partner.

This being said, many golfers have a wish list of the places they'd like to play before they depart for the great fairways of the hereafter. Some of these dream courses are venues they have seen the pros play on television. Others have appeared in golf magazine round-ups of the greatest public courses, greatest private courses, greatest courses beginning with the letter "N," and the like. Other fantasies have been inspired by the glimpse of a photo of a rolling fairway or thickly bunkered green, an image that beckons the viewer to place him/herself in the thick of the scene. However the "must plays" have made it onto the list, such courses are objects of desire that are frequently contemplated . . . and with patience, planning, and a bit of good luck, perhaps, sometimes played. The passionate duffer who splurges $425 on a round at Pebble Beach, or makes the pilgrimage to St. Andrews, will likely treasure the memory well into his or her next lifetime.

It was in considering my own wish list of courses, and comparing notes with friends on their dream links, that the seeds of *Fifty Places to Play Golf Before You Die* were sown. With somewhere in the vicinity of thirty thousand golf courses of various shapes and sizes around the world (not including miniature-golf courses)—and with my experience limited for the most part to more modest munis that would not make many wish lists—I felt ill-suited to decide which fifty courses should be included. So I resorted to a tactic that served me well in my first book, *Fifty Places to Fly Fish Before You Die*: I decided to seek some professional advice. I interviewed fifty people closely connected with the golf world about some of their favorite courses and experiences. These experts ranged from

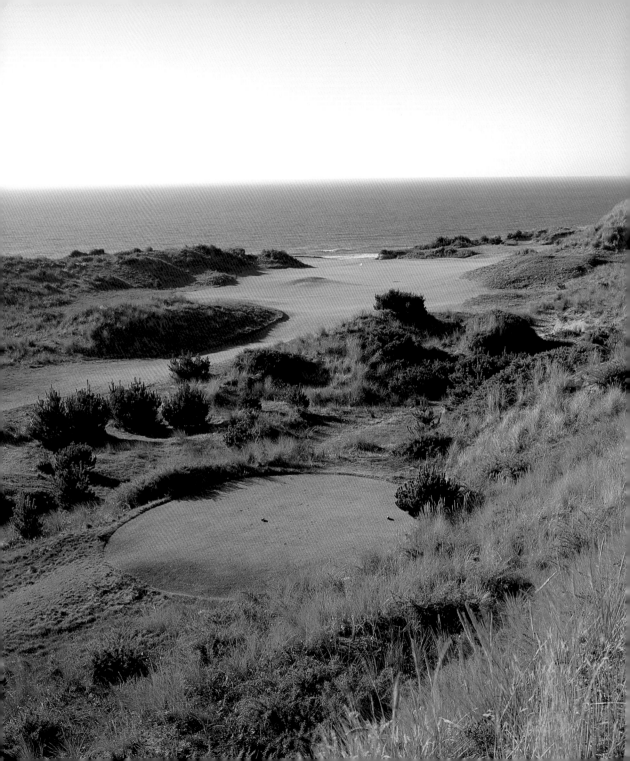

seasoned touring professionals (such as Mark O'Meara, Nick Faldo, and Cristie Kerr) to golf journalists and photographers (such as Brian McCallen and Matthew Harris) to instructors (such as Dave Pelz and Pia Nilsson) and golf course architects (such as Pete Dye, Tom Doak, and Robert Trent Jones, Jr.). Some spoke of courses they had designed or where they won major championships; others spoke of links where walking in the footsteps of heroes past and present made the experience unforgettable. Still others spoke of courses where the spirit of the game—the camaraderie and passion that can erase all cultural boundaries—manifested itself in a particularly illuminating or touching manner. People appreciate golf and golf courses for many different reasons, and this range of attractions is evidenced here. (To give a sense of the breadth of their golfing backgrounds, a bio of each individual is included at the conclusion of each essay.)

OPPOSITE:
With Pacific Dunes, Tom Doak made the most of a tremendous site.

Though this book collects fifty great golfing experiences, it by no means attempts to rank the courses discussed. Such ranking is largely subjective, as the course that appeals to a golf course architecture critic might be unfathomable to an every-other-weekend player. In this spirit, courses are listed alphabetically by state or country.

In the hope that a few readers might embark on adventures of their own, I have provided some "If You Go" information at the end of each section, offering would-be travelers a starting point for planning their trip. General pricing information is included, though green fees do sometimes change. (Note: Thanks to the volatility of some exchange rates, prices for non-U.S. courses are given in local currencies; exceptions include those destinations with which American travelers would generally have limited knowledge, such as Kenya or Morocco.) I have also provided some basic course information, including distances (from the championship tees, in every case), slope rating (if available), green fees, tee time contact information, and whether the course is public or private. The listing of championship tee yardage is not a recommendation that *you* play from those tees; players will get the best sense of the experience a pro has on a course— and the idea that the architect envisioned—by playing from the tee appropriate to their individual skills. Please also note that some of the private courses included in *Fifty Places to Play Golf Before You Die* are *very private*. It may take half a lifetime of careful friendship cultivation to gain a one-time admittance, but we must set our sights high! (Why, even yours truly was *almost* invited to play Pine Valley last year.)

While any round of golf is a good round, a trip to a dream venue can create memories for a lifetime. I hope this book helps you tee off on a few adventures of your own.

The Destinations

RTJ TRAIL

RECOMMENDED BY **Roger Rulewich**

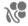

Watching the out-of-state traffic speed through Alabama en route to points south circa 1990, Dr. David Bronner had an epiphany of sorts. He surmised—quite correctly—that the trunks of many of those cars held golf bags. And he believed that there was no good reason why many of those sojourners would not linger in the Heart of Dixie to tee it up . . . that is, if there were high-quality, affordable courses for them to play. Three wouldn't be quite enough. Nor would five. Or ten. Eighteen would be just about right. And since Dr. Bronner was CEO of the Retirement Systems of the state of Alabama, he had access to the capital necessary to make it happen. Still, he needed someone to take what some considered to be an enormous gamble and make it a winner. That someone was Bobby Vaughan, then a director of golf at Tanglewood Park in North Carolina. He also needed a big name to hang on the project with which to garner the publicity that was necessary to make it work. Why not go after the living legend Robert Trent Jones, Sr.?

That's exactly what he did. Mr. Jones was retained, Bobby Vaughan assembled a crack team, and the project took hold. One hundred and twenty million dollars, a few closed-door negotiations to secure the land donated by corporations and municipalities, many bulldozers, and three years later, seven sparkling new golf complexes—three with 36 holes, four with 54 holes—stretched over three hundred miles from Mobile on the coast north to Huntsville at the foothills of the Appalachians. The Robert Trent Jones Golf Trail was born. It must give Dr. Bronner wonderful satisfaction to know that the Trail is now Alabama's number-one tourist attraction, and tourism is the state's number-one industry.

As Robert Trent Jones's chief design associate at the time, Roger Rulewich had his hand—quite literally—in the design of every one of the 324 holes of the original trail

OPPOSITE:
Hole number
one on the
Judge course,
one of the
twenty-five
tracks on
Alabama's
RTJ Trail.

17

(six more courses have been built since the initial Trail was conceived). "Most of our work wasn't done from plans," Roger recalled. "We developed a rough layout for a given course, and the next day started constructing it. Almost all the design was on the ground. Having the support of the pension system, we were able to do things I wouldn't have ever imagined doing. When we decided there was something spectacular that might be done, we could generally do it. Some sites were not defined in terms of acreage until we were done; we established the property lines after the fact. I can't imagine a better way of working. We had a sizable budget—and the permissions—to do what we wanted to create something great. It was a magical thing."

The Robert Trent Jones Trail is an amazing accomplishment, not simply for the vision of its progenitors and the scope of that vision but for the incredible quality and individuality of each layout. There's no mass production on the Trail, just the inspiration that may have come with the semidelirium of the most frenetic, largest-scale golf construction project in the history of the game. "Bobby Vaughan and I would leave from one site and head to the next. We thought the site that we left was our favorite, and it was, until we got to the next one. We put everything we had into every course. The sites Bobby selected were distinctive and different; he didn't want to repeat the same course again and again. We fell in love with each of them."

Another facet of the Trail that's truly remarkable is that it's difficult to pay more than $67 for a green fee. "Sweet Home Alabama," indeed!

The complexes on the RTJ Trail—Cambrian Ridge, Capitol Hill, Grand National, Hampton Cove, Highland Oaks, Magnolia Grove, Oxmoor Valley, Ross Bridge, the Shoals, and Silver Lakes—are each very different, but they do share some common characteristics. The 54-hole settings have two 18-hole courses (one out and back, one with returning nines) and one 18-hole par 3 course. The 36-hole complexes have three returning nines, and a 9-hole par 3 layout. These par 3s are not your standard pitch and putts; some holes come in at over 200 yards, and they're as well thought out as their 18-hole neighbors. Another characteristic that all the courses share is an abundance of tee boxes—up to 11 on some holes, amounting to as much as 3,000 yards' difference between the front and back, which give the less gifted golfer some hope of maintaining his equilibrium. From the blues, blacks, or purples (yes, purples), these courses pose a supreme challenge. Finally, there's an absence of homesites around the courses, as well as ample beauty. "I remember Dr. Bronner saying 'The only house I want to see on

these courses is the clubhouse,'" Roger said. "He wanted golf courses that stood on their own, not as part of an overall development scheme."

There are simply too many fine layouts, too many interesting holes on the Trail to go into much detail. Some highlights are Grand National, where Jones, Rulewich, Vaughan et al had 600-acre Lake Saugahatchee to work their magic around and over, including the picturesque 230-yard peninsular fifteenth green on the Lakes 18; the Canyon nine at Cambrian Ridge, which offers more topographical change than you thought possible on a southern course, including a 501-yard par 4 that descends 200 feet from the back tees; and the River Course, the only Robert Trent Jones, Sr. layout in the world lacking a single bunker (due to concerns that the river, which is prone to flooding, would make maintaining traps a nightmare).

"One of the great compliments we've received about the Trail is 'We don't see anything repeating itself,'" Roger said. "Doing that many courses at the same time made this a challenge. Each hole we cut or shaped, we never thought of the other courses. We looked at each hole as making a statement about the kind of golf hole we wanted to build. We weren't consciously trying to avoid being repetitive. I don't think we ever attempted to make comparisons, or even avoid comparisons. It just worked out."

ROGER RULEWICH is the chief golf course architect and principal of Roger Rulewich Group LLC, a company he formed in 1995 in Bernardston, Massachusetts, after thirty-four years with Robert Trent Jones, Sr. He was accepted into the American Society of Golf Course Architects in 1974, and served as president for the 1987–88 year. Roger has been the principal force in the design, remodeling, and field direction of more than 150 courses throughout the United States and the world. His list of credits includes the Robert Trent Jones Golf Trail; the Apple Rock Course in Horseshoe Bay, Texas (selected as Best New Resort Course of 1986 by *Golf Digest*); Metedeconk National Golf Club, a private course in Jackson, New Jersey; and the Crumpin-Fox Club in Bernardston, Massachusetts, rated the best public access course in New England.

If You Go

▶ **Getting There:** All the courses on the RTJ Trail are situated within fifteen miles of the interstate, and each course lies within two hours of the next. Many may choose to

begin at the northern or southern end of the Trail, Huntsville, or Mobile, respectively. Others may begin in the middle near Montgomery or Birmingham. All cities are served by domestic carriers. Even playing 36 holes a day you'll need two weeks to play them all, should you decide to do it in one shot.

▶ **Course Information:** The original seven golf complexes on the RTJ Trail have increased to ten, including Cambrian Ridge, Capitol Hill, Grand National, Hampton Cove, Highland Oaks, Magnolia Grove, Oxmoor Valley, Ross Bridge, the Shoals, and Silver Lakes. Green fees range from $37 in the low season (winter months) to $57 in the spring, with fees at Ross Bridge and CH Judge somewhat higher. Tee times are available fifteen days in advance of play; value packages can be booked by calling 800-949-4444 or visiting www.rtjgolf.com.

▶ **Accommodations:** If you book a package through the RTJ Trail, hotels can be arranged for you, with prices averaging around $40 per night per person. A comprehensive list of accommodations is available from the Alabama Department of Tourism (800-ALABAMA; www.touralabama.org).

BANFF SPRINGS

RECOMMENDED BY **James Levine**

Situated a mile high in the Canadian Rockies, Banff Springs is without question one of the most spectacular settings in the world for a golf course. Visitors like James Levine travel across the continent to take in the scenery, and sometimes they get more than they bargained for—a very special round of golf.

"My wife and I came out from New York to take a walking tour through the Canadian Rockies. We arrived a few days before the tour began to take a look at Lake Louise, which we'd always heard about. After taking in the lake, I went to look at the Banff Springs course. One look and I just had to play. In a moment of incredible generosity, my wife let me take a day off the hike to play the course. Better yet, she agreed to walk the course. After all the years we've been married, it was the first time she'd ever been out on the course with me. She came away thinking that a trek on the course was every bit as visually fantastic as the hikes we did on the mountain trails."

That a golf course exists against the rugged backdrop surrounding Lake Louise is a tale of continental expansion, wartime spoils, and envy—the makings of a good opera, one might say! In the 1880s, the railroads were pushing west across Canada. At certain points along the way great hotels were built, in keeping with the philosophy of the Canadian Pacific Railway's general manager William Van Horne, who said, "If we can't export the scenery, we will import the tourists." Near the confluence of the Bow and Spray Rivers eighty miles west of Calgary, there were hot springs—built-in tourist potential. In 1886 the baronial Banff Springs Hotel was commissioned; it opened in 1888, every bit as awe-inspiring as the mountains encircling the Bow Valley. Twenty years later, a basic 9-hole course was added to appeal to the burgeoning tourist trade. Near the end of World War I a second nine was built, under the guidance of Donald

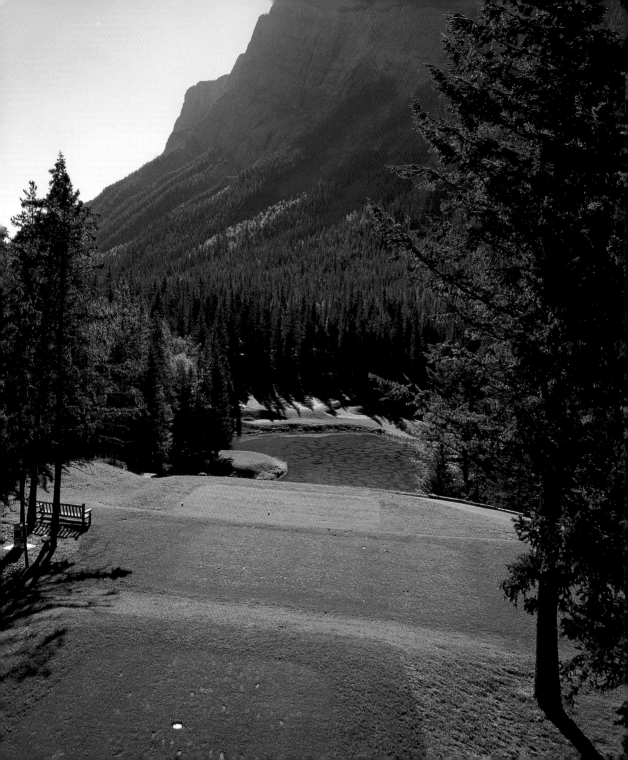

Ross, with the labor provided primarily by German prisoners of war. Visitors to Banff Springs circa 1920 found a beautiful setting and a decent, if not awe-inspiring, layout.

In 1926 Canadian Pacific's rival, Canadian National Railroad, unveiled a golf course of its own, Jasper Park, four hours north of Banff Springs. Jasper Park was quickly hailed as one of the greatest courses in Canada—indeed, in the world. Rankled by this development, administrators at Canadian Pacific decided that they would *have* to have a world-class course of their own to complement their grand hotel . . . and they hired Stanley Thompson, Jasper's creator, to work his magic. Thompson, one of the greatest architects in a generation of great architects, expanded the course beyond its initial boundaries. Working with the ample topsoil that his railroad client could easily provide, he built what was then the most expensive course ever constructed, topping $1 million. After Banff Springs opened in 1929, it wasn't long before it was recognized as one of the top ten courses in the world.

Stanley Thompson surely recognized the grandeur of this site along the Bow River, and he sculpted the holes on a broad scale to maximize the impact of the vistas. The 535-yard par 5 third hole, named Gibraltar, is bounded on the right by the flanks of Mount Rundle, which climbs nearly a mile into the clouds. When one approaches the green, the mountain still looms in the background, making it difficult to gauge the proper distance to the pin. Attempts to stick it close are further hampered by a putting surface that slopes toward the back. On several other holes, most notably the 445-yard par 4 fourteenth, called Wampum, the Banff Springs Hotel juts up behind the green, nearly as monolithic as the adjoining Rockies. The fifteenth hole, a 480-yard par 4 dubbed Spray, provides yet another incredible vista; players tee off from a precipice high above a tributary of the Spray River, with Mount Rundle again in the background. In the initial Thompson routing of the course, this was hole number 1, and the tee shot was considered by many to be the game's greatest opening play. The carry of roughly 150 yards to reach the fairway is not great considering the elevated tee and the thin air, yet the take-your-breath-away beauty of the setting is enough to unnerve unflappable players.

No essay on Banff Springs is quite complete without a mention of the Devil's Cauldron, perhaps golf's most compelling par 3. Players come upon the tee from a path in the woods, and their jaws invariably drop against their chest as their eyes take in the valley that opens below. Your shot is played from an elevated tee, some 70 feet above a natural glacial pond, to a green 171 yards away. The elevated punchbowl green is

*OPPOSITE:
The view from
the tee at
Banff's par 3
number 4, the
famed "Devil's
Cauldron."*

encircled by six bunkers, ready to engulf a shot that is swept left or right by winds that can funnel through the mountain passes.

"The course and hotel are quite literally in a national park, a wildlife preserve," Jim said. "A herd of elk trotted by while I was putting out on one green. Again and again, I thought, 'This is the most incredible golf hole I've ever seen.' I could've just dropped the clubs and walked around. But the course is just too engaging to do that."

JAMES LEVINE is a principal in Levine Greenberg, a literary agency with offices in New York and California, a clever ploy that allows him to regularly play courses on both coasts. Although he represented Craig Brass's *How to Quit Golf: A 12-Step Program*, he just can't stop. His office walls are lined with photos he's taken of golf courses around the world, from the spectacular Bandon Dunes off the Oregon coast to Farm Neck on Martha's Vineyard. Since his agency also represents Chris Santella, he figures it's now part of his professional responsibility—tax deductible, thank you—to visit and play *all* the courses in *Fifty Places to Play Golf Before You Die.*

If You Go

▶ **Getting There:** The Fairmont Banff Springs Hotel and its fabulous golf course are approximately eighty miles west of Calgary, Alberta, in the heart of the Canadian Rockies. Calgary is served by major carriers.

▶ **Course Information:** The Banff Springs course (technically known as the "Stanley Thompson 18") is a par 71 layout and plays 7,074 yards from the tips, with a slope rating of 142. Green fees for hotel guests and Canadian citizens range from $75 in May to $175 from mid-June through September (Canadian dollars). The course is generally open from mid-May through mid-October. For more information and tee times, call 403-762-6801.

▶ **Accommodations:** The Fairmont Banff Springs Hotel (800-441-1414; www.banff springs.com) was considered the crown jewel of the Canadian Pacific Railway's string of luxury hotels; it remains an amazing edifice. The hotel has 770 rooms in a variety of sizes; rooms begin at $639 Canadian. The Ultimate Golf Retreat Package includes accommodations, use of the Willow Stream spa, three meals a day, plus 18 holes of golf, for $939 Canadian per night based on double occupancy.

MIRABEL

RECOMMENDED BY **Cristie Kerr**

Some golf courses are notable for their stunning natural setting. Others display thought-provoking, flexible design. Still others—especially in the realm of private clubs—offer an unparalleled level of service. For Cristie Kerr, these three broad facets of golf appreciation all converge in the desert of north Scottsdale, at a private course called Mirabel.

"It's just a fabulous design by Tom Fazio," Cristie said, "and the setting is magnificent. From a service perspective, it's unbelievable. There are apples at some tees, and this wonderful beef jerky in jars. There was even a chef on one hole [the par 3 eighth] with an open fire pit. Until you experience it, it's very difficult to imagine the level of service you encounter at Mirabel."

Scottsdale, Arizona, is rich in both irrigated land and golf courses; it has more golf courses per capita than any other city in the world, with 174 public and private venues at this time. Tom Weiskopf, Robert Trent Jones Sr. and Jr., Jack Nicklaus, Jay Morrish, Robert Cupp, Arnold Palmer, Billy Casper, and Ben Crenshaw have all contributed designs. Settled in the late nineteenth century, Scottsdale had trouble attracting residents, let alone visitors, until the advent of air-conditioning in the 1950s. After a story appeared in *Life* magazine in 1956 naming it one of the nation's most desirable places to live, the onslaught of retirees and real estate entrepreneurs began. With just over 200,000 residents, the city today can boast a golf course for every 1,150 people. Scottsdale seems uncontainable in its incessant expansion into the surrounding desert; it's not too difficult to imagine another 100,000 residents and fifty new courses by 2020.

The site of Mirabel has a slightly turbulent past. The track rests atop another high-end course that was designed by Greg Norman, called Stonehaven. Stonehaven, a $15 million extravaganza slated to be a daily fee course, was going to take desert-style target golf to

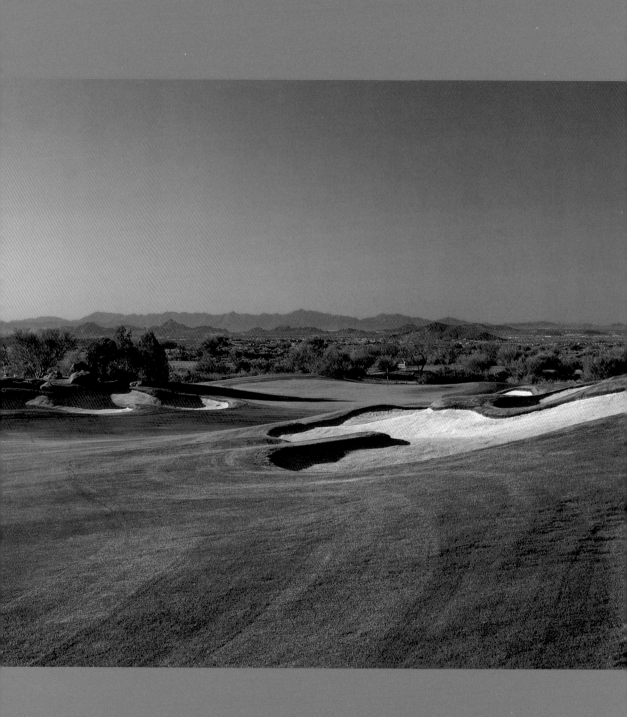

new extremes, providing just 42 acres of grassy landing areas. Before the first tee shot was struck, however, plans changed. New owners, who envisioned a private club, held that the Norman layout was simply too difficult. So the bulldozers were brought in again, this time under Tom Fazio's command, and an estimated $15 million more was plowed into the course. Norman was not particularly happy to see his first Arizona project go under—literally—and spoke of Stonehaven as "the greatest golf course ever built that no one will ever play."

Scottsdale is widely considered the birthplace of desert-style target golf, ushered in by Lyle Anderson and Jack Nicklaus with the unveiling of Desert Highlands in 1981. Many of the best-known venues here—the Boulders and Troon North, to name just two— exemplify the style, where fairway landing areas are limited and players must carry saguaro-dotted areas (that is, *the desert*) to make their way from tee to green. (The design evolved as an effort to preserve sensitive desert environments and conserve water.) Mirabel is a kinder and gentler alternative to the Valley of the Sun's more punitive tracks. With its more classical design, most holes offer a continuous surface of playable ground, rather than occasional green islands of sanctuary. All of the visual splendor of desert design is here—the vast vistas of stark mountains, the stunning contrast of fairway green and earthen browns—without the necessity of deploying a new golf ball after every other shot. There's enough fairway here to bring out the driver on most of the holes that demand it. And the forced cactus carries are minimal. At nearly 3,000 feet, Mirabel offers commanding vistas of the McDowell Mountains to the south and Black Mountain to the west. "The great thing about Fazio is his ability to build a challenging but playable course, and this one is more playable than a lot of desert courses," said Steve Adelson, Mirabel's general manager.

With his handiwork included in just about every "top 100" compilation—often, more than the courses of any other living architect—Tom Fazio is indisputably one of the greatest golf architects of his time. Where many designers look to the land for their inspiration, Fazio seems to look inward; once he arrives at a vision for what a course should be, he's not timid about moving earth to make it happen. Yet like other world-class architects, Fazio designs with a strategic focus that makes his layouts interesting for players of different skill levels. At Mirabel, Fazio uses the surrounding mountains to create drama and imaginative bunkering to create the illusion of more hazards than those that actually come into play.

OPPOSITE:
Mirabel offers
a kinder and
gentler version
of desert golf.

One of the unique amenities that Mirabel offers its members and guests is Mirabel Signature Beef Jerky, which is available at comfort stations around the course.

Although the club won't disclose exactly how the jerky is prepared, chef Tim Fields has admitted that the recipe calls for choice beef flank steak marinated in a stew of brown sugar, soy sauce, and Worcester brine before being dried overnight. After sampling some jerky during a pre–spring training round, then Yankee pitching ace Roger Clemens requested that five pounds be sent to the Yankees training camp. The jerky went over so well that now the Yankees receive thirty-two pounds of Mirabel jerky a month.

CRISTIE KERR began playing golf at the age of eight and turned professional in 1996 at the age of nineteen, after being the low amateur at the 1996 U.S. Women's Open. She has gone on to become a leading player on the LPGA Tour. In 2004 she had three victories, winning at the LPGA Takefuji Classic, the ShopRite LPGA Classic, and the State Farm Classic. With eleven top-ten finishes, Cristie was number 5 on the LPGA money list in 2004. A spokesperson for Evelyn Lauder's Breast Cancer Research Foundation, Cristie also launched the "Birdies for Breast Cancer" program to raise funds to fight the disease her mother was diagnosed with in July 2003 (for more information, visit www.birdies forbreastcancer.com). When she's not on the course or advocating for breast cancer research, Cristie enjoys cooking, baking, fishing, watching movies, and working out.

If You Go

▶ **Getting There:** Mirabel is situated in the northern part of Scottsdale, Arizona, a short drive from Sky Harbor Airport in Phoenix.

▶ **Course Information:** Mirabel plays to a par 71 and is 7,127 yards from the championship tees. The course is part of an exclusive development, limited to 350 members. For more information, contact Mirabel at 480-595-2545, or visit www.mirabel.com.

▶ **Accommodations:** Whether you ever get out on Mirabel or not, chances are good that you'll find a few other courses around Scottsdale that will be happy to have you visit. Countless packages are available, but you might begin your quest at Arizona Golf Packages (800-426-6148; www.arizonagolfpackages.com) or Scottsdale Golf and Lodging (888-368-9171; www.scottsdalegolf.com).

ROYAL MELBOURNE GOLF CLUB
(WEST)

RECOMMENDED BY **Nick Faldo**

✳

The six short weeks that Dr. Alister MacKenzie spent around the Australian state of Victoria in 1926 had an immeasurable impact on the sport of golf in Australia. In that short time, he and Alex Russell, a talented Australian amateur player and able assistant, routed the 18 holes at Yarra Yarra Golf Club, built bunkers at the Victoria, Kingston Heath, and Metropolitan golf clubs, and designed the West Course at Royal Melbourne. While some celebrate Augusta National as the greatest achievement of one of the world's greatest architects, many aficionados recognize Royal Melbourne as MacKenzie's finest accomplishment.

Among this group is Nick Faldo.

"I'm not sure that I really want to nail my colors to the mast, but the West Course at Royal Melbourne might just be the best golf course in the world, period," Nick said. "I think the best golf courses are the most natural courses—those that integrate seamlessly with their surroundings. Typically these surroundings are sandy, scrubby, and more rugged than pretty. Royal Melbourne meets these criteria. I also think that it's the most strategically interesting course anywhere, after St. Andrews. I love so many aspects of the design. The way it plays firm and fast-running, the way the bunkering frames and almost intrudes into the putting surfaces, the brilliance of the bunkering style, with its natural 'scrubby' look, the wide fairways that reward the golfer who thinks where best to position the drive, the mix of long, demanding, and short, intriguing par fours, the splendid contouring of the greens, the variety of approach shots that you can play into the greens which really reward imaginative shot making, and the fact that there is often a wind to contend with, coming at you in each and every direction during the course of a round."

Royal Melbourne is situated in the southeast suburbs of Melbourne, Australia's

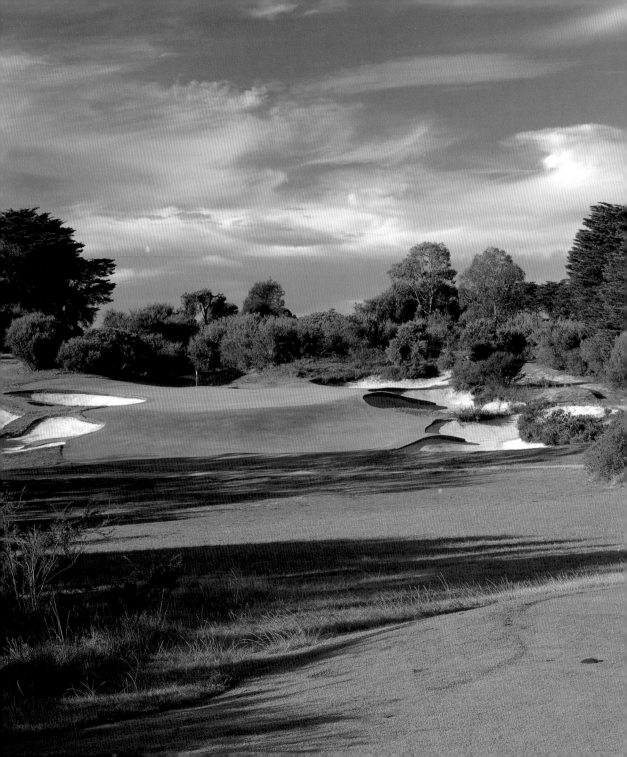

second-largest city, in a region that's been dubbed the Sandbelt. The twenty-five square miles of rolling sandy soil and delicate grasses bordering Port Phillip Bay provide ideal terrain for golf course design. It's no wonder that many of Australia's most renowned courses are here. "Melbournians will claim that their Sandbelt possesses the finest concentration of great golf courses in the world—a mighty boast indeed in the face of the magnificent collection of courses around Long Island, New York, the Monterey peninsula, and the British Heathland courses outside London," said Selwyn Berg, editor of Ausgolf.com. With his work at Royal Melbourne and the other Sandbelt courses he touched, MacKenzie introduced two outstanding characteristics to Australian golf courses: strategic as opposed to penal design, whereby the better player is tempted to position his ball closer to trouble in order to obtain the best angle to attack the pin. And the style of bunkering that still dominates the Sandbelt today—deep cavernous bunkers that appear as part of the natural undulation and typically carve beneath the very edges of the greens. The greens themselves are large contoured affairs that provide the purest of putting surfaces. (Much credit for the excellent greens goes to Claude Crockford, who joined the Royal Melbourne staff as head greenskeeper in 1934; former greenskeeper Mick Morcom played a significant role in creating the bunkers.)

Many holes at Royal Melbourne West are included on best-of lists; two make it onto Nick Faldo's all-time 18. "For holes number five and six on my 'best holes in the world' compilation, I would play numbers five and six on Royal Melbourne, a magnificently bunkered par three followed by a superb par four," Nick said. Number 5 plays 176 yards across a valley to what's been called one of golf's finest green sites. The green is framed by heather and bracken and bordered by a series of attractive bunkers that extend to within a foot of the putting surface. The green slopes heavily from front to back, which means that shots into the front section of the green are destined to roll backward and off. It's been said that when MacKenzie first saw the site of the fifth hole, he declared that his team should be able to create one of the best golf holes in existence. The construction of the hole was completed by Mick Morcom, and most would agree that he fulfilled MacKenzie's prophecy.

The 428-yard par 4 is Royal Melbourne's most famous hole, and properly encapsulates the Melbourne experience. From the elevated tee box, set among tea trees, the player faces a sharp dogleg right, where the bend occurs at approximately 220 yards. Those tempted to cut the corner must contend with nasty scrub and bunkers that

OPPOSITE:
Scrubby, wild,
and reward-
ing, Royal
Melbourne
West is
representative
of Alister
MacKenzie's
greatest
design work.

occupy the inside of the dogleg, as well as eucalyptus trees; in short, you can't cut the corner so much as you must *carry* the corner. Should you clear the wasteland, a modestly short shot to the green awaits you. If you opt for the safer left side of the fairway, you could be looking at a fairway wood to the green. You might pay a penalty for your caution, however, for those approaching the green from the left face a menacing bunker that rests on the front left of the putting surface. (Many of the fairways at Royal Melbourne are quite broad, giving average players the opportunity to stay in play; however, better players are rewarded for being on the *correct* portion of the fairway.) The elevated, tiered green slopes from back to front, and is among the slickest of Melbourne's fast greens. If the pin is placed on the lower tier and you find yourself above it, beware. To underscore this point, Brian McCallen writes in *The World's 500 Greatest Golf Holes* of Sam Snead's debacle in the 1959 Canada Cup on the sixth green: "The Slammer drove through the fairway into poor position at the sixth, put his second shot on the upper terrace of the green above the pin—and then putted his ball down the slippery slope into the front bunker!"

"Royal Melbourne has influenced my design work profoundly, probably more than any other course I've played," Nick concluded. "Some have described Shadow Ridge, my first design in America, as Palm Desert's answer to Royal Melbourne. One of my greatest regrets is that I've never won a tournament at Royal Melbourne. I still regularly travel to Australia in hopes of putting that right. I came close in 2003, when I shot a sixty-five in the third round of the Heineken Classic to lead by one. But Ernie Els shot a sixty-five on Sunday and beat me by one stroke."

NICK FALDO has six major wins and more than forty tournament victories worldwide, making him one of the greatest golfers of all time. A fierce competitor, he has claimed three Masters titles and three British Open championships. He has also led the European Order of Merit on three occasions and holds the all-time Ryder Cup record for most appearances (11) and most points scored (25). Nick was part of the first European team to win the Ryder Cup for twenty-eight years; he will captain the 2008 European Ryder Cup team. In 1990 he became the first international player to win the PGA Tour's Player of the Year Award, and between 1993 and 1994 held the world number one ranking for eighty-one weeks. Within the structure of his business vehicle, Faldo Enterprises, Nick heads up Faldo Design, a much-lauded golf course architecture business; the Faldo Series, a competition for younger golfers; and Faldo Wines. Faldo Management was

launched in 2004 to manage the affairs of professional golfers and promising young amateurs. His strong performance at recent majors (including low scores at the 2002 and 2003 U.S. Opens) shows he can still compete with the best. His autobiography, *Life Swings*, was published in 2004.

If You Go

▶ **Getting There:** Melbourne is situated in the Australian state of Victoria on the south-eastern coast of the continent. It's served by many major carriers from Los Angeles, including United Airlines (800-864-8331; www.united.com), Quantas (800-227-4500; www.quantas.com), and American Airlines (800-433-7300; www.aa.com). The weather is pleasant enough in Melbourne for year-round golf, though temperatures are warmest in the U.S. winter season.

▶ **Course Information:** Royal Melbourne plays 6,589 yards from the men's tees to a par 72. It's a private club, though overseas visitors from recognized golf clubs, with a current membership identification card and a letter of introduction from their home club, can gain access. Green fees are A$120 (approximately $95 U.S.) for visitors. Contact Royal Melbourne well in advance of your visit at +61 3 9598 6755. More information on the course is available at www.royalmelbourne.com.au. Ausgolf.com is an excellent repository of information on the other acclaimed Sandbelt region courses and offers a variety of golfing tours.

▶ **Accommodations:** Melbourne is a cosmopolitan city that rests on the northern banks of the Yarra River, about three miles from Port Phillip Bay. More than a thousand lodging options are available at www.visitvictoria.com.

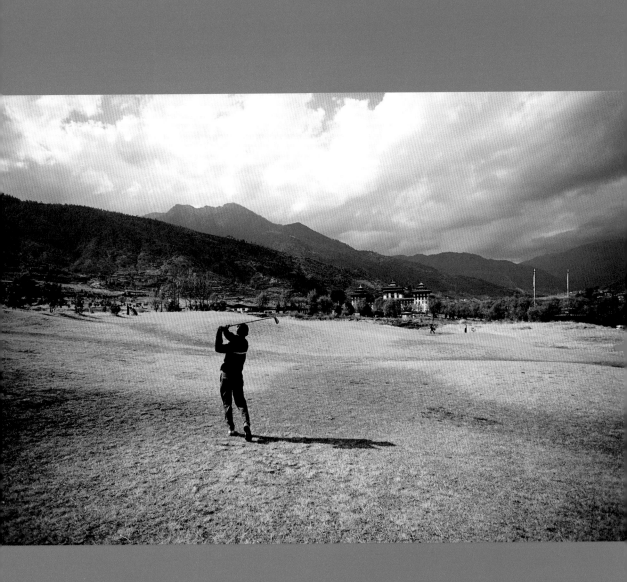

ROYAL THIMPHU GOLF CLUB

RECOMMENDED BY **John Barton**

John Barton traveled to the Himalayan nation of Bhutan to go hiking. But, as has happened more than once in his life, golf came calling. "My wife and I love the Himalayas," John said. "We'd been on trekking adventures in Nepal and India and were planning a trip to Bhutan. When the lady in New York who arranged our trip heard what I did for a living, she mentioned it to one of her contacts in Bhutan, a man who is an avid golfer. He was thrilled that someone from *Golf Digest* was coming to visit and made sure to arrange a couple of rounds."

Most Westerners know little about Bhutan (Land of the Thunder Dragon), a tiny country the size of West Virginia that's sandwiched between India to the south and China to the north. That's largely because until the past few decades tourists were not welcome. The ban on tourists was lifted in 1974, and today a limited number of visitors are allowed, each paying a tariff of $200 a day (this keeps out the backpacker-types who are less likely to contribute to the local economy). Those fortunate enough to make the long journey are not disappointed. The Bhutanese are warm people, heavily influenced by Buddhist traditions that seem mystical to the eyes of outsiders. And the surroundings are overwhelming. Ancient temples cling to hillsides, defying gravity, while towering mountains—including 23,996-foot Jhomolhari, the "Mountain of the Goddess"—reach high into the clouds. Perhaps this proximity to the heavens helps lend Bhutan its sacred aura.

Bhutan is a nation at a crossroads, at the intersection where ancient traditions meet modernity as presented by the outside world. The perfect metaphor for Bhutan's current state is found in the story of the country's first stoplight. Several years ago, a stoplight was installed on the main street of the royal city and capital Thimphu (population

OPPOSITE:
Set in the iso-
lated Himalayan
nation of
Bhutan, Royal
Thimphu may
be the world's
most remote
golf course.

35,000). After a short time, Thimphu's residents decided that a stoplight was inconsistent with their lifestyle, and the light was removed on the king's orders.

His Royal Majesty Jigme Singye Wangchuck, however, has no issues with golf, which is still a very new phenomenon in Bhutan. The first course was constructed by an Indian army officer in the early 1970s on some fallow rice paddies in Thimphu. This track—9-hole Royal Thimphu—remains the crown jewel of Bhutanese golf . . . and the country's sole public course. (A few other private "courses"—6 holes here, 8 holes there—are scattered about on military bases.) There are roughly one hundred members at Royal Thimphu; each pays an annual fee of 6,000 ngultrum, approximately $130. While ornately carved Bhutanese masks and finely woven textiles are readily available in Thimphu's markets, extra sleeves of Top-Flites are not. Bhutanese golfers must rely on friends traveling abroad or the largesse of visitors for clubs and other equipment. The king is among Thimphu's members. "There was a handicap sheet taped to the clubhouse window," John recalled. "At the top of the list was one member whose number was thirteen-point-two. His name was displayed simply as 'His Majesty.'"

Conditions on the course are somewhat more rustic than one would expect, say, at the average track in Palm Desert. "Some course maintenance was being performed by a couple of old ladies with scythes," John noted. "Stray dogs were sleeping in piles in the rough, and a cow roamed one of the fairways. A few holes had small water hazards around the green that resembled sunken bathtubs." The hardpan fairways may recall midsummer at an underfunded suburban muni, but the surroundings will quickly remind you that you're not at home. On the fifth hole, for example, you aim your tee shot at the top floor of the Thimphu *dzong*, a monolithic temple/government building that houses the offices of the king.

In a wonderful story that appeared in the November 2003 issue of *Golf Digest*, John described the passion with which some Bhutanese had embraced the game. "I met Karma Lam, a wiry golfer who has volunteered for the Bhutan Olympic Committee and is a part-time basketball and tennis coach. 'I don't know what it's like in other countries,' Karma told me, 'but in Bhutan, golfers are completely addicted. Golf takes over everything.'" Thanks to the efforts of *Sports Illustrated* golf writer Rick Lipsey, Bhutan's golfing ranks are likely to swell in future generations. Working with the government and visiting U.S. teaching pros, Lipsey and Karma Lam have launched the Bhutan Youth Golf Association, which provides clinics and monthly tournaments.

However cobbled together their swings, however hardpan the fairways, John Barton found something approaching grace in the Bhutanese attitude toward golf. "My most memorable rounds of golf have not been on famous championship courses. It's the people you meet, the surroundings, that make golf special. That's how I found things at Royal Thimphu. It doesn't matter to people there that it's not a lavish course. They play it with as much fervor as any course in the West. Whoever you are and wherever you're from, all the barriers fall away when you meet someone on a golf course."

JOHN BARTON has worked as an editor and writer for *Golf Digest* since 1993. Currently he is editor in chief of Golf Digest International, based in his hometown of London, where he oversees a network of more than thirty international editions of *Golf Digest* and other affiliate magazines. Previously, working out of the company's Connecticut and New York headquarters, he served as senior editor of *Golf Digest* until 2000, editor of GolfDigest.com until 2001, and executive editor of *Golf Digest* until 2003. Recent articles John has authored include stories on playing in the Russian Amateur Championship, in the Putt-Putt U.S. Open, and in the first-ever North Korean Open. Editing projects include overseeing *Golf Digest*'s biennial Planet Golf survey, which he created in 1999 and which ranks the best golf courses all over the world. A graduate of the University of Bristol, England, John holds a B.Sc. in psychology and zoology.

If You Go

▶ **Getting There:** In his *Golf Digest* piece on Bhutan, John Barton calls Royal Thimphu the most remote golf course in the world. Requiring nearly twenty-four hours of flying time from New York (via London, Bangkok, and Calcutta), capped off by a hair-raising drive through the mountains to the valley where Thimphu rests, it's not a trip to be taken lightly. Once you reach Asia, Druk Air (www.drukair.com.bt) provides service to Bhutan from Calcutta, New Delhi, and Bangkok; cost is approximately $700 round-trip.

▶ **Course Information:** Royal Thimphu is a 9-hole par 33 layout measuring 2,700 yards. If you make it this far, it's not too difficult to get out on the course. Western golfers of even modest skills are lauded like PGA pros! The appreciation of the Bhutanese people that you will likely develop on the course will be enhanced if you set aside some time to take in Bhutan's cultural wonders. These include the palatial seventeenth-

century Tashichhoe Dzong, home of the National Assembly and summer residence of the capital's monastic community. A hike to the gravity-defying Taktsang Monastery, Bhutan's most sacred site, is also in order. You'll get a wonderful taste of life in Bhutan by visiting Thimphu's weekend market, where many fine crafts and fresh produce are purveyed.

▶ **Accommodations:** Because of the limited access to Bhutan and the necessary paperwork that is required, travelers must work through one of the tour companies authorized to guide visitors around the country. A list of approved tour companies and back- ground information is available at the Department of Tourism, Bhutan (975 2-323251; www.tourism.gov.bt). Rick Lipsey's organization, Golf Bhutan (212-531-1602; www.golf bhutan.com), is the only operation offering golf-specific tours and includes play on several of the "private" courses mentioned above. The tour company you choose will take care of all the details (lodging, meals, etc.) so that you can focus on the experience. Excellent general tourism information is available at the official government Web site, www.kingdomofbhutan.com.

PACIFIC GROVE MUNICIPAL
GOLF COURSE

RECOMMENDED BY **Peter Finch**

✳

The Pacific Grove Municipal Golf Course rests just a few miles north of some of the priciest golf real estate in the world. Yet despite its glamorous locale there is no elaborate clubhouse, no bag drop, no parking attendant—and greens fees are less than lunch for two at some of the most exclusive resorts nearby.

These are a few of the reasons that Pacific Grove Muni has a special place in Peter Finch's heart; it has nothing to do with the fact that the course was the site of Peter's finest round!

"I was out on the central California coast on a golf pilgrimage to Pebble Beach," Peter recalled. "I played Pebble, Spyglass Hill, and Spanish Bay over three days. They're all very challenging for a guy with a middle-handicap. Mine is in the low teens, and anyone with that skill set is going to struggle a bit. I think people struggle at Pebble as they struggle at St. Andrews, as the setting does a job on your head.

"After the round at Spanish Bay, I felt pretty beaten up by the courses. I also was a little discouraged. I didn't play very well at Spanish Bay, and the round was extremely slow, as there was a business outing in front of my group. I ended the day disappointed with my game, and disappointed that there were so many players out there. I didn't know if I even wanted to play the next day. I definitely had a bad attitude.

"When the morning came around, I thought that maybe I'd just go over and have a look at the Pacific Grove course. I knew that the back nine had been laid out by Jack Neville, the same fellow who did Pebble Beach, and I'd heard that it was a treat. I drove down there and walked into the pro shop. The guy behind the counter was a bit gruff. I said I wanted to play as a single and he replied, 'You can't. We have a big outing going out in fifteen minutes . . . unless you go out with the twosome that's on the tee right now.'

I ran up to the tee to see if I could join the twosome, and when they consented I hustled back to the parking lot, threw on my shoes, and grabbed my bag. I caught up with the twosome as they were putting out on the first hole, a short par three."

Thus began the golfing redemption of Peter Finch.

The 18 holes at Pacific Grove are the sum total of two 9-hole layouts built nearly thirty years apart. The front was laid out in 1932 by a former U.S. Amateur champion named Chandler Egan, the back nine in 1960 by Jack Neville of Pebble Beach fame. The front nine is a fairly typical muni, with screens up in a few places so that people on the next fairway don't get beaned by errant shots. The back nine, however, morphs into a fabulous links-style layout, weaving back and forth along the Pacific. Two high points on the back are the sixteenth hole, a 355-yard par 4 where the tee box rests next to the photogenic Point Pinos Lighthouse, the longest continuously operating lighthouse on the West Coast; and the seventeenth, a 153-yard par 3 that plays across a freshwater pond to a green fringed with Monterey cypress, with the Pacific crashing on the left.

The twosome that Peter hooked up with had quite a positive impact on his day. "They were two local folks, Patricia, who I suspect was somewhat affluent, and Jose, who was an older gentleman and Patricia's gardener. They had a regular golf date. She took him out to play at some of the tonier clubs in the area. Though the front was decidedly unremarkable, Patricia, Jose, and I had wonderful conversations, and I could feel my funk lifting. I was starting to feel good about golf again. Here I'd stumbled across a little muni where I could run out on the spur of the moment and, for thirty-six dollars, have a pleasant outing with real people.

"On the back nine, things changed abruptly. It's a completely different course, just amazing. It takes you right out on the water and combines incredible views of the Pacific and Monterey Bay with windswept bluffs reminiscent of some of the great courses of Scotland and Ireland. At one point Jose pointed out Johnny Miller's house. The sun was shining. It was a quintessential California moment, as if we were in the middle of a Beach Boys video. I knew I was playing well, but I wasn't adding things up. I wasn't thinking about it too much, I was just living in the moment.

"We got to the eighteenth green and I said good-bye to Patricia and Jose. I totaled my score up and realized that I hadn't played the first hole. If I had played the first hole, it might have been my best round ever. I went to the pro shop and asked if I could play the first hole. The same gruff guy behind the counter said, 'No.' I said, 'Please. If I play the

first hole, it would be my best round ever.' He said, 'I can't do that. We have this outing going.' I gave it one last try. 'Please. Please let me out.' He kind of scowled and tilted his head toward the tee. I nearly holed the par three; the ball lipped out, leaving me with a four-foot putt for birdie. I missed the putt, but I still got a par. It was the best round of my life.

"When I went back in and thanked him, I got a little smile out of him. I came away feeling really pumped about golf again. It stayed with me for a long while. Pacific Grove gave me this special feeling, the feeling you get going to a nice place that's underappreciated. You take someone to such a place, they feel like you've let them in on a secret."

PETER FINCH played his first round of golf in junior high school and was immediately hooked. He is now a senior editor at *Golf Digest* and *Golf World* magazines, where he is in charge of travel coverage and special projects, positions he has held since early 2003. His editorial projects include, among other things, *Golf Digest*'s annual Best New Courses report and its biennial 100 Greatest Courses and 75 Best Resort surveys. His travels as a golf writer have taken him everywhere from St. Andrews to the inside of a Phoenix cryonics lab, where the head of slugger Ted Williams is (allegedly) frozen. A graduate of Stanford University, Peter was previously the editor of *SmartMoney* magazine and before that an editor at *BusinessWeek*.

> **If You Go**

▶ **Getting There:** Pacific Grove is about two hours' drive from the San Jose airport, which is served by most major airlines.

▶ **Course Information:** The par 70 Pacific Grove Municipal Golf Club measures a modest 5,732 yards from the back tees and has a slope rating of 119. Greens fees for visitors are $36—that's less than 10 percent of the fees at Pebble Beach, if you're counting. Call 831-648-3177 for more information and tee times.

▶ **Accommodations:** Pacific Grove is a pleasant town between Carmel and Monterey. The Pacific Grove chamber of commerce (800-656-6650; www.pacificgrove.org) highlights bed-and-breakfasts, inns, and other accommodations.

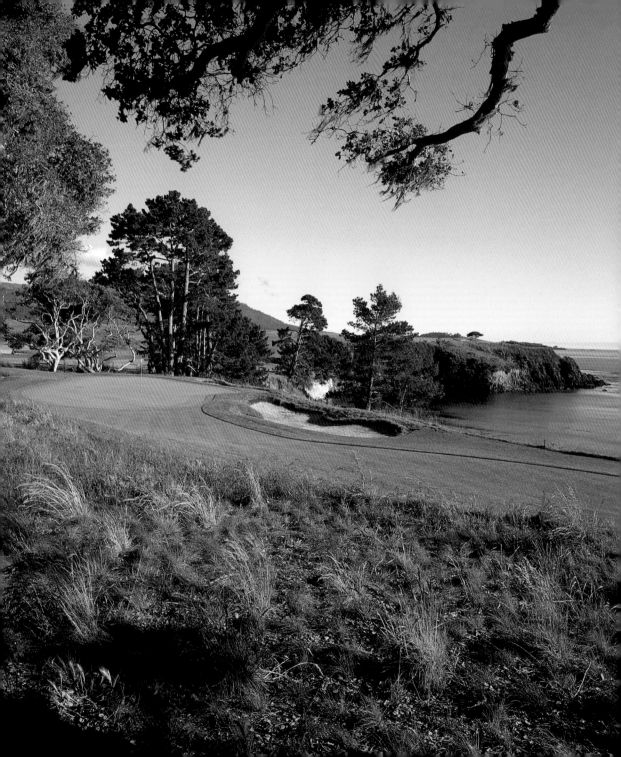

PEBBLE BEACH GOLF LINKS

RECOMMENDED BY **Mark O'Meara**

Professional golfer and all-around nice guy Mark O'Meara does not mince words when asked about his favorite golf course. "I've played on the Tour for twenty-five years, all over the world, and I'm hard-pressed not to put Pebble Beach at the top of my list. Since before the first time I played there when I was sixteen and participating in the California Amateur Championship, I'd heard so much and had so many expectations. When I drove onto the Seventeen-Mile Drive, it didn't let me down. It was incredible then, and it's incredible now. I've had the good fortune to play with many celebrities, athletes, and politicians. I've had a great time every time.

"And it doesn't hurt that I've had some success there."

The Pebble Beach Golf Links was established on central California's Monterey Peninsula in 1919, spanning a spit of land artist Francis McComas called "the greatest meeting of land and water in the world." (This quote has often been used to describe the course, though it was uttered years before ground was broken on Pebble's first tee box.) It was designed by Jack Neville and Douglas Grant, two prominent California amateur players with no course architecture experience whatsoever. As any good golf architect would advise, Neville and Grant did not set out to impress their vision upon the land but instead let the land define their task. Near the end of his life, Jack Neville, speaking to a reporter for the *San Francisco Chronicle*, had this to say about his role in creating Pebble Beach: "It was all there in plain sight. Very little clearing was necessary. The big thing, naturally, was to get as many holes as possible along the bay. It took a little imagination, but not much. Years before it was built, I could see this place as a golf links. Nature had intended it to be nothing else. All we did was cut away a few trees, install a few sprinklers, and sow a little seed."

OPPOSITE:
The 187-yard
par 3 fifth was
designed by Jack
Nicklaus and
opened for play
in 1999.

Thanks to years of televised final-round coverage of the AT&T Pro-Am and a smattering of U.S. Open Championships—not to mention countless golf calendars and coffee table tomes—the links of Pebble Beach are superimposed upon the world's collective golf consciousness. There's the iconic Lone Cypress, once attacked by arsonists but saved by a vigilant Carmel resident. There's the wee seventh hole, a mere 100 yards to a well-bunkered green backed by the Pacific, which can demand a delicate pitch or a slugged long iron, depending on the wind. Then there's the breathtaking eighth, a 416-yard par 4 that demands a daunting second shot over an ocean chasm to reach a precipitously sloping green. Average players, lacking the might to position themselves properly for this approach shot and/or to carry the cove, would benefit their tallies by bailing out and laying up on the left side of the fairway. But duffers don't travel from all ends of the earth to play it safe, so grab your hybrid iron or trouble wood, take your best swing, and drop a ball into the Monterey Bay. It's all part of the experience.

If there's one hole that defines Pebble Beach in the popular imagination it's the eighteenth, a 543-yard par 5 skirting Carmel Bay that's widely considered golf's finest finishing hole. Walking up the misty fairway on an off-season afternoon, accompanied by the sound of lapping surf and barking leopard seals, it's easy to imagine the penetrating gazes and roaring applause of thousands of onlookers as you prepare to hit a safe third shot home en route to victory. Mark O'Meara has known that sensation an incredible five times. But one instance is especially etched in his heart.

"I had won the AT&T Pebble Beach National Pro-Am in 1989 and came back in 1990," Mark recalled. "This time, I invited my dad, Bob O'Meara, to play as my partner. He had played with me at the tourney a few years before, but we didn't win, though he had made the cut. I was paired with my dad all four days, and he made the cut again. I don't know of any other competitive sport where you can play with your dad alongside you. Being able to share something like this with your dad is just an amazing thing.

"I was fortunate enough to have another good tourney in 1990. On the final day, we reached the eighteenth, and I had a one shot lead. I only needed a par to win. Throughout the tourney, my dad had always hit first. He drives very straight generally, and here, on the seventy-second hole of the tournament, he pulls it left, right into the ocean. He turned to me and said, 'This isn't a good time to hit a shot like that, is it?' I said, 'No Dad, it's not the best time.' I bore down extra hard, and got it down the fairway. We're walking together down the fairway, and about eighty yards from the tee, as we're getting to the

place where his ball went out, my dad asked, 'What do you want me to do?' I said, 'If I were you, I'd keep the ball in your pocket and walk up the fairway with me. Take in the beauty, the fans, the television cameras. Take it all in, and enjoy it.' My dad turned to me and said, 'You know, that's the best advice you've given me all week.' I proceeded to par the hole and won the tourney, and gave my dad a hug and kiss on the eighteenth green.

"About a month later, I got a call from my dad. He said, 'I flipped through *USA Today* the day after the tournament. There was a big story about your victory, and the big purse you got. Down below the big story, there was a listing of team scores. It said that your team had won $8,400. I'm wondering when I can expect my check for $4,200.' I said, 'You can't collect money, Dad. You're an amateur.' He said, 'Okay. I'll turn pro.'"

MARK O'MEARA took up golf when he was thirteen, and turned pro in 1980, shortly after graduating from Long Beach State University. Since turning pro, Mark has won more than a dozen PGA tourneys, including the AT&T Pebble Beach National Pro-Am (five times), the Masters (1998), and the British Open (1998). He is an avid and accomplished fly fisherman and fly tier, and he recently teamed with PGA TOUR Design Services to build TPC of Valencia, California. Mark lives in the Orlando, Florida, area with his wife, Alicia, and their children, Michelle and Shaun Robert.

If You Go

▶ **Getting There:** Pebble Beach and the other attractions of greater Carmel are within a few hours' drive from the San Jose and San Francisco airports, both of which are served by most major airlines.

▶ **Course Information:** The par 72 Pebble Beach Golf Links measures 6,737 yards from the back tees, and carries a slope rating of 144. Pebble Beach currently boasts America's highest public course greens fees—$425. Tee times are hard to come by, so plan in advance. For reservations, call 800-654-9300 or visit www.pebblebeach.com.

▶ **Accommodations:** The Lodge at Pebble Beach is consistently ranked among the best resort lodging in America; Garden View rooms start at $555 (800-654-9300). If you'd rather reserve your savings for greens fees, there are many options available around Carmel (800-550-4333; www.carmelcalifornia.org), Pacific Grove (800-656-6650; www.pacificgrove.org), and Monterey (831-648-5360; www.mpcc.com).

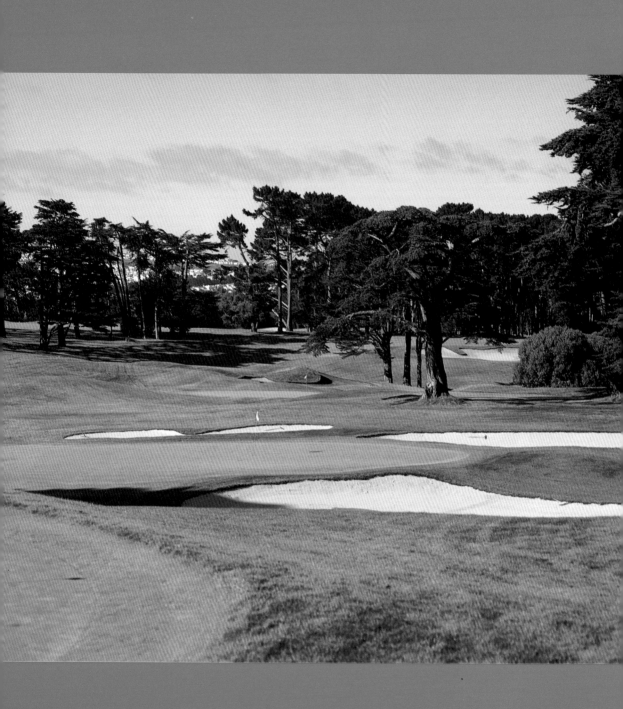

SAN FRANCISCO GOLF CLUB

RECOMMENDED BY **Brian Hewitt**

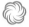

The venerable Olympic Club—specifically, the Lake Course—has more than thirty thousand trees and a fairway bunker, and garners the lion's share of the golfing public's attention when "great golf courses" and "San Francisco" are muttered in the same breath. After all, the Olympic Club has hosted four U.S. Opens and many Sunday afternoon television viewers. But the Olympic Club's understated neighbor, the San Francisco Golf Club, is where many golf insiders leave their heart . . . if they're fortunate enough to get a chance to play.

"I have a friend from high school who's a member there," said Brian Hewitt. "Every time he gets me out there, it's unforgettable. There's a minimalist little pro shop and a decidedly unobnoxious clubhouse. The parking lot's not full of obsequious hustlers scrambling for your bag. And most important, the presentation of golf is low key and very, very good. It's the old school of golf design. I would have to describe the San Francisco Golf Club as a golf course lover's golf course."

The San Francisco Golf Club is one of the oldest clubs established west of the Mississippi. It was organized in 1895, and initially members set up shop at a crude 9-hole layout in the Presidio. Later, after squatting for a time on some land owned by the Spring Valley Water Company, members purchased a site half a mile from the beach, and A. W. Tillinghast was commissioned to design the layout that's played today. Tillinghast was still relatively new to his craft, having designed his first course ten years before near the Delaware Gap in Pennsylvania, at the behest of well-to-do family friends. Completed in 1918, it is, some feel, Tillinghast's greatest achievement. If his designs are marked by one common feature, most agree that it's a lack of commonality; Tillinghast seemed to thrive on variety, and the San Francisco Golf Club captures that variety. The bunkering

OPPOSITE: A. W. Tillinghast is said to have overseen the hand-carving of each bunker at San Francisco Golf Club.

47

on San Francisco's rolling terrain is especially noteworthy, both for the traps' graceful design and for the havoc they can wreak upon imperfect approaches. The ninth hole, for example, has nine bunkers; the eighteenth has eleven. Accounts from the time report that Tillinghast had a fairly hands-on approach to course design in these early days, overseeing the hand-carving of bunkers by laborers, one by one.

The San Francisco Golf Club has several extremely noteworthy holes that often show up on "great golf hole" lists. One is number 9, a 570-yard uphill monster that plays considerably longer when the famous fog eats up any roll the fairways might surrender. Players are given a fairly generous landing area for the drive, but a series of traps on the right of the landing area for the second shot are unnerving, as is the approach shot to a lightning-quick green—the one ensconcing nine bunkers. There are no reports of any players having putted for eagle, though during his college days Tiger Woods is said to have once hit back-to-back drivers, leaving himself just 10 yards shy of the green.

The 190-yard seventh hole is one of the most famous par 3s in golf, for both its shot value and its historical precedent. (Tillinghast likewise remembered number 7 as one of his favorite creations.) The shot plays downhill. On the right of the green the land falls off abruptly; on the left, a series of bunkers awaits. While a wonderful hole by any standards, number 7's notoriety rests in its place in history. In 1859 the hole's valley setting was the site of the last formal duel to take place in California. The battle, between state supreme court justice David Terry and U.S. senator David Broderick, had erupted over differing opinions about the preservation of the Union. Pro-Union Terry prevailed. Some historians feel that had the duel ended with a different winner, California's bountiful reserves of gold and silver may have gone to the Confederacy . . . which may have led to a very different outcome.

"There are a few memories of the San Francisco Golf Club that particularly stick out in my mind," Brian recalled. "On one occasion, I was playing on a Friday morning in the spring of 1998, while they happened to be playing the U.S. Open down the hill at the Olympic. Here I was, playing this incredible old Tillinghast course, and we could hear the roars of the crowd drifting up the hill. It just didn't seem like things could get much better. Another time, my group was getting ready to tee off on the back nine. The first and tenth tees share the same tee box. They go off in different directions at ninety-degree angles. As we got up to the tee, another group was going off on number one, and we waited our turn. One of the guys going off the first tee was Mac O'Grady.

"The caddies there add considerably to the experience," Brian continued. "I generally like to do my own yardages and club selection. The one place I'll trust the caddies without fear is the San Francisco Golf Club. The last time I visited I played very well, and I give much of the credit to my caddy. Not only was I not asking for distance, I wasn't even asking for a particular club. The caddy would just hand me a club and say 'firm' or 'easy.' I didn't even look at the club that was being handed to me."

BRIAN HEWITT joined the Golf Channel team in 2003 after years of reporting for *Golfweek* magazine. During that time, he brought his insightful perspective to Golf Channel viewers as a frequent guest on *Viewer's Forum*. Brian serves as the "Golf Channel Insider" for both Golf Central and the Sprint Pre/Post Game, delivering behind-the-scenes reports from the PGA Tour. He also serves as a contributing editor to TheGolfChannel.com.

If You Go

▶ **Getting There:** The San Francisco Golf Club is in the southwest corner of San Francisco, a $25 cab ride from either downtown or the San Francisco International Airport.

▶ **Course Information:** The San Francisco Golf Club plays to a par 71 and is 6,716 yards from the back tees, with a slope rating of 134. The club is very private; if you're somehow able to wangle your way on, greens fees are $150. There are many other wonderful golf opportunities available in greater San Francisco, including two nearby munis—the recently renovated Harding Park and the short but incredibly picturesque Lincoln Park. Extensive information on Bay Area courses is available at www.sfgolfer.com.

▶ **Accommodations:** No other city of its size can offer the abundance of eclectic accommodations, fine eateries, and classic watering holes that San Francisco serves up. A good place to start your planning is the San Francisco Convention and Visitors Bureau (415-974-6900; www.sfvisitor.org). While the trendy restaurants are ever-changing, the best bars have staying power. The Redwood Room (in the Clift Hotel, near Union Square) and Vesuvios (on Columbus in North Beach) are as different as could be, and both wonderful.

GOLDEN PEBBLE GOLF CLUB

RECOMMENDED BY **John R. Johnson**

❋

Copyright infringements are a problem in China, as many manufacturers flood foreign markets with bootleg CDs and knockoff designer handbags. There was a recent issue, however, where the potential plaintiff—a fairly well-known golf resort in the vicinity of Carmel, California—stood on somewhat shaky ground vis-à-vis a Chinese enterprise. Photographer John R. Johnson tells the story like this: "About ten years ago, a new golf enterprise was being developed on the southern tip of the Liaodong peninsula, almost due east of Beijing. It was going to be China's first coastal golf course, and the area of the coast was called Jin Shi Tan—the literal English translation of which is Golden Pebble Beach. As the course prepared to open for play, the owners planned to use that trade name when presented in English.

"Now understandably the resort in California is very protective of their brand. When this resort got word that an upstart operation in China was planning to use a very similar name, they immediately fired off a cease-and-desist letter. The owners of the Chinese property sent a note back, the gist of which was, 'We are very honored that you have contacted us. You may not have realized, but our region has been called Jin Shi Tan for over thirty-five hundred years. Perhaps you should consider changing the name of your course instead.' Before litigation or an international incident could ensue, a compromise was reached. Golden Pebble Beach would be called simply Golden Pebble."

Considering China's new infatuation with capitalism, it's not surprising that the number of golf courses is increasing at an exponential rate—from none twenty years ago to approximately two hundred in 2004 to an estimated twelve hundred by 2008. Though the number of courses has increased dramatically, along with the quality of the designs, Golden Pebble remains a highlight on the Sino golf spectrum. It's distinguished by its

OPPOSITE:
Golden Pebble,
China's first
coastal golf
course, rests
along the cliffs
above the
Yellow Sea.

spectacular setting on dramatic cliff sides above the Yellow Sea, on land that's essentially a national park area. "Though the course would ultimately have some homes as part of the overall development, the owners did not want to compromise the dramatic land-scape," said Peter L. H. Thompson, the American architect who designed Golden Pebble. "We also wanted to leave some shore access for local residents. We set out to make the course recede and fit into the land, and to limit the amount of earth that we moved, as there were many fossils, and many sensitive geologic formations. The area had been the site of a village, and there were cultural and religious elements here and there—for example, two statues along the cliff's edge, the Goddess of the Ocean and the God of the Lost Seafarer. We were allowed to move them, but only once ceremonies were performed. The government didn't particularly care what was done, but we felt that it was important to respect the mores of the villagers. Despite all the communist teach-ings they've been exposed to, the local people fall back upon the old teachings in times of duress."

John Johnson was on hand for the creation of the course, and it was an experience that shed a bit of light on the way of life in a small Chinese fishing village. "They had hundreds of people working on the course, many husband and wife teams. These people had no concept of what a golf course was. They were shown pictures of what they were building and followed instructions. They had some heavy equipment but were not mak-ing much use of it. I remember the image of a backhoe sitting idle, with people working all around it, digging irrigation ditches by hand. The husband would swing a pickax, and his wife would scoop out the dirt in between swings."

A number of holes at Golden Pebble run along the cliffs and provide fascinating topographical relief. Looking ahead across the seascape, one can take in the next hole as a three-dimensional cutaway while the current hole is being played. "This setup pulls you through the course visually as you're physically progressing along," Thompson added. "The tide is very pronounced at Jin Shi Tan. If you play the ocean holes at differ-ent times of day, you encounter very different scenery. Sometimes the water is lapping against the cliff; other times, the villagers are on the beach harvesting snails."

One of the most stunning holes at Golden Pebble is the par 3 139-yard seventh. From the tee, a pagoda rests to the left, and another pagoda looms in the distance on a point of land, by a larger building that acts as a kelp factory. Players hit across an abyss to a small green that juts out above the beach. "When the wind blows, it can blow the ball right off

the green," John continued. "This happened after my tee shot. I went to the drop zone, hit the ball up on the green, and the wind blew it back right off the green to me. This happened four times before I just gave up." During his visit, John hiked down to the kelp factory. "They pull these small boats loaded with kelp up from the beach by a cable and lay it out in the sun to dry. It was fascinating."

JOHN R. JOHNSON is the president and creative director of Johnson Design Golf Marketing, where he leads the team of talented professionals who create the collateral and digital marketing materials for a broad cross-section of the industry. He is highly sought out as a speaker for marketing, branding, Internet, and image issues in the golf industry. Many golfers already know John for his photographs. Besides contributing photos to every major golf publication, motivational posters, and various coffee table books, he has built up client and project list that is like a who's who of the golf world. He has twice been named National Golf Photographer of the Year.

If You Go

▶ **Getting There:** Golden Pebble is located approximately thirty miles from the city of Dalian, which is roughly an hour's flight from Beijing. Dalian has direct flights from most major Asian cities. The resort is served by light-rail, shuttle, and taxi. Jin Shi Tan is part of a national tourist zone and is quite open to foreign visitation. The prime visiting season is May through September.

▶ **Course Information:** Golden Pebble Golf Club is a par 72 layout and plays 7,119 yards from the back tees. Technically a private course, visitors can play by staying at one of the hotels in Dalian, or by working through a tour operator. Golfing China (www.golfingchina.com) offers a package that includes round-trip airline tickets (departure from Beijing), four-star hotel/country resort, greens fees, and city-airport transfers for 3,980 RMB per person (roughly $480). Golf 007 Travel (www.golf007.com) offers three-days/nights packages departing from Hong Kong that include round-trip airline tickets, accommodations, two greens fees, and transfers for HK$5,120 (roughly $660).

▶ **Accommodations:** For those wishing to visit Golden Pebble on their own, several hotels in Dalian come well regarded. These include the Furama Hotel Dalian (86-411 263 0888) and the Wanda International Hotel (86-411 362 8888).

CASA DE CAMPO, TEETH OF THE DOG

RECOMMENDED BY **Pete Dye**

When Pete Dye first visited the site near La Romana, Dominican Republic, that would-one day become Teeth of the Dog, it was hard to imagine much of anything growing there, let alone the Caribbean's most celebrated golf course. "The land was pretty much useless, at least for human purposes," he recalled. "It was too dry for growing sugarcane and there was too little vegetation to graze cattle. No one much cared about it." After flying over the land by helicopter and drifting along the coastline in a skiff, Dye decided that he needed a closer look. "I went out and walked the land and suddenly noticed that there were three distinct areas that were concaved, all along the same stretch of shoreline. I wanted to measure the areas. Back in town, I couldn't find a tape measure, but was able to locate a yardstick. I measured off one hundred feet of rope and went back to the site. The first concave was three hundred eighty yards, the second two hundred, and the third four hundred fifty yards. Here they were, right in succession. On the other nine, the sixth and eighth were concave too. There was a little area in the middle that went the other way. I manufactured the seventh hole. The others were all right there. You usually don't find such things along the edge of the ocean. It was like the man upstairs had laid out those holes."

Casa de Campo, the lavish resort that hosts Teeth of the Dog and two other fine Dye creations (the Links, designed with Pete's wife, Alice, and Dye Fore), has emerged as one of the Caribbean's great escapes. The brainchild of a sugar baron named Alvaro Carta, the 7,000-acre grounds of Casa de Campo include three polo fields, a large marina, fifteen swimming pools, a state-of-the-art shooting center, a tennis center, a host of first-class restaurants, and a range of accommodations from comfortable to decadent. The scene is completed by the presence on a nearby hillside of Altos de Chavón, a replica sixteenth-

OPPOSITE:
The par 3
sixteenth is
widely consid-
ered the most
fabulous
hole at Teeth
of the Dog.

century Mediterranean village. While vacationers from Europe, South America, and the United States come for the amenities, which are amplified by the friendly Dominican staffers, golfers—as the resort's promotional literature states—come to "take a bite out of the dog." Whether they bite or are bitten, players who have gone around once are generally quite eager to take on Teeth of the Dog again . . . and again.

The "teeth" of Teeth of the Dog refer to a local nickname for the island's jagged-edged coral reefs; while the course's owner wanted to name the track Cajuiles after the cashew trees that grow in the mountains, Dye lobbied for Teeth of the Dog and eventually won. The course was built without the use of heavy machinery, and the detailing is evident. After four relatively tranquil holes that meander downhill, you finally reach the sea. Four fabulous waterside holes follow, including two of golf's great oceanside par 3s: the 157-yard fifth and the 224-yard seventh. The wind is often blowing from the water or toward it. When the wind is coming off the water, one needs nerve to start one's shot over the Caribbean—and faith that the breeze will bring it back to the peninsular greens. "Down on the fifth and the seventh holes, you're so close to the water that you can feel the spray," Pete Dye said. "You can look into that clear Caribbean Sea and see the fish—you're only four feet above it at high tide. You feel like you're practically in the water." Local divers who collect recently lost balls from the shallows along holes 5 through 8 find many willing customers among players heading for the back nine.

There are many memorable holes at Teeth of the Dog, providing stimulation for all the senses. In a recent story on TravelGolf.com, writer Judd Klinger described how in the eighties, players teeing off on the fifteenth might have had the chance to glimpse naked supermodels; the villa there was once the residence of Oscar de la Renta, and the designer's legion of models would sometimes sunbathe *au naturel* in sight of the tee box. Many feel that the 194-yard par 3 sixteenth is the course's most spectacular hole. It is here that the coral "teeth" are most prominent, resting just to the right of the green. Lining up to play your tee shot into the well-bunkered green as the foam bubbles up from the waves below borders on the sublime.

While Dye's signature pothole bunkers and ample opportunities to dunk a ball make Teeth of the Dog a constant challenge, the course remains quite playable; perhaps that's part of its long-standing popularity. That, and the views. "Ambience is such an important aspect of any golf course's success," Pete Dye ventured. "If you want to put a course on the map, build a course next to the ocean, in the mountains, or arrange it so Ben

Hogan or Arnold Palmer can win the first tourney there. It's so important to have an outside ambience."

PETE DYE is considered one of the most influential golf course architects of the past fifty years. Each of his designs is distinct from the rest, yet each bears the signature Dye style and challenge. Dye's hands-on approach and organic style are superbly influenced by the traditions of the game. In fact, it was in 1963 that Dye's style crystalized on a visit to Scotland. It was there that he discovered railroad ties, tiny pot bunkers, and many other course elements that he has successfully incorporated over the years. Most of these features can be found on his internationally celebrated courses, including the Stadium Course at the Tournament Players Club at Sawgrass, the PGA West Course, the Ocean Course at Kiawah Island, and Whistling Straits in Kohler, Wisconsin. His work also includes a collaboration with Jack Nicklaus on the Harbour Town Golf Links in Hilton Head, South Carolina.

If You Go

▶ **Getting There:** Casa de Campo is located near the town of La Romana, roughly thirty-five miles from the Dominican capital of Santo Domingo, which is served by most major airlines.

▶ **Course Information:** The par 72 Teeth of the Dog measures 6,888 yards from the back tees and has a slope rating of 140. Greens fees during high season (December 21–May 31 and August 16–December 20) are $205; during the landscaping season (June 1–August 15), fees are $147. In addition to the resort's fine offerings, the private La Romana Country Club is sometimes accessible to Casa de Campo guests. Call 800-877-3643 or visit www.casadecampo.com.do for more information.

▶ **Accommodations:** Amidst its 7,000 acres, Casa de Campo offers a range of accommodations, from standard guest rooms to elegant villas. Rooms begin at $353 during the high season (January–March), and at $224 during the off season (April–December). Guests have access to a golf cart to convey them around the vast property. Between Casa de Campo and the faux-Mediterranean town of Altos de Chavón, you'll find a host of fine restaurants, which include the Tropicana, Casa del Rio, and La Piazzeta.

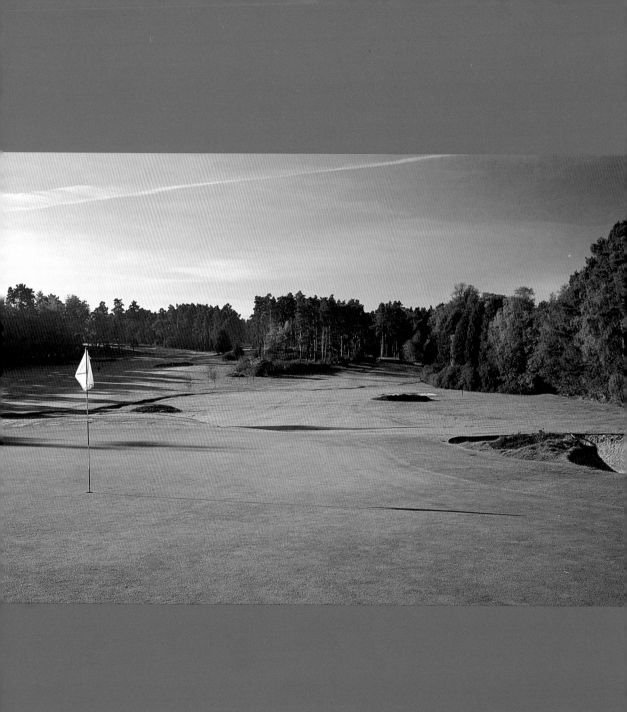

SWINLEY FOREST GOLF CLUB

RECOMMENDED BY **Dale Concannon**

Dale Concannon has a favorite quote about Swinley Forest: "'If Augusta National is the cathedral in the pines, Swinley is the holy grail.' The quote comes from Henry Cotton."

Swinley Forest is a lovely "heath and heather" course in the town of Ascot, county Berkshire, twenty-five-odd miles west of London. It was designed by the venerable Harry S. Colt in 1910 and stands among Colt's great treasures, though it's a treasure that has escaped the notice of all but aficionados. "What makes Swinley so special is that it's a stone's throw from two other famous courses by Colt—Sunningdale and Wentworth—but few people who aren't immersed in the world of course design know about it," Dale, an unabashed lover of Colt's work, said. "Those in the know, however, feel passionately about it. When a dear American friend of mine, course architect and restorationist Keith Foster, steps off the plane at Heathrow, the first thing he says is, 'Take me to Swinley.'"

Harry Colt was one among the pioneers among early-twentieth-century British architects. His work on such gems as Rye, Moor-Park West, and Stoke Poges (now Stoke Park) in England, as well as Sunningdale and Wentworth, took design on inland sites to new levels of artistry. The heathlands of southern England were an ideal place for Colt to apply his craft, as the sandy soil could easily be contoured without heavy machinery. His layouts are notable as much for their strategic elements as for their attention to more practical issues of course maintenance, such as drainage and soil preparation. At Swinley, Colt married the serenity of the setting with a thoughtful design that's challenging for skilled players yet not overly punitive for the rest of us.

Dale's opinion of Swinley has evolved since the first time he played. "A friend I used to teach was a member," Dale said, "and he made the proper introductions so I could play. I was a professional golfer at the time, and thought I'd murder the course. Well,

OPPOSITE: Swinley Forest, 25 miles west of London, is one of Harry Colt's under-appreciated masterpieces.

suffice it to say, I shot a figure I'd rather not share here! At the time, I didn't realize how great Swinley was. I'm a bit of a golf historian and a collector of antique golf equipment and memorabilia. In the course of my travels, I came upon some of Harry Colt's drawings and collections. As I learned more about Colt, I began to appreciate this course more and more. Some courses you need fourteen clubs and a cannon to play effectively. This course is only six thousand yards. But you can't touch the solid-gold quality of Swinley. It's the essence of British golf."

Swinley Forest is diminutive by modern standards, in part because the course has five par 3s. "When Harry Colt was brought in to design the course he explored the site in great detail," Dale explained. "He soon identified five swales that he felt would be perfect for greens. The five swales that he picked out are the five par threes, and he built the rest of the holes around them." There's not a bad hole on Swinley, and the course's long par 4s are comparable to Great Britain's best. However, most visitors come away with a lasting impression of the one-shotters—numbers 4, 8, 10, 13, and 17. Among these, the 185-yard Redan fourth may be the most memorable. More uphill than it seems from the tee, the green is perched on a natural shelf and is guarded by a gaping bunker on the left.

Visitors to Swinley get a flavor of the distinctive experience that awaits before they reach the first tee—or the clubhouse, for that matter. "You can't merely walk into the pro shop with a member and plunk your greens fee down," Dale continued. "You have to go through a mini interview. First, you must call the club secretary. He'll suggest that you come along at a certain time and he will have a chat with you. When you arrive, you're ushered into a little room. Then the secretary will chat with you for forty-five minutes or so to see if you're worthy of the course. Even the pros have to go through the process. Ernie Els played there recently, and he had to meet with the secretary—though his meeting was probably shorter than yours or mine. It's a quaint Edwardian throwback. In some respects, the whole course is. You half expect Bernard Darwin to walk into the clubhouse."

When asked to speculate about what the secretary might wish to grant access to Swinley Forest, Dale laughed. "I asked him once. His reply was, 'It depends on two things, young man. The way you stand, and the type of shoes that you wear.'"

Dale shared a tale involving a member of the royal family—perhaps apocryphal—that speaks to the very *Englishness* of the course. "Edward VIII—the king who abdicated the throne to marry an American divorcée, Wallis Simpson—was 'crazy keen' about golf, and

was reputed to have played every course in England. He came to Swinley Forest one day to play and brought along his personal teacher, Archie Compston. After they played their round, prince and his pro repaired to the clubhouse for tea and sandwiches. As they sat down, the secretary came to their table and said, 'I'm sorry, but I'm afraid that professionals are not welcome in the clubhouse.' Edward VIII was incensed and left the clubhouse along with his teacher. The rumor is that Swinley Forest was slated to receive the coveted 'royal' designation, but due to the prince's pique the designation was not given."

DALE CONCANNON is the author of twelve books on the game, including his London *Times* best-selling biography of Nick Faldo, *Driven*. In 1982 he became the first professional golfer to play an exhibition match inside a British prison on a 3-hole course laid out by the inmates! Taking no blame for the riot that saw the place razed not long after, he became a full-time golf writer in 1985. A contributor to many international golf magazines, his books include *Golf: The Early Days; From Tee to Green; The Round of My Life; The Worst of Golf; Bullets, Bombs & Birdies—Golf in the Time of War;* and *The Ryder Cup: A History*. A longtime collector of antique golfing memorabilia, he currently has one of the finest private collections of pre-1950 golf photography in the world.

If You Go

▶ **Getting There:** Swinley Forest Golf Club is situated in South Ascot, roughly thirty miles west of Heathrow Airport near London. Ascot is less than an hour's train ride from London's Waterloo station, or one and a half hours from Heathrow.

▶ **Course Information:** Intimate Swinley Forest is just 5,952 yards from the back tees, and plays to a par 68. The course is private, though guests are allowed with members, providing they pass muster in their interview with the club secretary. Fees are £65.

▶ **Accommodations:** While Swinley Forest can easily be reached from downtown London, the Stoke Park Club (+44 1753 71 71 71; www.stokeparkclub.com) offers five-star accommodations close by, with rooms beginning at £280. The course here is another H. S. Colt design; while Dale Concannon feels it's not among Colt's best work, it has two claims to fame—it was the seventh hole here that inspired Alister MacKenzie in the design of the twelfth at Augusta National; and the golfing scene from the movie *Goldfinger* was filmed here.

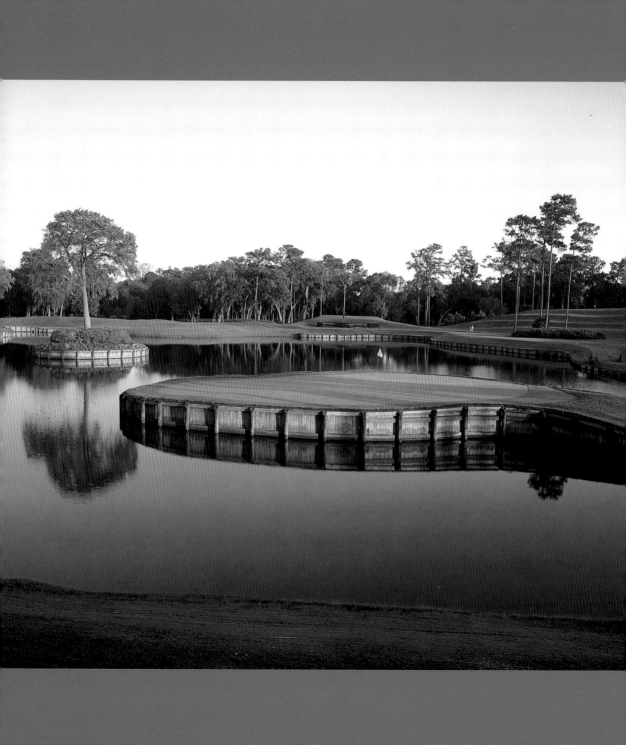

TPC SAWGRASS, STADIUM COURSE

RECOMMENDED BY **Alice Dye**

The concept of the Stadium Course at the Tournament Players Club at Sawgrass belongs to former Professional Golf Association tour commissioner Deane Beman. "The PGA Tour wanted its own tournament at their own venue," Alice Dye recalled. "Deane wanted a permanent venue that would essentially serve as the site for a fifth major. He wanted each green to have four plateaus for four different pin placements, for each day of the tourney." Beman also envisioned a course that would be designed with the spectator as well as the player in mind. The layout would need to give fans good vantage points to the action. Last, the course would have to be open to the public, so average Joes and Josephines could test their mettle against the same course that their heroes played.

Deane Beman was the enabler of the TPC concept, but it's Pete Dye's wicked genius that has made the Stadium Course at Sawgrass so memorable. Many who've played it— including some of the pros—place this course among his most "dye-abolical" designs. "Professionals who play on the PGA Tour get to know the courses that are regular stops pretty well," Alice continued. "They have a good sense of where they need to place a shot on the green to get the ball close to the pin. When they come to a new course, they don't know exactly where to play their shots. In this respect, a new course is something of an equalizer. When the first tournaments were staged at TPC Sawgrass, some of the pros complained bitterly that the course was too hard. But a lot of it had to do with knowing where to hit approach shots on those small greens to stop the ball for the various pin placements. Raymond Floyd was one of the first pros to play the course, and Pete went around with him and told him where to play his shots. Ray shot a sixty-eight, but finished the eighteenth with a seven when Pete did not tell him where to hit the ball. To do well at TPC, you've got to be making good shots. It's not the kind of course where you can get

OPPOSITE:
Many don't
realize that
the design of
number 17 at
TPC Sawgrass
was some-
thing of an
afterthought.

away with making lots of putts, because that generally won't happen. The course sifts the poorer players out, and the professionals appreciate that. The same people who criticized it came to love it."

Like so many Pete and Alice Dye designs, TPC at Sawgrass is not bone-crushingly long, nor unreasonably punitive . . . that is, if the player is using his head. Strategic thinking is paramount, with execution a close second; some would suggest that a grounded psyche trumps all considerations on the Stadium Course, as the layout can certainly play games with your head. Take the 529-yard par 5 eleventh. Gambling players capable of connecting two very strong shots can play the left side of the fairway, though the second shot must clear an oak tree and fly two immense bunkers that run much of the second half of the hole. Most players lay up to the right, where another imposing oak tree can block your approach if the shot is less than precise.

The seventeenth hole at Sawgrass has made the first TPC course recognizable to almost every golfer, even those who frequent only miniature golf courses. Some architectural purists dismissed it as a novelty. Many course designers have since mimicked it. "The island hole was so unique, so different, no one even complained about it," Alice said. "It should have been the most controversial hole on the course, but I don't think anyone knew what to say."

Considering 17's notoriety, it's interesting to note that the island green was really an afterthought, albeit a brilliant afterthought. "We knew that seventeen was going to be a short par three," Alice continued, "and the original plan was to have a water hazard on the right side. However, there was good sand around the site of where we thought the green would be, and such good material was at a premium on the site, which was quite swampy. We kept digging and digging this sand out—mostly for the fifteenth and sixteenth holes. Eventually, there was a hole where the green was going to be. Pete wasn't sure what he was going to do, and I suggested that we make an island green."

Though it is but a pitch shot for many players, the seventeenth has proven a source of great consternation for tour player and tyro alike. At 50 feet wide across the front, 87 feet wide across the back, and 90 feet deep, the green is not insurmountably tiny. Yet when there's a million dollars on the line—it can seem the size of a postage stamp. One year when uncommonly high winds made club selection trickier than usual, sixty-four balls went wet during the opening round of the Players Championship; this is a statistic that

every duffer relishes with glee. It's estimated that in the course of a year, more than 120,000 balls find the pond.

When asked for a bit of advice that would prove beneficial to those playing Sawgrass, Alice Dye didn't hesitate for a moment. "I wish that when people play Sawgrass, they'd play the tee that they play at home. A lot of men come out here and feel like they have to play from where the pros play to get the full experience. The reality is that when an average guy plays from the back tees, he ends up playing woman's golf—two woods and a chip onto the green. It kills the spirit of most of the holes, and kills the fun, too."

ALICE DYE has won fifty amateur championships, including nine state championships in Indiana, two USGA Senior and two Canadian senior tournaments. She has served on the USGA Women's Committee and the LPGA Advisory Council, was the first woman president of the American Society of Golf Course Architects, and the first woman to serve as an independent director of the PGA of America. As an architect Alice worked with her husband, Pete, to codesign PGA West in La Quinta, California; the Ocean Course in Kiawah, South Carolina; Harbour Town Golf Links in Hilton Head, South Carolina; Crooked Stick Golf Club in Carmel, Indiana; and Teeth of the Dog in La Romana, Dominican Republic. Alice has received numerous awards, including honors from the Indiana Hall of Fame, the Red Coat of Fort Wayne, and the Don Rossi Award for Lifetime Contributions to Golf. She served as captain of the 1992 Women's World Cup.

If You Go

▶ **Getting There:** TPC Sawgrass is roughly thirty-five miles south of the Jacksonville, Florida, International Airport, which is served by most major carriers.

▶ **Course Information:** The Stadium Course at TPC Sawgrass is par 72 and plays 6,954 yards from the championship tees. The course is open to guests at the Marriott at Sawgrass (see below). Greens fees for the Stadium Course range from $150 to $290, depending on when you play. Visit www.tpc.com for more details.

▶ **Accommodations:** Guests at the Marriott at Sawgrass (800-457-4653; www.sawgrass marriott.com), may have access to the course. Golf packages begin at $497 per person/ per night based on double occupancy and go as high as $659.

WAILUA MUNICIPAL GOLF COURSE

RECOMMENDED BY **Mary Bea Porter King**

Home to such wish-list venues as Princeville and Kauai Lagoons, the island of Kauai beckons to mainland golfers, especially to the snowbound, for whom golf is either a distant memory or a distant hope. While these resort courses and their sometimes hefty greens fees may claim the lion's share of tee times made by mainlanders, many local folks put Wailua Municipal at the top of their lists. This includes Mary Bea Porter King.

"The first time I saw Wailua, I was taking my son to a junior golf clinic," Mary Bea recalled. "The woman running the program was a classmate of mine from Arizona State University and a fellow golf team member. We got to talking, reminiscing about our college golf experiences. I ended up offering to help. This was my entrée into junior golf and, as things turned out, the beginning of a long relationship with Wailua. Incidentally, I eventually took over the program from this woman."

Wailua Municipal is situated in the small community of Kapaa, on the eastern coast of Kauai; due west lies Mount Waialeale, reputed to be the wettest spot on earth. Wailua is the oldest course on Kauai, and the first layout to be built in Hawaii outside of Oahu. The course opened its fairways in 1920 with just 6 holes; a few years later, the first nine was completed with 3 holes added by one of Hawaii's golf pioneers, Francis H. I'i Brown. The course remained a 9-hole track until 1962, when Toyo Shirai laid out the back nine and reshaped the front. Shirai, who passed away in 2003, was golf incarnate on Kauai. Besides his design work on Wailua, Shirai designed the Kukuiolono course in Kalaheo, served as head pro and superintendent at Wailua, and helped establish Kauai's junior golf program, launching the careers of such notables as David Ishii and Guy Yamamoto.

While lacking some of the amenities of its more opulent neighbors (a snack bar adjoins the pro shop in lieu of a tony grill), Wailua makes good on all the other promises one might associate with the phrase "Kauai golf"—palms, warm breezes, and rich vistas of both the Pacific and verdant Hawaiian hillsides. Built on relatively flat terrain, the course's narrow fairways wind through groves of coconut, Norfolk pine, and ironwood trees, with 4 holes adjoining Wailua Bay and Wailua Golf Course Beach, which many consider to be one of the island's comeliest beaches. "Wailua was always intriguing to me," Mary Bea continued. "When you drive by the course it looks flat—and, frankly, not very difficult. The truth is, Wailua is quite challenging, though it's very fair. To find success, you have to use every club in your bag, and you have to work the ball in both directions to contend with doglegs and the constant wind. The course doesn't favor a hook or fade."

One of Mary Bea's fondest memories of Wailua was the time she walked the course with an old friend, Ben Crenshaw. "In 1995, I had the chance to share Wailua with Ben. We were friends in college, and I had asked him to come to Kauai to do a clinic with the kids. When the subject of Wailua came up, it was as if I'd suggested 'let's go to the candy store' to a child. He'd always wanted to see the course but never had. Ben asked if I could pick him up early so we could go around the course before the clinic began. When I picked him up it started raining, but that didn't stop him. Walking the course with Ben was like looking at a painting through an artist's eyes. In all the times I had played, I hadn't looked at the course through an architect's perspective. I'd mostly looked at the ocean! In keeping with classic design notions, bunkers guard the front of most greens, but if you've hit your tee or approach shot to the correct side of the fairway, you can play to the green without maneuvering the hazard."

The hole at Wailua that stands out for many—regulars and visitors alike—is number 17, a 173-yard par 3. The seventeenth plays from an elevated tee out to the Pacific, into the teeth of the trade winds. The hot-dog-shaped green is fronted by bunkers that were added in 1975 in preparation for the USGA Public Links Championship that was held here. "Ben pointed out to me that number seventeen is from the original nine holes," Mary Bea continued. "The movement that's achieved in front of the green could only have been accomplished with horse and plow or by hand."

The tropical-postcard view from the seventeenth tee will warm the most winter-chilled golfer well into the summer season!

MARY BEA PORTER KING started playing golf at the age of seven in Southern California under the guidance of Betty Hicks. She went on to compete successfully in the junior, college, and professional ranks, where she earned her living playing golf by the rules. Mary Bea now spends most of her time educating juniors in the game of golf. She serves on the USGA executive committee and is the president of Hawaii State and Kauai Junior Golf Associations. As a member of the executive committee, she is chair of the following USGA committees: U.S. Junior Amateur, Regional Affairs, Intercollegiate Relations, and Regional Associations. She also serves on the Championship, Amateur Status, and Members committees. Mary Bea has received many honors, including induction into the Hawaii Golf Hall of Fame; induction into the ASU Sports Hall of Fame in four sports; and the LPGA Teaching Division's Budget Service Award in recognition for service in junior golf. She was also the first recipient of the Mary Bea Porter Humanitarian Award, established by the Metropolitan Golf Writers Association after she saved the life of a drowning three-year-old boy during a tournament qualifying round in Phoenix, Arizona.

If You Go

▶ **Getting There:** Wailua is near the town of Kapaa, on the island of Kauai. Some direct flights from Los Angeles and San Francisco to Kauai are available on United Airlines (800-864-8331; www.united.com); direct flights from Los Angeles are available on American Airlines (800-433-7300; www.aa.com); other flights to Kauai go through Honolulu or Maui. The airport, near the town of Lihue, is less than an hour from the course.

▶ **Course Information:** Wailua plays 6,981 yards from the back tees, with a slope rating of 129. Greens fees range from $32 to $44 for nonresidents. The course is extremely popular, so making a tee-time reservation (by calling 808-246-2793) is advisable.

▶ **Accommodations:** The Kauai Visitors Association (800-262-1400; www.kauaidiscovery.com) provides a comprehensive listing of accommodations on the Garden Isle. Visitors intent on a golfing vacation at Kauai might opt to stay at one of the golf-oriented resorts: Princeville Resort (800-826-4400; www.princeville.com) or the Hyatt Regency Kauai (800-858-6300; http://kauai.hyatt.com).

ROYAL CALCUTTA GOLF CLUB

RECOMMENDED BY **Rick Lipsey**

During the brighter days of the British empire—that is, when there still *was* an empire—
it was not uncommon for the colonizers to import a bit of the homeland to their outposts
to make life away from home more bearable. Trout were introduced into the streams of
New Zealand. Cricket was introduced in South Africa.

And golf was brought to India.

Thus it should come as no great surprise that the oldest golf club in the world outside
of the British Isles hails from Calcutta; the Royal Calcutta Golf Club was established in
1829. (The oldest club, incidentally, is the Gentleman Golfers of Edinburgh, formed in
1744.) The current site of the Royal Calcutta Golf Club, in the city's Tollygunge district,
made a strong impression on Rick Lipsey. "The atmosphere is amazing, certainly unlike
any that I've experienced at any course of its distinction," Rick said. "To reach the course,
you drive through a portion of this terrible slum. You don't feel as though it's dangerous,
but it certainly isn't pretty. As you near the course, there's a lake with cows eating garbage
along the sides. It's like the East River in New York during tougher times. But eventually
you reach the course, and things get better. Calcutta—and, for that matter, India—is a
land of great juxtapositions."

The current incarnation of Royal Calcutta dates back to 1912. At 7,300 yards, and fes-
tooned with fifty-two natural water hazards, it's a challenging track, and it's been a peren-
nial training ground for some of India's finest players. Arjun Atwal, the only Indian
national on the PGA Tour, had his start at Royal Calcutta. So did Smriti Mehra, the first
professional golfer to hail from India. "The most wonderful memory I have from Royal
Calcutta," Simi said, "was when I won the All India Amateur Championship in 1994. It
was thirty-six-hole match play and I brought back my opponent on the thirtieth hole.

Soon after, I turned pro and joined the LPGA. I've always been extremely happy that I won this event on my most favorite course in India." Simi started playing when she was fourteen; her brother Sanjeev, a jocular fellow who is a member at Royal Calcutta, began playing at age six. "My mother was playing the courses in Calcutta when she was pregnant with Simi and me," he said. "Golf is our birthright!"

Sanjeev was eager to dispel the negative image that Calcutta sometimes suffers in the United States. "Calcutta gets a bad rap thanks to Mother Teresa and the lepers and all that baloney. Calcutta has over ten million people in a city originally planned for a hundred thousand by the British, so you can imagine what we have had to go through—it's an infrastructure nightmare. But like any developing economy weighed down by corrupt individuals, we have organization through chaos. I want the media pundits in their offices in the States wondering whether Calcutta is civilized or not to know that we have Pizza Huts, and a McDonald's is on the way. Two of the defining points for American civilization have arrived, so you can feel safe in Calcutta," Sanjeev finished with a laugh.

The presence of franchise outposts may provide the wary American visitor a modicum of comfort, and the warm, convivial atmosphere of the Royal Calcutta clubhouse and its jolly members will make any traveler feel at home. Still, there are reminders here and there that you're not at the local muni. "The course is routed through the last remaining swatch of what was once a vast jungle," Rick noted. "There are cobras in some of the deeper patches of rough, and wild jackals also call the course home. In fact, a sign bears the legend, 'Beware of the jackals.' There's a green on one par five that's abutted by a thirty-floor building. This is especially jarring, as Calcutta is not overwhelmed with tall buildings. Occasionally, people from the neighborhood will loiter around the greens on the holes that are near the course's boundaries." Considering the oasis the course must represent, who can blame them?

Over nearly a century of play, Royal Calcutta has been the site of many great championships. It's even had a small role in India's political intrigue. "There was a time in the seventies when the Communist party was trying to mobilize the citizenry to oppose industrialists and capitalists," Sanjeev recalled. "There was a huge movement to overthrow those who were perceived as 'the rich.' This leftist group—the Naxalites—tried to use the premises of the club for their criminal activities. There were murders and other assorted mayhem perpetrated on the course, but club members—who certainly must have been viewed as agents of the oppressing class—were never bothered. It was just the

various political factions hacking each other off. The battles usually occurred at night. Play was never interrupted, though occasionally members would come across a corpse in one of the tanks [i.e., water hazards]."

Trees come into play in a memorable way on several holes at Royal Calcutta. "On one par four, a gargantuan banyan tree sits about one hundred yards in front of the tee," Rick said. "It must be forty yards wide, like a giant mushroom. It makes the Lone Cypress look like a twig. Banyan trees are considered sacred in India. Even though it's in the middle of the fairway, it won't be cut down. The hole has a large tank on the left, and it doglegs left. Despite this, better players have to hit a hard fade over the water because of the tree."

One of Sanjeev's favorite holes is the sixteenth. "It's the cutest par four," he said. "Big guys can hit it within twenty yards of the green, but there's trouble if you're not on target. There are two palm trees in the middle of the fairway, and the hole is aptly nicknamed Mutt and Jeff, in their honor. Though it's short, many championships are won or lost on this hole as players come down the stretch."

Thanks to vagaries in the labor market and a variety of other circumstances, conditions at Royal Calcutta can fluctuate between very good and much less tolerable. "We had to shut the club down in April 2003 due to labor problems," Sanjeev related, "and when we reopened in October I was saddened as I saw a complete jungle on my beloved Royal. But the staff and the committee worked tirelessly, and within a month we were able to stage the East India Championship. The Royal came through all the rot just fine. At this year's tourney, professionals and amateurs who came from all over India said that this was still the best track in the country."

RICK LIPSEY is a lifelong golfer. Currently a five-handicapper, he captained his team at Cornell University, and he's been a staff golf writer at *Sports Illustrated* since 1994. Rick grew up caddying in the suburbs of New York City, working primarily at Westchester Country Club. He also worked at events on the PGA Tour, where he once looped for Greg Norman. Over the last few years, Rick has become passionate about golf in Asia. In 2002 he spent three months in Bhutan, the Himalayan kingdom, working as the first-ever pro at Royal Thimphu Golf Club. He also created the Bhutan Youth Golf Association, a year-round golf program for children (www.golfbhutan.com). In 2004 Rick spent three weeks golfing in India. He lives in New York City with his wife and two children.

14

DESTINATION

▶ **Getting There:** Calcutta is served by numerous airlines, including Air India, British Airways, and Delta. Most flights from the United States go through London or Paris.

▶ **Course Information:** Royal Calcutta is 7,300 yards from the tourney tees and plays to a par 72. While this is technically a private club, members are happy to host greens-fee-paying outsiders. The fee is very modest at 750 Rupees ($18). Reasonable fees are made possible in part by the many sponsorship opportunities that are offered around the course; the pro shop is sponsored by Willis cigarettes, the bar by Johnnie Walker.

▶ **Accommodations:** Simi Mehra recommends the Tollygunge Club (91-33 2417 6022; www.thetollygungeclub.com), which has seventy air-conditioned rooms plus sporting facilities of its own, including a golf course. It's a chip shot away from the course.

BALLYLIFFIN GOLF CLUB

RECOMMENDED BY **Nick Edmund**

There are many "best-kept secrets" among the cabalistic corps of golf travel enthusiasts. But if you were to canvas a random roomful of golf writers in the United Kingdom, odds are pretty good that one of the "secrets" they'd share would be Ballyliffin.

"In 1991, I was working on a book on courses in Great Britain that I'd done for several years running," Nick Edmund said, recalling his introduction to Ballyliffin. "I asked a golf photographer friend, Matthew Harris, if there was a course he'd recommend. He said 'Ballyliffin.' I thought he meant Ballybunion, and I asked him if he was sure. He replied, 'Yes. You must go and see it.' Two months later I visited. I absolutely fell in love with it. It was everything you could hope for in a links course—extraordinary rippling fairways, ocean vistas. It was completely unadulterated, as if it had been there for three hundred years, and the people there were so incredibly friendly. I thought I'd seen every important links course in Ireland, but here was Ballyliffin. The only thing lacking was the bunkers, which were a bit worse for wear. Still, they didn't detract from the experience."

Ballyliffin Golf Club is the most northerly golf course in Ireland, situated on the Inishowen Peninsula. "To reach Ballyliffin, you travel quite a ways through peaceful countryside," Nick described. "You go for a long way without seeing much more than a sheep. Then you come over a hill, and there's the links land and the sea."

The original 9-hole course at Ballyliffin was established in 1948, designed and constructed by local enthusiasts. In 1973 a new 18-hole course—called the Old Course, by the way—was opened, on a 400-acre site near the original links. The design for this track had contributions from architects Eddie Hackett, Charlie Lawrie, and Harry Pennick, as well as Martin Hopkins, an agricultural adviser in the region. Their piecemeal collaboration created a course that seems to have been routed by forces of nature. The highlights

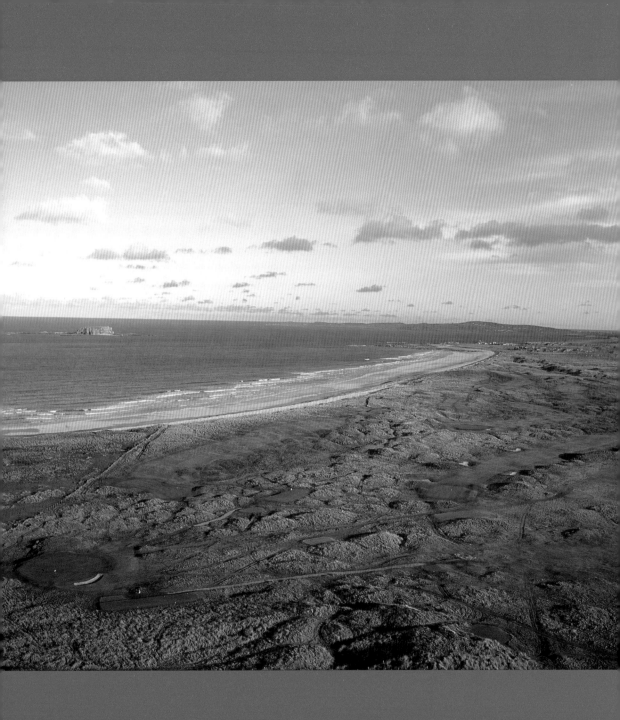

are plentiful on the Old Course. The par 3s are all memorable, particularly the 162-yard fifth hole, where your tee shot is played to a green that's flanked by sand hills left and right. One of Nick's favorite holes is the 488-yard par 5 fourth. "You start from an elevated tee and you can see much of the course, the Atlantic and Glashedy Rock. It's got that classic rippling fairway, and you can see the entire hole unfold before you. Though there can be a tricky crosswind, the green is reachable in two. It rests on a natural plateau and there are no bunkers in the way. It's a great feeling if you get up in two."

Nick was passionate about Ballyliffin, and he took it upon himself to spread the good word. "In 1993 I was introduced to Nick Faldo's manager in connection with a book I was doing about courses in Ireland. I asked him what courses had Nick seen. Had he been to Ballybunion? His manager said, 'No, but it's on the top of the list.' I mentioned some other courses, among them Ballyliffin. He said, 'Why not put an itinerary together?' Come June, Nick Faldo and his entourage were hovering over Ballyliffin in a helicopter. Later, Nick said that it was the most natural links course he'd ever seen. As you might imagine, coming from Nick, this really put Ballyliffin on the map."

In 1992 the Ballyliffin Club began contemplating the addition of a second 18 on the site. Pat Ruddy and Tom Craddock were brought in to review the land and reported to the club that it "was probably the finest piece of links golfing terrain that they had ever seen." By 1995, the Glashedy Links—named for the rocky island a mile off the coast—opened to critical acclaim. Where the Old Course is charming beyond compare, Glashedy is just plain formidable. "A mighty course," Nick declared, "built on a grand scale!" It is long at nearly 7,200 yards, with narrow fairways and an abundance of revetted (turf-stacked) bunkers. Players having an off day will find little mercy here. Yet Glashedy serves up the same spectacular views as its somewhat friendlier neighbor. From the elevated tee on the 183-yard par 3 seventh, much of the course is visible. The 572-yard par 5 thirteenth is an epic ramble through a valley of sand dunes.

With the same inevitability of the tides that ebb and flow around Glashedy Rock, Nick Edmund and his new acquaintance Nick Faldo were pulled toward Ballyliffin. "By the time Glashedy opened, I was running a golf public relations company. I was involved with the initial marketing for Glashedy, and tried to get Nick Faldo involved. There were favorable talks, but it didn't quite happen. A few years later I ended up going to work for Faldo Design. The years passed until 2004. Through all this time I'd never forgotten about Ballyliffin, and I still wanted to somehow involve Nick Faldo with the course.

OPPOSITE:
Nick Faldo
called Bally-
liffin the most
natural links
he'd ever seen.

"On a 2004 visit to Ballyliffin, it suddenly occurred to me how I could get Nick involved: he could renovate the bunkers on the Old Course! I contacted the club, which I had very good relations with, and made my pitch: Thankfully, they said 'Yes!' Thus far, the front nine has been completed, and the back should be done by the summer of 2005. It's been a small dream come true to make this happen, squaring the circle, as it were."

NICK EDMUND qualified as a barrister in 1984 and he began to practice at the English Criminal Bar. Golf, however, has been a major distraction all his life. In 1987 he was invited to produce a "where to play, where to stay" guide to golf in Britain; the successful *Following the Fairways* resulted and thirteen editions of this book have been published. Nick is a regular contributor to the leading golf magazine, *LINKS*, and among his other published works are the award-winning *Visions in Golf, The Strokesaver Guide to the Classic Courses of Great Britain and Ireland*, and nine golf yearbooks. Since 1998 Nick has been responsible for developing Nick Faldo's golf course design business, Faldo Design. He and his wife Teresa, and their two sons, George and Max, live in London.

If You Go

▶ **Getting There:** Ballyliffin is Ireland's most northerly golf club. The closest international airport is in Belfast, Northern Ireland; from there, it's two hours to Ballyliffin. Direct flights to Belfast are available from Newark, New Jersey, on Continental (800-231-0856; www.continental.com). The town of Derry is just twenty-five miles from Ballyliffin, and the airport here is served by British Airways (800-AIRWAYS; www.britishair.com) from London and Glasgow, Scotland.

▶ **Course Information:** The Old Course at Ballyliffin measures 6,604 yards from the back tees and plays to a par 71. The Glashedy course measures 7,135 yards from the back, playing to a par 72. Greens fees on the Old Links range from £30 to £55, depending on the season; fees on Glashedy range from £45 to £75. Tee times can be reserved online at www.ballyliffingolfclub.com, or by calling +353 7493 76119.

▶ **Accommodations:** Ballyliffin is a resort town, though pleasantly devoid of the tacky trappings Americans might associate with the phrase. A variety of accommodations are listed at www.ballyliffingolfclub.com.

THE EUROPEAN CLUB

RECOMMENDED BY **Pat Ruddy**

The European Club, thirty-five miles south of Dublin, is a vibrant tribute to the twin passions that have ruled Pat Ruddy's life: cultivating an understanding of what makes a good golf course and finding the wherewithal to put that understanding into practice with one's own hands. "My 'training' as a golf architect started at the same time as my 'training' as a golf writer," Pat recalled. "It was in a small west-of-Ireland town where my father was one of the foremost golf enthusiasts and where the local golf club was so ill-funded that it had to move location three times while I was a boy. Three times I found myself helping Dad and his pals load all the club's paraphernalia into the back of a few trucks and move to the newly rented lands—a few hand-pushed lawnmowers, some scythes, rakes and shovels, flagpoles and bunting, hole cups and fencing posts, and barbed wire to fence the greens in order to keep sheep and cattle off!

"It would take a few weeks of volunteer mowing and scraping to create our new golf course—nine holes, no bunkers—and to be at play once more. So one learned the essence of the game—a field, grass low enough to play ball, and someone to play with or against. All other golf is merely an extension or 'improvement' on this template. All but a few Irish golf courses in the 1950s were rudimentary, and one was immersed in the idea of building or creating a golf course through work rather than through high finance."

After a celebrated career as a golf writer and a few smaller-scale but successful efforts as a designer, Pat began to set his sights on the Big Project, one that had been gestating since boyhood. "My dream of a golf course of my own arose from images in a book by Henry Cotton in which he reported that Jimmy Demaret and Jack Burke were building a great course of their own in Texas and calling it Champions. To think of it—a fellow

77

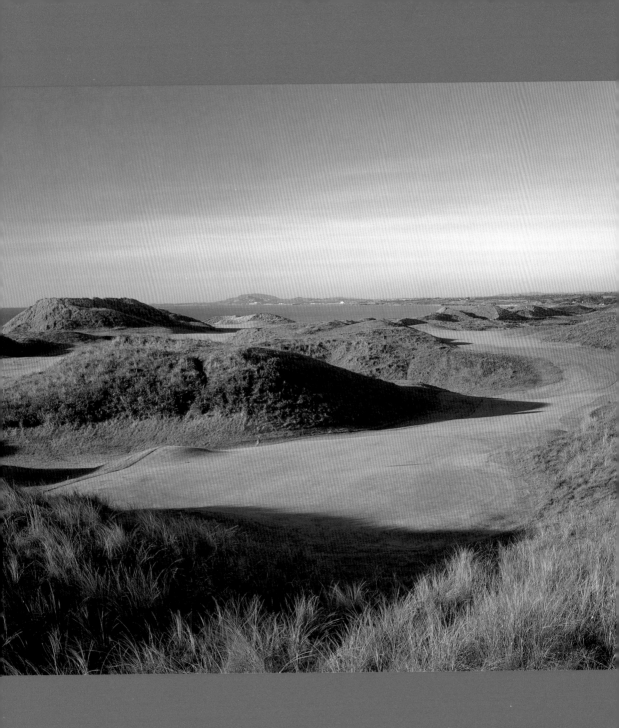

could own his own golf course! It took all of thirty years, with one failed attempt in between, to finally get my own golf course, but it was always going to happen, as I was driven by the thought. Of course, I hadn't plans for a great big place. Just a golf course where I could hit millions of shots in peace and come out and attack Trevino and company on tour. Alas, the course proved bigger and the golf less intense."

There was little question that the course Pat would create for himself would be a links, and he surveyed the Irish coast by helicopter to identify the appropriate site. After years of searching, the land south of Dublin was found in 1986. Recalling the bravado of Demaret and Burke, he sought a big name for the project and landed on the European Club. "One of my great challenges has been to see if one could live up to the grandeur of such a name during one's lifetime," Pat said. "In this approach, I have been encouraged by the thought that the R and A has been in St. Andrews for hundreds of years and still doesn't own a golf course, while the town of St. Andrews had owned a golf links for hundreds of years before finally adding a clubhouse about a decade ago. Compared to them, I am really flying at the speed of light!"

Does the European Club live up to the grandeur of its name? Most visitors would say, yes. The site, which adjoins Arklow Bay and provides vistas out to the confluence of St. George's Channel and the Irish Sea beyond, may be one of the last true links sites to be developed in Ireland. The large dunes and the hard, undulating turf that are trademarks of links land are surely here. But to appreciate what the European Club is all about, players should do their best to eschew the views and more obvious links icons and focus on the minutiae of the design: the placement of a strategic pot bunker, the swale before a green that sends a subtle signal to the knowing player of where to roll his approach. It's not showy, but stately. "We are in an age of copyists and an age when anything that is rumpled near the sea—or, failing that, a lake—causes storms of excitement amongst the observers of modern architecture," Pat bemoaned. "They seem to be very confused by scenery at the cost of golf. I try to look at the land and become absorbed by it and to drench it with my dreams of the best golf shots I can play, and the golf shots I cannot play, and the golf shots that will be played in future generations which we cannot yet fully comprehend. What would Old Tom Morris have thought of the lob wedge?"

The 470-yard par 4 seventh hole at the European Club has garnered much attention for its thoughtful use of visual devices to both entice and strike fear into the player attempting to advance the ball toward a green that's backed by Brittas Bay. "The fact that

OPPOSITE:
The European Club, south of Dublin, is a fitting culmination of Pat Ruddy's lifelong service to golf.

one can stand on this fairway and see nothing man-made on a rotation of three hundred and sixty degrees is a great and a rare experience nowadays," Pat said. "It's a good place for a picnic and a relaxed sit-down with a book at one of the many times that we do not have golfers about!" Holes 12 and 13 are also favorites, as they play right along the beach. Indeed, if one goes astray onto the beach on these holes, the ball is still technically in play. It was at the par 4 430-yard twelfth that one could once encounter a rare Irish sea creature, as Pat described. "We had one villainous member—now dead, alas—who had the habit of taking a break from the golf and going skinny-dipping in the sea at hole twelve. One day, he emerged from the waves to be greeted by a bemused American looking for his golf ball amid the shale and sand. 'Can't find mine anywhere, either,' chirped my friend, donning his clothes and lifting his clubs to continue his round."

Less than two decades from its inception, the European Club is already comparing quite favorably with the venerable courses that Pat Ruddy once wrote about, finding its way onto many "top 100" lists. With the recent completion of the links at Rosapenna and Druids Heath, Pat will now focus his energies exclusively on *his* course—to, in his words, "ensure that this links is most carefully devised to combat the elements of golf for at least fifty years to come." Accolades aside, Pat has already had a wonderful time of it. "Who wouldn't love to see Tiger Woods play a course that they had designed? And Johnny Miller—who gave me his shoes—and Ian Baker-Finch and so many others? The one big regret I have is that my dad didn't live to see it. Though the excitement would likely have killed him!"

PAT RUDDY is a man of golf—a golf writer, golf promoter, course architect, and course owner. The links of the European Club, which he designed and owns, was rated ninety-eighth best course in the world by *GOLF Magazine* in 2003, and it is included in Britain and Ireland's top 100 by the leading local polls, alongside his other designs at Druids Glen, Ballyliffin, and Donegal. His other internationally recognized designs include Portsalon, St. Margaret's, and Montreal Island (Canada).

If You Go

▶ **Getting There:** The European Club is less than an hour south of Dublin, which is served by Aer Lingus (800-474 7424; www.aerlingus.com), among other airlines.

▶ **Course Information:** The course is open to visitors throughout the year, with the exception of Christmas week. Greens fees are 150 euro from April through October, 75 euro from November through March. For more information and tee times, call +353 404 47415 or visit www.theeuropeanclub.com.

▶ **Accommodations:** A broad range of lodging can be found in Dublin, from guesthouses to five-star hotels. The Dublin Tourism Web site (www.visitdublin.com) is one good starting point for your research; so is Dublin City Centre Hotels (800-869-4330; www.dublin.city-centre-hotels.com). While in Dublin, lovers of good beer will appreciate a visit to the House of Guinness (www.guinnessstorehouse.com). Lovers of literature may wish to pay homage to James Joyce at the James Joyce Centre (www.jamesjoyce.ie).

16

DESTINATION

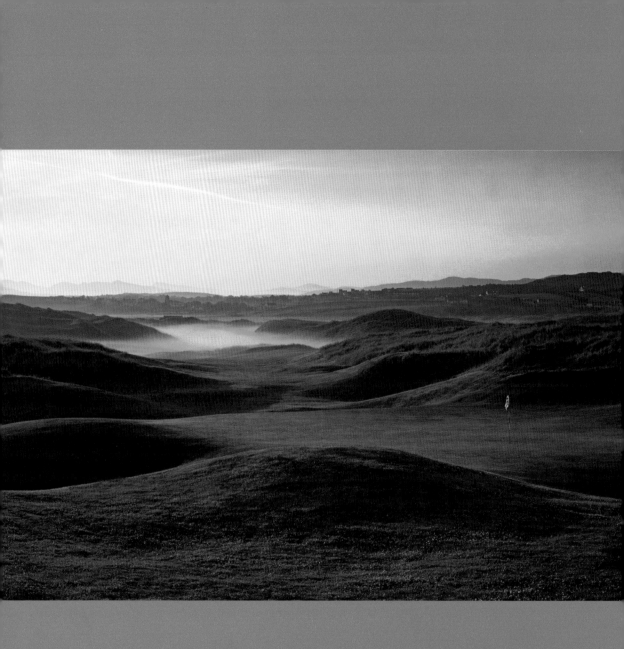

ROSAPENNA GOLF CLUB

RECOMMENDED BY **Larry Lambrecht**

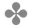

Each year, photographer Larry Lambrecht travels to Ireland to collect photos for his calendar on the links of Ireland. "On each trip, I try to find a new venue, a new jewel," Larry said. "I'd heard about Rosapenna way up in County Donegal in the past; that there was a nice hotel there, and an Old Tom Morris course. In 2003, there was word that a new course was going to be opening up there, that it was going to be a Pat Ruddy design. I went over with a writer friend, Brian McCallen. We weren't disappointed."

The story of Rosapenna begins in 1891, when Old Tom Morris took a sightseeing ride around Donegal while visiting the nearby estate of a friend, the earl of Leitrim. A stretch of the coastline presented itself as a promising links site, and before returning home Morris had staked out what would come to be known as the Old Tom Morris Course through the wild dunes land. The earl, who owned the land and built an impressive hotel, made Rosapenna a playground for wealthy Englishmen. The course attracted much attention at the turn of the century, and visiting champions (including Harry Vardon and James Braid) added a few touches to the course over the years. Only three of the greens were relaid, more testimony to Morris's preternatural design skills. The first 10 holes of the course run between the ocean and dunes to provide an honest links experience that reaches its apex on the 198-yard par 3 sixth hole, a one-shotter to an elevated green with no room for error. The last 8 holes head inland, as the remaining land along Mulroy Bay was just too rough to sculpt without modern land-moving equipment. You'll be asked to hit over the R248 road several times; the road is not considered a hazard, and shots that come to rest here can be relieved without a penalty. From the seventeenth tee, Sheephaven Bay and the Rosapenna Hotel provide a stunning backdrop.

OPPOSITE:
The Sandy Hills course at Rosapenna was built with the benefit of bulldozers, a luxury that eluded Old Tom Morris.

DESTINATION

17

83

But Old Tom Morris is just the beginning. The story picks up again in 1981, when a local boy named Frank Casey returned to his home to buy the course after making a little money in the world beyond County Donegal. The place had fallen on harder times; the grand hotel had burned to the ground in 1962, to be replaced by a much lesser structure, and the golf course likewise fell into shoddiness. Casey, whose father had been the head-waiter at Rosapenna, remembered the better days and slowly revitalized the property. Through much hard work, he's returned Rosapenna to its former four-star status. "Frank's a great host," Larry recalled. "He's involved in every aspect of the operation. He's there in a suit in the morning, on the golf course in the day, in a tux working as maître d' at night at the restaurant. It's commendable to see someone so devoted to making a place a success."

Perhaps the greatest achievement Frank Casey will be remembered for is the commissioning of the second 18 holes at Rosapenna, now known as the Sandy Hills Course. To create a bookend for the Old Tom Morris, Casey called upon golf writer turned architect Pat Ruddy. Ruddy, not well known in the United States beyond the cognoscenti, is the Emerald Isle's pre-eminent designer, and he has a great affection for links-style courses. Working with the benefit of bulldozers and the like, Ruddy set about slicing through the unruly dunes that Old Tom had abandoned to forge the new layout.

"Sandy Hill is a big swath of dunes, with a golf course dropped on it," Larry commented, approvingly. "From the longer tees, I'd imagine that it would be pretty difficult for the average player. If the wind is up, it can be pretty severe. But as far as atmosphere goes, it's stellar. The setting is remote. You see the town in the distance—and, of course, the hotel—but it's not infringing upon the beauty. I love the ocean, the dunes, the grass, the flowers, the rabbits, and the foxes that you find in a wild links setting like Rosapenna. It's unbeatable."

Where some links courses are contrasts in the yellow of gorse, the white of the sand, and the green of the fairways, Sandy Hills is a complex study in green, with fairways, hummocks, and putting surfaces offering an ever-shifting palette that's wonderfully rich in texture. Players from the middle tees have no unduly long carries, and landing areas are fairly obvious. Still, wayward drives are not well tolerated; you may find your ball but don't count on much more than a chop shot back into the fairway. The thoughtful player who thinks through the consequences of each shot will do better here than the unthinking big hitter. Elevated greens on many holes negate the bump-and-run approach,

forcing accurate, lofted approaches. The holes on Sandy Hills are set above Old Tom's layout, providing almost constant views across the old course to the ocean.

The apex of the Sandy Hills experience comes in the middle stretch, between holes 6 and 13, which bisects the dunes. On the sixth hole, you drive over a crest that reveals a sliver of the bay and Muckish Mountain. On the par 3 seventh, you tee off downhill to a tiny green that juts from the dunes. The tenth fairway winds back toward the sea through a valley in the dunes, with the raised green framed again by Muckish Mountain.

"Northwestern Ireland has a great collection of links courses," Larry's traveling companion Brian McCallen commented. "They are quintessential. Ballyliffin is way up in the north, above Northern Ireland—it seems like it's near Santa's workshop. It's a colossal links, there are four-hundred-sixty-yard par fours on one of the eighteens, the Glashedy course—tremendous stuff. Then there's County Sligo Golf Club at Rosses Point, where you play in the shadow of Ben Bulben; the poet William Butler Yeats's grave is just up the road. Over in County Mayo, there's a course called Carne. It's an Eddie Hackett design and one of the great remote links in the world. These courses are all incredible, underplayed, and priced well below other big-name venues. I would group the assembly of courses here with any group of golf courses anywhere. When you're this far removed from the tourist centers, you also get a taste of the real Ireland. It's not all lace curtains and statues of leprechauns.

"I've never been to a course in Ireland where I've felt I've been treated badly," Larry continued. "I wish I could travel throughout the country and just play golf each time I'm there, but usually I have to work. Especially if the sun is shining!"

LARRY LAMBRECHT is an award-winning photographer with fifteen years of experience in creating successful photographic campaigns. His work has been featured in many books and calendars, including *Discovering Donald Ross; America's Linksland: A Century of Long Island Golf; Ocean Forest and the 38th Walker Cup Match; At the End of the Oaks: The Official History of the Sea Island Golf Club; Golf's Great Moments; Golf Magazine's Top 500 Golf Holes; USGA Calendar;* and *Sports Illustrated golf calendar.* His most recent work is the coffee table book *Emerald Gems: The Links of Ireland,* which features photography of every links in Ireland.

▶ **Getting There:** Rosapenna is a bit off the beaten track, in the northwestern reaches of Ireland's most northwesterly county. The closest international airport is actually in Belfast in Northern Ireland; from here, it's 120 miles (or three hours) to Rosapenna. From Knock, it's 137 miles (three and a half hours); from Dublin, 172 miles (five hours). Direct flights to Belfast are available from Newark, New Jersey, on Continental (800-231-0856; www.continental.com). Eastern Airways (+44 8703 66 91 00; www.easternairways.com) has service to Belfast from a number of UK airports.

▶ **Course Information:** The Old Tom Morris Course is a par 72 layout and plays 6,271 yards; greens fees for this course are £50. The Sandy Hills Course is also par 72, and it plays 7,005 yards; greens fees are £75.

▶ **Accommodations:** The Rosapenna Hotel (+353 74 91 55301; www.rosapenna.ie) is situated at the links and, through the hard work of owner Frank Casey, has earned back a four-star reputation. A range of accommodations is available here, and golf packages are offered. Two day/two night stays including dinner and two rounds of golf on the Old Tom Morris Course range from £260 in the off-season to £280 in the summer.

DESTINATION 17

UGOLINO GOLF CLUB

RECOMMENDED BY **Ken Howard**

Romantic travelers flock to Tuscany to wander the region's ancient villages, sample fine Chiantis, and drink in the cultural wonders of Florence. At the risk of dampening the romance a bit, Ken Howard would suggest that you bring your sticks along too.

"When I mentioned to a friend, Fox Jones, that I was going to be visiting a friend in San Casciano dei Bagni in Tuscany, he said that I must play Firenze Ugolino. He couldn't describe exactly where it was, but recalled that it was on the other side of Florence and that they sometimes play the Italian Open there. When we reached Florence, we initially stayed at Villa San Michele, which overlooks the entire city. I asked the porter if he could get me a car. When the driver came around, I asked him if he could take me to the course. He said he had an idea of where it was but wasn't sure. Off we went. Soon we were climbing these narrow, curving streets. The women were all dressed in black, and the men were hanging out on the corners, smoking. It seemed unlikely that a golf course would suddenly appear in this setting.

"Farther on, we reach a church, something that happens quite frequently driving around Florence. There was light streaming through the doorway, and an old man pushing a broom—very cinematic. The driver asked him about the golf course. The man waved his hand to the left, said drive a bit farther. We drive on a bit longer and see a man walking along the road. We ask him about the course, and he points us back in the other direction. We'd driven past the driveway, as there was only a tiny placard. This time we make the turn. As we're heading up the driveway, some metal gates swing open to a fantastic setting. There's a pool, a winding driveway, and then the clubhouse, fronted by marble steps. I was then introduced to Florio, who ushers me inside the clubhouse. We have a nice meal. Florio can't speak any English, but it doesn't matter. We then go out to

play on this beautiful, rustic course. There's hardly a soul out there. The sun is slowly setting. I'd recommend Ugolino to anyone . . . if they can find it!"

As in so many other regions, golf was introduced to Italy by the British, with the first club established in 1889 in Florence, in the Cascine area. The sport gained in popularity enough by 1905 to merit an Italian National Championship, which was held in Florence. In post–World War I Italy, more and more people showed interest in the game, and the Tourist Board recognized the potential draw of golf courses; in fact, in its historical notes, *Circolo del Golf dell'Ugolino* reports that Florence was promoted throughout Italy on signs with the wording: "Florence: 18 hole golf course." To further capitalize on golf's appeal, the Ugolino course was built in 1933, designed by the British architects Cecil R. Blandford and Peter Gannon, who designed many courses around Italy in the 1920s and 1930s as the game expanded. The original course was a par 69 track. The course was later stretched out to a par 72, with the renovation guided by Italian architect Piero Mancinelli.

Ugolino is emblematic of the courses of its time. Narrow fairways lined by pine and olive trees and small greens place a premium on accuracy, and constantly rolling terrain—especially on the front 9—makes for many interesting lies. Just as important to visitors, the hills of Ugolino provide fabulous views of the Tuscan countryside. What better way to enjoy this beautiful region than from the fairways of one of Italy's most venerable courses?

In addition to Ugolino, golfers visiting Tuscany have a number of other courses to choose from. These include Castelfalfi Golf Club, Cosmopolitan Golf Club, Montenatini Golf Course, Le Pavoniere Golf Club, Poggio Dei Medici Golf, and Versilia Golf. And, of course, there are more than a few fine Chiantis to be cherished as you make your way from course to course. Providing your driver knows the way!

KEN HOWARD is an Emmy and Tony award winner who became firmly established in the public's mind as Coach Reeves on *The White Shadow*, a television series he co-created based on his own experiences as the only white player on his high school basketball team. He has also starred as Detective Lieutenant Max Cavanaugh on NBC's *Crossing Jordan*. Among Ken's other series, miniseries, and TV movie credits are recurring and guest-starring roles in *It's Not Easy; The Colbys; Dynasty; Curb Your Enthusiasm; The Practice; Arli$$; The West Wing; Perfect Murder, Perfect Town;* and *The Thorn Birds*. He stars

in Fox 2000's *In Her Shoes* with Shirley MacLaine, Cameron Diaz, and Toni Collette. Ken has just completed filming on Dreamworks' upcoming feature, *Dreamer*, costarring Dakota Fanning, Kris Kristofferson, and Elisabeth Shue. A kidney transplant success, he works with the National Kidney Foundation to encourage people to donate their organs. Ken is an ardent golfer, and has played around the world.

If You Go

▶ **Getting There:** Ugolino Golf Club is roughly fifteen miles from downtown Florence, which is served by most major carriers, including Alitalia (800-223-5730; www.alitaliausa.com).

▶ **Course Information:** Ugolino plays a modest 6,240 yards to a par 72, with a slope rating of 131. The greens fees range from 60 to 80 euros. Tee times are advised and can be made by e-mailing info@golfugolino.it or faxing +39 55 2301141. For more information, call +39 55 2301009, or visit www.golfugolino.it.

▶ **Accommodations:** Some visitors to Florence prefer to stay at one of the city's fine hotels. Others prefer to rent a villa in the countryside. The Ugolino Web site (www.golfugolino.it/nuovo/eng/hotel_e.htm) lists a range of options.

18

DESTINATION

TAIHEIYO GOLF CLUB, GOTEMBA

RECOMMENDED BY **Matthew Harris**

It is not uncommon for Japanese golfers to travel to California and other U.S. venues to play a few rounds. This inclination for westward travel is not a commentary on the quality of Japan's courses. With a low ratio of courses to players (roughly one course for every five thousand players) and steep greens fees, it's often more economically and logistically practical for Japanese linksters to go abroad. The truth is that Japan has many wonderful golf courses worthy of visitors, as Matthew Harris discovered.

"I first learned about the possibilities of golf in Japan from my good friend, a photographer named Koji Aoki, in the mid-eighties. A few years later, I had a chance conversation with Seve Ballesteros, whom I had got to know from being on tour. I asked him about the golf in Japan. His enthusiasm was very evident. 'It's fantastic, you must go,' he said. 'You'll take wonderful pictures.' In autumn of 1989, I visited for three weeks. I still recall my first sight of Mount Fuji. It was a cloudy day, but suddenly the clouds parted, and there it was. I remember gulping—it took my breath away."

On this trip and subsequent visits, Matthew was able to play a number of courses, but the Taiheiyo Golf Club at Gotemba, designed by master Japanese architect Shunsuke Kato in 1977, struck a resonant chord. "Taiheiyo is carved out of a forest of cedar and Japanese cypress. As you make your way around the course Mount Fuji looms above, and you take it in from slightly different angles. The lights and shadows from the different perspectives are magical. The topography of the course makes it quite interesting. The front nine begins below the level of the back nine, so you first drop down the hillside and then slowly climb up, as if heading toward the mountain. The ninth green sits just below the tenth, the tenth below the eleventh, and so on. The overall design, the use of landscaping, the angle the layout takes to the mountain are all just terrific. And the greens are

OPPOSITE:
Mount Fuji
is omnipresent
throughout
a round
at Taiheiyo's
Gotemba
course.

amongst the truest that you'll find anywhere; when the pros are here each November for the Taiheiyo Masters Tournament, they love them."

The drama at Taiheiyo builds as you climb toward the mountain. The 191-yard par 3 thirteenth plays from an elevated tee to a green that's protected by a swirling bunker that wraps itself around almost half of the left side; the right half is guarded by a very well placed pine tree and a shallow trap that rests in front of it. On the 192-yard par 3 seventeenth, the course's primary geographic feature is brilliantly highlighted. "From the back of the green you get Gotemba's most imposing view of Mount Fuji, thanks to the genius shaping of the tree line," Matthew said. "The corridor formed by the trees draws your eyes back to the mountain. Number seventeen also happens to be a great golf hole whose positioning within the overall routing could not be better. Your tee shot has to whistle through a narrow chute of trees and then continue over the water in front of the sloping green. The par five number eighteen is a fantastic finishing hole, a monster. Its strength lies in the undulating two-tier green that you will encounter . . . once you finally get on to it! You are also asked to clear a suitably blended—horizontally split—lake in front of this devilish green. Looking over your shoulder as you leave the green, you have snow capped Mount Fuji waving at you. At this point, you may be thinking that skiing would have been a far easier way to have spent your day!"

To some Western eyes, Japan is a land of mysterious ceremonies and traditions. The cloak of ritual that seems to enshroud Japanese life extends to the golf course. "Golf in Japan is an adventure of sorts," Matthew continued. "You generally get up quite early to beat the traffic to make your way from the city out to the courses, which are all in the countryside. For many Japanese people, to be out in nature on a golf course, away from the city, is a wonderful privilege. There's a terrific caddie system in Japan, so you're very well looked after. You play nine holes, and then the tradition is to stop and have a bite to eat. Sometimes it helps your game, sometimes you lose your flow. After you play the next nine—or eighteen, as it's pretty common to play twenty-seven holes in a day—you have tea, and then a Japanese hot bath. In my opinion, the greatest contribution the Japanese have made to golf is the introduction of a hot bath to the clubhouse for relaxation afterward. I don't think any golf course that claims to be world class can make that claim if they don't have a soaking tub!"

Beyond the Japanese bath, Matthew has fond memories of the people he encountered on the course. "If you possibly can, play with Japanese people when you visit. Many out-

siders have this perception of Japanese men as being very serious, very businesslike. But when they play golf this wonderful sense of humor emerges. Their golf language has some English mixed in. A player might be speaking rapidly in Japanese, and then you'll hear a bit of English—'nice shot,' for example—which actually comes out 'ni-sha.' At one point in a round, I made a double bogey on a par five. My partner came up and clapped me on the back and said 'fantastic double bogey.' If one of my countrymen said this to me, I would have taken it as being facetious. But this gentleman wasn't giving me a hard time. He was saying it could be so much worse.

"I have to say that one of the most distinctive noises in golf is the sound of the ball dropping into the cup in Japan. It's a *plink-plink* sound. It must have something to do with the density of the metal that's used, and that the bottom of the cup sits above the base. If I were blindfolded, I would recognize where I was by that sound alone."

MATTHEW HARRIS is an award-winning golf photographer whose work has taken him to forty-four countries over four continents. He has covered eighty-plus major championships and Ryder Cups since 1984. Matthew is coauthor of *Classic Golf Courses of Great Britain & Ireland* in 1997 and *Passions: Golfing* in 2005; his photographs are regularly used in *Golf Digest* and *Golf World,* as well as numerous other international titles. Matthew is on the judging panel of *Golf World* (UK) Top 100 British golf course list, and is the founder of the Golf Picture Library, one of the world's leading sources of golf images. He was a special invitee at the inaugural Art of Golf Festival at Pinehurst in 2001. A reformed member of the Tommy Bolt Anger Management Society, he plays most of his golf at Ashridge near London and is an honorary member at Ballyliffin and the European Club in Ireland.

If You Go

▶ **Getting There:** Gotemba is located roughly sixty miles southwest of Tokyo, at the eastern access point to Mount Fuji; it's a ninety-minute train ride from Tokyo's Shinjuku Station.

▶ **Course Information:** Taiheiyo Gotemba (www.taiheiyoclub.co.jp/course/gotemba) plays 7,072 yards from the championship tees, to a par 72. Like many courses in Japan, it has two sets of greens, one for the winter season and one for the summer season.

Greens fees for midweek lay are 30,700 yen (approximately $280 U.S.). For more information and tee times, call +81-550-89-6222.

▶ **Accommodations:** Vistors to the Gotemba Course can opt to stay in Toyko or nearby in the Shizuko prefecture. The Shinjuko Prince Hotel (+81-3-3205-1111; www.prince hotelsjapan.com/ShinjukoPrinceHotel/) rests above the train station; trains from here will spirit you to Gotemba. The Japan National Tourist Organization Web site (www.jnto.go.jp/eng/) lists other hotels. The Shizuko Guide (www.shizuoka-guide.com/english/search/stay/list.asp?area=2) highlights lodging options in the vicinity of the course.

19

DESTINATION

PRAIRIE DUNES COUNTRY CLUB

RECOMMENDED BY **Bill Coore**

Bill Coore first visited Prairie Dunes in the late 1970s, and came away believing that no student of golf course architecture should miss it. "I'd heard a great deal about Prairie Dunes over the years," Bill said, "but being from North Carolina, I hadn't had the occasion to visit the Midwest. When I moved to Texas, I had the opportunity to go there. I wasn't familiar with Middle America, and I pictured Kansas as flat farming country. As you drive toward Hutchinson, there's nothing to dispel that idea. However, on the out-skirts of town, there's this small but incredibly beautiful dunes property, where the course is sited. I was amazed by the topography and the golf course itself. Prairie Dunes was something to behold."

Prairie Dunes is an anomaly, to say the least. Here among the endless cornfields, Mother Nature and her maidservant, the wind, gathered sands into dunes, and sprinkled them with prairie grasses, sand plum trees, and yucca, making for an odd amalgam that must have whispered "golf" to the well-tuned ear. "When you're at Prairie Dunes, the wind and dunes are so omnipresent you feel that the ocean is just over the horizon," Bill mused. "That it happens to be in the middle of America is surprising and wonderful."

The well-tuned ears that heard the land's cry belonged to the Carey family, which had amassed a fortune in the salt mining business, and to Perry Maxwell. Maxwell was one of the great but underrecognized architects of the twentieth century. He took up golf at age thirty in the midst of a successful banking career, and within ten years began applying his aptitude with numbers to course design full-time. Maxwell championed the cause of grass greens in the Midwest; sand or "brown" greens were in broad use at the time, as grass was considered too difficult to maintain in the intense heat of summer. He also contributed significantly to the design of Crystal Downs (working with Alister

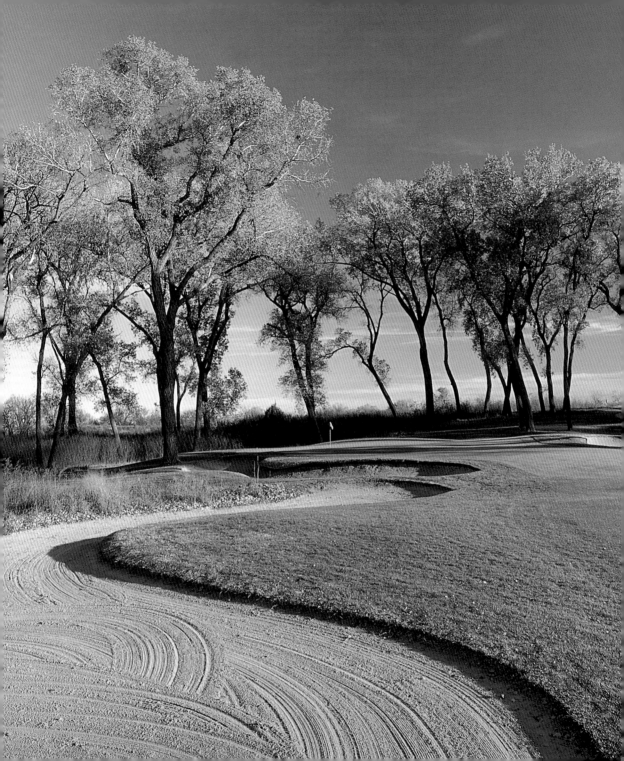

MacKenzie) in northern Michigan, and consulted on redesigns at Augusta National, Colonial, Pine Valley, and the National Golf Links. "The way I've heard it, the Careys invited Maxwell to come to Hutchinson to look at one piece of property as a prospective golf course site," Bill Coore explained. "In his wanderings, Maxwell noticed the site that would eventually become Prairie Dunes and suggested that the Careys study it as an alternative. We often laud architects for their vision in selecting sites, but I think that too often, the owners get short shrift. In this case, the Careys made a leap of faith and put their trust in Maxwell to work with the site." History has shown that their trust was well placed.

Maxwell surveyed the land for a month before routing 18 holes through this strange inland links land. In an oft-quoted line, he reported to his client that "there are one hundred eighteen golf holes here. All I have to do is eliminate a hundred." A first nine was built immediately using eighteen horses and mules, Fresno scrapers, and wheelbarrows. It opened for play in 1937. The second nine was not completed for twenty years, five years after Maxwell's death. This work was overseen by Perry's son Press, who was a master architect in his own right. The rolling, rumpled fairways bend here and there through high prairie grasses and wildflowers that are ever defining play. Prairie Dunes is a wonder by any approximation, as distinctive as any course on the planet; its pacing and synergy with the land are especially amazing when we remember that it was the result of two distinct design phases, by two individuals.

That Prairie Dunes is now in prime condition (it hosted the United States Women's Open in 2002 and will host the U.S. Senior Open in 2006) is thanks in part to the work of the design team of Coore Crenshaw. "Back in '81 or '82, before Ben and I formed our partnership, Prairie Dunes' superintendent at the time, Doug Petersan, asked me to offer suggestions about drainage issues on the eighteenth hole," Bill said. "We discussed some options for the eighteenth and other spots on the course, and it was my good fortune to be chosen to help with the course. A few years after Ben and I got together, we were asked to work on three of the greens—numbers one, two, and fourteen. In preparation for the U.S. Senior Open and under the guidance of superintendent Stan George, one of our staffers, Dave Axland, has created several new tees and performed bunker restoration work. We feel fortunate we've been asked to stay involved in the evolution of the course.

Prairie Dunes has had a profound influence on American golf course architecture; it certainly inspired Bill Coore, Ben Crenshaw, and owner Dick Youngscap in the creation

OPPOSITE:
At one with its
inland links
setting, Prairie
Dunes is a
must-see for
students
of golf course
architecture.

of Sand Hills. "It's quite likely that if Prairie Dunes hadn't existed, Sand Hills might not have been built," Bill confided. When asked what design insights he came away with from his time at Prairie Dunes, Bill highlighted three. "First, how to lay out a golf course on an extraordinary piece of property so that it's a complement. Prairie Dunes looks like it softly feathered out of the sky, it's in such great harmony with the natural contours of the site. It's so well thought out that it looks like it could be no other way. Second, you just can't help but study the contours of the land there. If you study how wind blows sand, you get a sense of how interesting land formations can be. Variety is infinite. Every contour has been blown in such a way that it's different from those adjacent to it. As an architect, I have to answer the question, 'How can golf be incorporated into those contours?' Last, I've learned so much about greens. Both Perry and Press and their teams did a remarkable job of matching Mother Nature's contours with the greens and making them work. We've tried to take a bit from Prairie Dunes and emulate them with some of our designs. When you try to do it yourself, you realize how difficult it must have been. The contours look so natural, yet function so wonderfully for golf. It's one thing to do very artistic greens, it's another to do greens that are artistic and functional. To do both as it was done at Prairie Dunes is really an accomplishment. They are some of the best greens anywhere in the world."

Prairie Dunes is a private golf club, but the emphasis is hardly on wealth or prestige. It is on golf. "The fact that through the years one of the most prominent members and best players—a fellow named Rusty Hilst—is a public-school teacher says something about the unpretentious attitude of the place," Bill concluded. "Prairie Dunes is about the appreciation of the game. The people there are very friendly, and very protective of what they have, and they are justifiably proud. The course and the club are compliments to golf and the way golf should be."

BILL COORE is a native of North Carolina and played much of his early golf at the Donald Ross courses of Pinehurst and the Perry Maxwell–designed Old Town Club in Winston-Salem. A 1968 graduate of Wake Forest University, he began his professional design and construction career in 1972 with the firm of Pete Dye and Associates. Under the Dyes' guidance, Bill was introduced to the elements of creative design and physical construction. Bill formed his own design company in 1982. Thereafter, he completed courses at Rockport Country Club in Rockport, Texas; Kings Crossing Golf and Country

Club in Corpus Christi, Texas; and Golf du Médoc in Bordeaux, France. Since forming Coore and Crenshaw with partner Ben Crenshaw, Bill has worked on many highly regarded designs, including the Plantation course at Kapalua, Maui; Friar's Head Golf Club on Long Island; and the Sand Hills Golf Club near Mullen, Nebraska. Bill and his wife, Sue, now reside in Scottsdale, Arizona.

If You Go

▶ **Getting There:** Situated in the south-central plains of Kansas, Hutchinson is approximately forty-five miles northwest of Wichita, which is served by most major carriers.

▶ **Course Information:** Par 70 Prairie Dunes Country Club plays 6,598 yards from the back tees, but with a fairly constant wind to contend with it generally plays longer. It has a slope rating of 139. Though it is a private club, a proper letter of introduction can help a visitor gain access to the course at certain times of the week. Address your letter to Prairie Dunes Country Club, 4812 E. 30th, Hutchinson, KS 67502. The course is open from March 1 through October 15. Should you gain access, the greens fee is $200. In the meantime, you can get a taste of the course by taking the virtual tour at the Prairie Dunes Web site, www.prairiedunes.com.

▶ **Accommodations:** Hutchinson is a pleasant burg of 40,000 residents, with accommodations ranging from chain motels to bed-and-breakfasts. A rundown of available options is listed on the Hutchinson Chamber of Commerce Web site at www.hutch chamber.com, or by calling the chamber at 620-662-3391.

DESTINATION 20

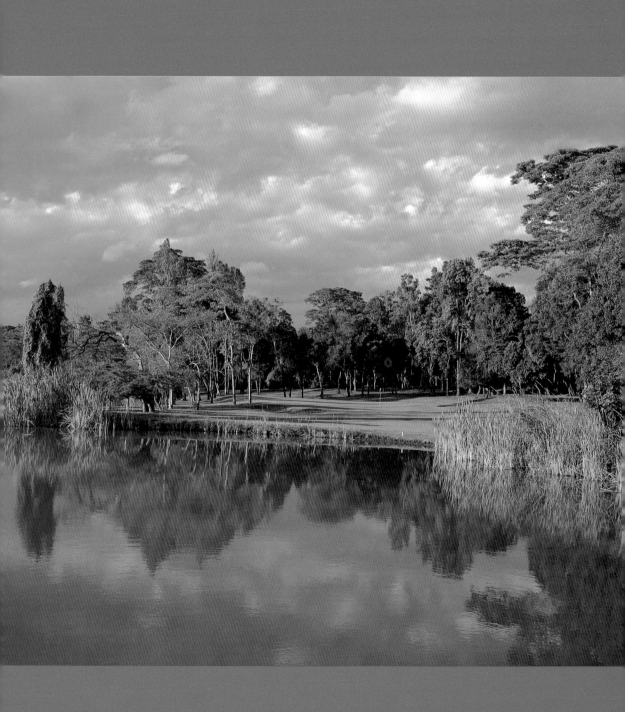

WINDSOR GOLF AND COUNTRY CLUB

RECOMMENDED BY **Mike Klemme**

❧

Mike Klemme had always wanted to go to Kenya. One day, at the least likely of places, the opportunity arose.

"I was at a golf industry conference in Scottsdale," Mike said, "and someone tapped me on the shoulder. I turned around and it was a gentleman who introduced himself as the owner of a golf resort in Kenya. 'I understand that you're a photographer,' he said. We got to chatting and soon worked out a deal. I'd get a trip to Kenya in trade for photographs of the resort. I took my whole family."

The golf resort in question is the Windsor Golf and Country Club, on the outskirts of Nairobi. The appearance of golf in Kenya coincided with the arrival of British colonialists in the early 1900s. Courses were soon springing up all around the East African nation. The lush landscapes lent themselves wonderfully to golf course development and offered a variety of settings—beachside, mountain, and parkland courses were all possible. (One course was even hewn from the side of a volcano!) Great variety is complemented by a climate that's very well suited for year-round golf. Today, Kenya offers thirty-six courses; many are 9-holers, though thanks to increasing demand (mostly from visitors), many of these are being expanded to 18 holes. The oldest course is the Nairobi Golf Club, which opened in 1906; the newest is Windsor.

Windsor Golf and Country Club winds its way through a forest of indigenous trees— ebony, ithare, and mukui—that's bordered by flower farms and arabica coffee plantations. The parkland layout was designed by Irishman Tom Macauley, and it opened its fairways to players in 1992. On a clear day, Windsor offers up some incredible vistas, including 17,000-foot-tall Mount Kenya and the Ngong hills, where whites first settled in the early days of colonial occupation. Abundant birdlife calls Windsor home; there's even

OPPOSITE:
Monkeys make up a distinctive gallery presence on the back 9 at Windsor.

a resident ornithologist who leads birding tours around the course to take in the Egyptian geese, black kites, egrets, and brown eagles that are frequently encountered soaring over the fairways. There are other residents, too, as Mike learned during his visit. "After we arrived, I went out to scout the course for some potential photos. It was near evening, and I was by myself. As I was walking up the fourteenth fairway, two or three green monkeys came running in front of me. I knew I wasn't home in Oklahoma anymore. There was a grove of trees on one side of the fairway, and as I got closer I saw that there were hundreds of monkeys up in the canopy. Many jumped down and started running across the fairway. It was a little intimidating."

You'll have to dig deep in the *Rules of Golf* to get a ruling on monkey interference.

The layout at Windsor is marked by many water hazards, which provide sustenance for animal life and challenge for players. Island greens are encountered on several holes, and Windsor's par 5 fifth, clocking in at 640 yards, is one of the African continent's longest holes. Fortunately, at an altitude of 6,000 feet, your ball will get about 10 percent extra carry.

The eighteenth hole at Windsor is perhaps most representative of the seeming contradiction of golf in Kenya. "Number eighteen is a long par five and has an island green," Mike said. "Most of the monkeys are on the back nine, so there's a chance that you'll encounter one here. As you play up to the hole, there's a tremendous British colonial–style hotel in the background. It wraps around the island green, a very awesome sight."

Many visitors who make their way to Kenya have a safari in mind, and Windsor does not disappoint on this front. "The people who own Windsor also own tent camps that are out in the bush," Mike continued. "Visitors will often do wildlife trips in the early morning and the late afternoon, and play golf in the middle of the day. It's part of the whole experience." Nairobi is especially convenient for such adventures, as the city adjoins Nairobi National Park, home to leopards, lions, water buffalo, rhinos, cheetahs, hippos, crocodiles, and many other animals you're not likely to encounter running wild at your local park.

Another pleasant facet of visiting Kenya is the warmth and kindness of the local people. "I always thought that the nicest people on earth lived in Oklahoma, but after several trips, I'm now convinced they live in Kenya," Mike concluded. "We stayed in several different places in the course of our trip. At each place, all the staff knew my children's names within an hour. Anytime the children wandered off, the staff would

entertain them. And every night after dinner, there was something special awaiting us, whether it be wildlife drives or a hot-air balloon ride over the golf course."

MIKE KLEMME is one of the most widely published golf course photographers in the world. His assignments have taken him to every state in the United States, to Kenya, Morocco, Italy, Ireland, Finland, Korea, Thailand, and Malaysia. His images have been used in many books, including George Peper's *Grand Slam Golf* and *Golf Courses of the PGA Tour*, Brian McCallen's *Golf Resorts of the World*, and Jim Franks's *Golf Watching*. Mike's photographs have appeared in countless magazines, including *GOLF Magazine*, *Golf Digest*, *Links*, *Travel + Leisure Golf*, *Golf Connoisseur*, *Cigar Aficionado*, *The Robb Report*, *Men's Journal*, and *Sports Illustrated*. He is also the author and photographer of *A View from the Rough*. Mike has served on *GOLF Magazine's* panel to select the top 100 golf courses in the world since 1990, and is secretary/treasurer of the Academy of Golf Artists.

If You Go

▶ **Getting There**: The Windsor Golf and Country Club is a fifteen-minute drive from the city center of Nairobi and forty-five minutes from the Jomo Kenyatta International Airport. Nairobi is served by many major carriers, including American Airlines (800-433-7300; www.aa.com), British Airways (800-247-9297; www.ba.com), and Swiss Airlines (877-359-7947; www.swiss.com).

▶ **Course Information**: The course at Windsor Golf and Country Club (+254 20 862300; www.windsorgolfresort.com) is 6,751 yards from the long tees and plays to a par 72. Rates are from 2,400 to 3,000 Kenya shillings (approximately $32 to $40 U.S.).

▶ **Accommodations**: The Windsor Golf and Country Club offers 130 rooms with complete resort amenities. It's considered one of the finest hotels in Nairobi and offers vistas of Mount Kenya and the sacred Maasai Buffalo Mountain in the distance. Deluxe double rooms begin at approximately $320. For reservations, contact Windsor at +254 20 862300, or visit www.windsorgolfresort.com.

21

DESTINATION

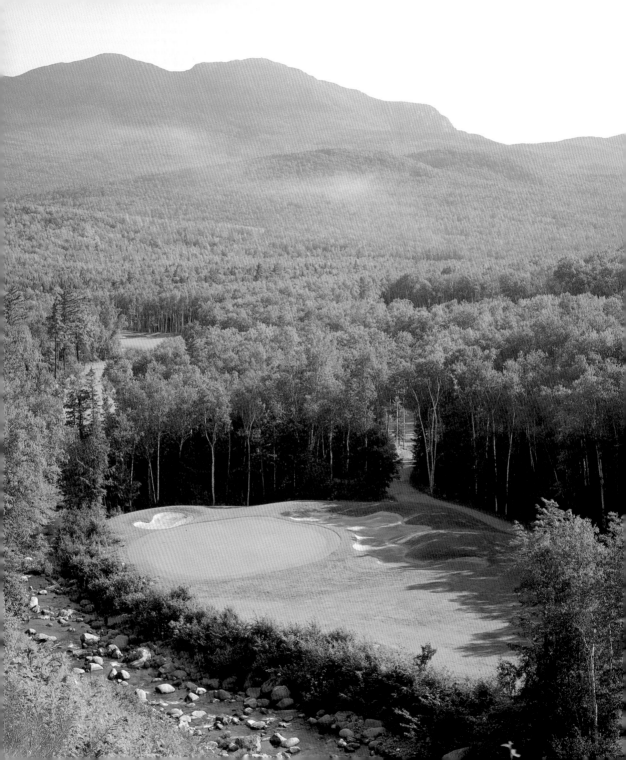

SUGARLOAF / USA GOLF CLUB

RECOMMENDED BY **Robert Trent Jones, Jr.**

✿

As the populations of greater Boston and New York swelled through the nineteenth and early twentieth centuries, the rugged mountains of western Maine remained isolated and largely undeveloped. It was a land frequented by loggers, mill hands, and the occasional urban sportsman who traveled north to hunt and fish. Though modest lodges catered to the hunters and anglers, the area could hardly be considered a travel destination. The seeds of change were planted in 1949, when some local ski enthusiasts, led by a store-keeper named Amos Winter, set out to find some new terrain after access to their first mountain was lost to a damming project. By 1951 the first trail had been cut on 4,000-foot Sugarloaf Mountain. Fifty-odd years later, the site is home to one of New England's premier ski resorts. As has happened at so many ski operations, ownership interests realized that visitor levels tended to drop a bit in the snowless summer months; they believed that a golf course could make Sugarloaf a true four-season resort.

In 1985 the course was built. And some would say that the golf course is good enough to make future generations view Sugarloaf as "a golf resort that has some skiing."

"Sugarloaf is one of the most spectacular courses I've ever been associated with," said Robert Trent Jones, Jr. "The course stretches over a large property. Thanks to the amount of land we had to work with and the dense forests, each hole is isolated. You don't see any other holes or other golfers, except around the clubhouse. It's real wilderness golf. Sugarloaf gives you lots of options. On the sixth hole, for example, which runs dramatically uphill, if you don't like your game you can drop your clubs, pick up your skis, and keep climbing. The hole looks right up at some ski runs. At the beginning of the golf season, it's quite possible to ski in the morning and play eighteen in the afternoon."

The 6,910-yard layout at Sugarloaf takes great advantage of its mountainous terrain.

OPPOSITE:
On the par 3 eleventh at Sugarloaf, players must carry the Carrabassett River. Mount Bigelow looms in the distance.

The elevation on the front nine and back nine differs by 300 feet. Many tees are perched on ledges affording panoramic views of the Carrabassett Valley. In the fall, when the oaks, birch, and maples are turning against the backdrop of green provided by thick stands of pine, the colors can be spectacular. Indeed, an early autumn round, when cool nights ignite the foliage but days are still warm enough for shirtsleeve play, can be the nicest time to visit the Downeast state.

The drama builds slowly at Sugarloaf. The first 5 holes meander downhill, into the valley. The sixth, a 403-yard dogleg right, climbs up again; when you turn right for your approach, Sugarloaf Mountain is there to greet you. Should you turn around, you'll notice Mount Bigelow, which rests behind the sixth tee. The 187-yard par 3 eighth pays homage to the twelfth at Augusta National, with a pond abutting the front of the green. The play here is simple: hit the green or find the drop area.

On the back nine the course joins the Carrabassett River, creating a stretch of 6 fabulous holes that the course's creator has called the String of Pearls, for the luminescence of the rushing river that fronts, backs, or parallels numbers 10 through 15. "The course really begins when you get to the back," Robert commented. Number 10 is a short 334-yard par 4, made shorter by an elevated tee that's 90 feet above the fairway. Adams Mountain provides a backdrop. In the initial blueprint, the green was going to be across the river, but environmental regulations kept the putting surface on the tee side of the Carrabassett. To give the hole some verve, three large fairway bunkers were built, making a dead accurate tee shot a necessity. On the eleventh, players climb up 128 feet for the tee shot of the day. On this 216-yard par 3, players must carry the river to a green that snugs up against the trees. The shot is interesting, made all the more so by the brooding presence of Mount Bigelow in the background. Golf balls that don't clear the river have been reported to turn up on farmland some fifteen miles downstream, where they've been swept out of the river bed by high water.

The river borders the left side of the par 5 twelfth, a hole that's considered one of the better birdie opportunities on the course, providing you hit a strong drive to the right side of the fairway. Holes 13 and 14 are both 401 yards; number 13 plays along a narrow fairway with river left, and number 14 finds the river cutting in front of the green. The last pearl on the string, number 15, is a 178-yard par 3 that again plays over the river.

Wildlife abounds in the north woods around Sugarloaf, and fairway encounters with black bear, deer, and Maine's state animal are not uncommon. "Moose come down to the

course pretty regularly," Robert said. "At the peak of foliage season, in early October, you might also hear the noise of moose rutting. The moose and bears are members at Sugarloaf and they play scratch, so be careful.

"The fairways are narrow at Sugarloaf," Robert continued. "If you miss a shot, you're in the woods. If you hit a shot in the woods when the moose are rutting, you may want to just drop another ball."

ROBERT TRENT JONES, JR. is a master golf course architect and chairman of the board for Robert Trent Jones II LLC, based in Palo Alto, California. He has designed more than 230 courses in forty countries, including Chateau Whistler Golf Club, British Columbia; the Links at Spanish Bay, Pebble Beach, California; Princeville Golf Resort courses, Kauai, Hawaii; Pine Lake and Golden Valley Golf Clubs, Japan; Alcanada Golf, Majorca, Spain; Turning Stone Oneida Nation Kahluyat Course, New York; and Windsor Golf Club, Florida. In addition to winning many Best Course and Best New Course awards, Robert has received the Golden Bear Award, State of California, Department of Parks and Recreation (1984); the American Academy of Achievement Award (1989); induction into the California Golf Hall of Fame (1991) and the Golf Hall of Fame of Northern California (2000); and has received the Family of the Year Award, National Golf Foundation (1996).

If You Go

▶ **Getting There:** While removed from New England's major thoroughfares, Sugarloaf is just four hours' drive from Boston. Both Portland and Bangor, Maine, are served by most major airlines; Sugarloaf is just two hours from Portland.

▶ **Course Information:** Sugarloaf/USA Golf Club plays 6,910 yards from the blues, to a par 72, with a slope rating of 151. Greens fees range from $69 to $110. To reserve a tee time, call 207-237-6812 or visit www.sugarloaf.com.

▶ **Accommodations:** Sugarloaf/USA is a full-service, four-season resort. Three lodging options are available on the property: the Grand Summit has 120 rooms, Sugarloaf Inn has forty-four rooms and is a bit more modest in its amenities; for larger groups, condominium rentals are available. Packages are available from $89 to $149 per person. For more information, call 800-THE-LOAF.

DESTINATION 22

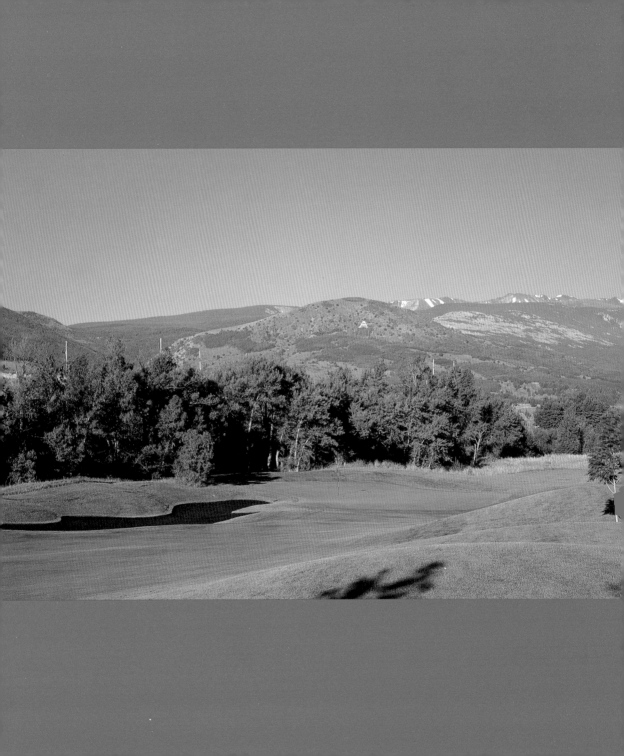

OLD WORKS COURSE

RECOMMENDED BY **John Olenoski**

✻

Life is hard in a mining town, and it only gets harder when the mine closes down. This was the fate that faced Anaconda, Montana (population 7,000), in the early 1980s. The Washoe Smelter, which produced nearly one-sixth of the world's copper, dimmed its fires forever, eliminating 1,100 jobs (and over 60 percent of Deer Lodge County's tax base) overnight. To make matters even worse, Anaconda was left with the detritus of nearly one hundred years of smelting operations. The region of town that had housed the smelters was so environmentally degraded by arsenic and other by-products of the smelting process that it was listed as one of the largest EPA Superfund sites in the country. The Atlantic Richfield Company (ARCO), which had purchased the land from Anaconda six years before its Superfund designation, was faced with the task of removing tons of waste material from the property or taking remedial action. After meetings with the Environmental Protection Agency and the Anaconda community, ARCO determined that remedial action—in the form of a golf course—would be more cost-effective and offer better land reuse opportunities.

Thus began the quest of a group of professionals, including John Olenoski, to transform a toxic dump into a golf destination.

"I was working in the Florida office of Jack Nicklaus Design in 1994, as a design coordinator," John recalled. "A very dear friend of mine, Bruce Borland, was the lead designer on the Old Works project but, due to his busy schedule, Jack offered me the Old Works project out in Montana and promoted me to design associate. Word went around the office about what kind of site it was. My associates were joking around, telling me I was going to come back like one of those fish with three eyes from the television show *The Simpsons*. At the time I thought, 'Jeez, will my next project be at Chernobyl?' But

OPPOSITE:

Black sand bunkers (composed of slag) are a constant reminder of Old Works' copper mining past.

109

when we flew out to Anaconda for the ground-breaking ceremonies I saw that the site had many great features for a golf course—nice topography, a beautiful stream running through the site, and lots of interesting features from the smelting days. Plus, there's the backdrop of the surrounding Pintler Mountains. The people I met that day thought I was crazy being so excited about a site that most considered the town dump.

"There's no question that there were some doubters around town, and this became apparent right at the outset of construction. At first we had to do retention dams to keep runoff from coming off the hillsides onto the site. We hydromulched the faces of the dams, to prevent them from eroding. The hydromulch has a greenish-blue tint that's very brilliant when it first goes on but fades pretty quickly. When the tint faded, people up in town were saying, 'Told you you couldn't get anything to grow down there!' This went around the town like wildfire."

Environmentally sound or "green" golf course design has gained momentum in the past few decades, thanks to increased ecological awareness. To conserve water and limit fertilizer use, new turfgrasses like Seashore Paspalum have been developed; this grass can be irrigated with salty water. Many designs now incorporate drainage systems that catch storm water so it can be recycled throughout the course. Course designers are also paying closer attention to native plant species. By preserving or incorporating vegetation indigenous to the region where a course is being built, designers create a more natural setting. This can protect and even stimulate wildlife species. But restoration projects like Old Works take the green design concept to a whole new level.

In keeping with the classic design notion of working with what the site has provided, the Nicklaus Design team incorporated debris from the smelter's heyday into the layout, including flues, smelting ovens, and brick walls. An engineered soil cover (or "cap") of 18 to 23 inches was installed over contaminated soil; this cap, which is made of clay as well as topsoil and vegetation, provides a safe buffer for both players and workers. To manage water infiltration, specially made liners were used under bunkers, tees, greens, and the course's two lakes. Eleven independent drainage networks were installed, and 133 surface grates were constructed to catch and route flows into the networks. To reduce the potential for irrigation infiltration through the soil cap, a central computer, flow sensors, and an on-site weather station were installed to assist in managing the amount of water used each day.

While some of the wonders of Old Works lurk under the fairways, many are quite visible and add to the pleasure of a round. Most distinctive among these are the course's black bunkers, which are made from slag, a residue of the smelting process. "There was a mountain of slag as we drove in," John said. "Something like twenty million cubic tons. We thought it might work in lieu of conventional sand. They set up a bunker filled with slag at the Deer Lodge Country Club, and we took Jack over to try it. He felt it played quite well and was excited to use it. We sent the slag off to labs, and even to an optometrist, to test it to be sure it wasn't harmful and met Jack's bunker sand requirements. The lab results came back saying it is nearly an ideal bunker sand, if you can accept the color. During Jack's playing test of the slag, one spectator asked, 'Will you have black and white bunkers on the course?' Jack jokingly replied, 'No, I don't think so, I've never been much good at checkers.'"

Great piles of slag and old furnace flues seem incongruous with a fine golf course, yet at Old Works they prove intensely harmonious, seamlessly blending the land's past and present. The past is especially present on the front nine, where the par 5 third hole has a fairway bordered by calciners (a type of furnace), the par 3 fourth hole has a backdrop dominated by an old flue, and the par 3 seventh is played from an elevated tee made of slag. "It was difficult at times to keep some of the artifacts in the layout," John said. "The original plan called for the entire site to be capped. Working with the EPA, all the *i*'s had to be dotted, all the *t*'s crossed. We had to wear steel-toed boots, safety vests, and hard hats and use decontamination trailers during construction of the course. Jack would wear the hard hat and safety vest but wanted nothing to do with the steel-toed boots during his visits."

Small towns, especially those that have been beaten down by adversity, show a great propensity for banding together for survival. The day of the Old Works Course grand opening must have represented a small step toward rejuvenation, and the townspeople of Anaconda responded with great enthusiasm. "As Jack and our group were riding into town, there were banners at the car dealerships reading, 'Welcome Jack!,'" John recalled. "They closed the schools, and all the kids were out on the site, hoping for autographs. Jack signed hundreds of them that day. As for the course grand opening, I think it was one of the biggest openings we'd ever been involved with. Some three thousand spectators showed up to watch Jack play this unique golf course—it was like a tournament out there.

23

DESTINATION

"That was seven years ago, and I'm sure that some of the enthusiasm has waned," John continued. "But I'd like to think that having that course built made some kind of difference to that town. And that sense of maybe making a difference has made Old Works one of the most rewarding projects I've ever worked on."

JOHN OLENOSKI began his golf architecture career with celebrated designer Arthur Hills in 1985. After five years with Arthur Hills, John joined Nicklaus Design in 1990 as a design coordinator. In addition to Old Works, John was given the opportunity to be associated with a number of outstanding Nicklaus signature courses, such as Colleton River on Hilton Head Island, South Carolina; Eldorado in Cabo San Lucas, Mexico; and Cimarron Hills in Georgetown, Texas. He now operates Olenoski Design, based in Austin, Texas.

If You Go

► **Getting There:** Anaconda, Montana, is twenty-five miles west of the city of Butte and ten miles west of the junction of Interstates 15 and 90, approximately halfway between Glacier and Yellowstone National parks. Butte is served by Horizon Air (800-252-7522; www.alaskaair.com) and Delta Connection/Skywest (800-221-1212; www.delta.com) via Salt Lake City and Seattle.

► **Course Information:** Old Works measures 7,705 yards from the back tees, with a slope rating of 133. The course is situated at 5,000 feet, and this altitude will help you cover the distance. Greens fees range from $29 in the early spring and fall to $41 in the late spring and summer. Tee times can be made at 888-229-4833. Detailed information about the course is available at www.oldworks.org.

► **Accommodations:** Old Works has put together golf packages with a number of properties in Anaconda, which are listed at www.oldworks.org/packages.html. To learn a bit more about the region's rich mining heritage, consider a visit to the Anaconda Visitor Center Complex. If you're a hunter or angler, don't forget to bring your gear. Anaconda is in the heart of southwestern Montana, and the sporting opportunities abound.

ROYAL DAR ES SALAAM GOLF CLUB

RECOMMENDED BY **Rich Lerner**

✳

Resting at the fulcrum between Europe and northern Africa, cloaked in exotic robes long before the release of the movie *Casablanca*, Morocco is a colorful land that has long enticed adventurous travelers. Roughly the size of California, Morocco is a place of tremendous contrasts, where snowcapped mountains rise from the edges of an inhospitable desert, where millennium-old neighborhoods survive in the midst of modern cityscapes.

And thanks to King Hassan II, it's also a land of great golf courses. "If you want to golf *and* have an adventure that departs from your typical American resort experience, you'll find Morocco appealing," Rich Lerner said.

Golf was introduced to Morocco in the early 1900s but did not gain much momentum until the latter part of the century, when King Hassan II took the throne. The king was a passionate player who forged a close relationship with Billy Casper, and together they did for golf in Morocco what President Eisenhower and Arnold Palmer did for the game in America . . . albeit with a slightly smaller following. Morocco now boasts sixteen good courses. One of the crowning golf achievements of the king's reign came in 1971, when Robert Trent Jones, Sr. was commissioned to forge Royal Dar es Salaam from a forest of cork oak and eucalyptus trees on a hill overlooking the city. Dar es Salaam—or "House of Peace"—hosts two 18-hole layouts and one 9-hole track in the capital city of Rabat, on the Atlantic coast. The Red Course is the championship venue, a par 73 measuring in at a whopping 7,462 yards from the back tees; it's considered the most challenging course in Morocco. While the narrow fairways cry for the good judgment of a long iron off the tee, the distance demands driver—and, one hopes, lots of roll! The Hussan II Trophy, for many years a European Tour event, attracted some top-notch

113

players to Dar es Salaam's Red Course. Billy Casper won the tournament twice, as did Payne Stewart.

Several holes are memorable. The 200-yard par 3 ninth is played across a lake to an island green; flamingos are often seen high-stepping around the green. A few holes later, the 567-yard par 5 twelfth finishes against a backdrop of Roman columns transferred here from the ancient city of Volubilis a few miles away. After 18 holes on this demanding track, many will feel as if chariots of gladiators have been on their heels. Yet the fragrances of mimosa, rose, hibiscus, and orange trees fill the air, and the presence of banana and papyrus plants all further the oasis feeling that the phrase "Moroccan golf course" inevitably conjures.

"If you've made it to Morocco, you're probably not going to leave without making a visit to Marrakech," Rich continued. "It's an extraordinary city, blending old and new in a jarring and exciting way." Marrakech now has three high-quality golf courses—Amelkis, La Palmeraie, and Royal Marrakech—making the thousand-year-old city Morocco's golf hot spot.

Royal Marrakech is one of Morocco's oldest courses, dating back to 1923, when it was built by the pasha of Marrakech after a trip to the United Kingdom, where he came upon the game. Rather pedestrian in its first incarnation, Royal Marrakech was redesigned ten years later by a trio of Frenchmen—Gustave Gollias, Bouchaib Stitou, and Arnaud Massy, the winner of the 1907 British Open and the only Frenchman to achieve this milestone. It went on to become a favorite of the king and his colleagues, and has also hosted many dignitaries (Winston Churchill and Dwight Eisenhower played a few rounds here after the Casablanca Conference of 1943). The layout wanders among cypress, palm, olive, orange, and apricot trees and rests near the foot of the Atlas Mountains, where perpetually snow-covered Mount Toubkal soars to 13,665 feet.

Though part of Africa and the Arab world, Morocco has strong ties to Europe. Perhaps these links help explain the nickname of the course's signature hole. "The par 3 fifteenth is both famous and funny," Rich related. "Guarding the green are two rather prominent grassy mounds, with a bunker in between. It's called the Brigitte Bardot hole, as the mounds, anatomically speaking, reminded someone of the actress in her youth."

Rich found some fine golf in Morocco, and was equally inspired by the exotic surroundings. "The sense of history here is profound, and it's also a charming destination. After playing golf in Marrakech, we walked through the Medina, the old walled Moorish

OPPOSITE:
The par 3
ninth at Dar
es Salaam
requires a 200-
yard water
carry from the
back tees.

24

DESTINATION

city, a labyrinth of alleyways. We made our way to a tannery. It was as if we'd returned to the year two A.D. There was a guy standing in the distance in a loincloth with some animal skins draped over the walls behind him. At the time, I thought that the scene must be little different than it was in that spot a thousand or two thousand years ago."

RICH LERNER has been a mainstay at the Golf Channel for the past eight years. He can be seen hosting *Golf Central* and Champions Tour coverage with Brandel Chamblee, and is a contributing writer for TheGolfChannel.com. Additionally, Rich has hosted the 2003 Solheim Cup from Sweden, the 2004 Tavistock Cup, and the 2004 UBS Cup; his essays have punctuated the network's coverage of golf's major championships. His one-hour specials include *New York Stories* and *Courage on the Fairways. Se Ri Pak, A Champion's Journey* earned Rich the prestigious Women's Sports Foundation Journalism Award. Prior to joining the Golf Channel, Rich was the host of a Prime Sports Radio Network afternoon drive time talk show distributed to approximately 110 radio stations nation-wide.

If You Go

▶ **Getting There:** Rabat, Morocco, is served by several carriers, including Air France (800-237-2747; www.airfrance.com) and Royal Air Maroc (www.royalairmaroc.com). Marrakech can be reached from Rabat in a few hours.

▶ **Course Information:** Par 73 Royal Dar es Salaam measures 7,462 yards from the back tees. Greens fees are 400 dirham (approximately $50). Information about the club can be found by calling the Royal Moroccan Golf Federation at +212 37 75 59 60. Par 72 Royal Marrakech Golf Club is 6,475 yards. Greens fees are also approximately $50. For more information, call +212 44 44 43 41. A number of tour operators offer Moroccan golf extravaganzas.

▶ **Accommodations:** Both Rabat and Marrakech offer a wide variety of accommodations, from Western-style hotels to *riads,* small palaces that have now been transformed into luxury inns; www.maroc-selection.com provides an overview of places to stay. After Dar es Salaam, take in the Mohammed V Mausoleum, a wonderful example of Moroccan architecture. While in Marrakech, be sure to visit the Medina and the Koutoubia Mosque.

SAND HILLS GOLF CLUB

RECOMMENDED BY **Steve Mona**

It is generally understood that wind is not the golfer's friend. It knocks down shots, blows them off track, confounds club selection, and otherwise makes a mess of things. One possible exception occurs in the north-central region of Nebraska, where generations of gusts slowly blew sand from the Great Plains into hills and ridges, creating the largest stabilized sand dune area in North America. This dune region—the Sand Hills— is mobilized by abundant native grasses, whose golden shades provide a pleasing contrast to the brilliant green of the fescue fairways that constitute the Sand Hills Golf Club.

Sand Hills Golf Club is situated on an 8,000-acre ranch in the middle of the 23,600-square-mile Sand Hills Mixed Grasslands area. "It's way out there in rural Nebraska, fifty miles from North Platte, off Interstate Eighty," Steve Mona recalled. "There aren't any other golf courses around. There's barely a town. Coming from my home in Lawrence, Kansas, you cross into the mountain time zone. This reinforces the idea that you're going to a very different place. When you get there, it's very easy to drive right by it if you're not paying attention. There's just a small sign—no words, just a logo. It's a very small road, not the kind of entrance you'd expect for a great golf course. After a mile or so, you get to the clubhouse. The course is not right adjacent, you don't see it on the way in. After hooking up with my friends, we drove on a cart path over to the course, just to have a look. It's another mile or so. You come around a corner and the whole thing opens up in front of you. It practically took my breath away."

Some courses are built through the painstaking movement of thousands of tons of earth. Others are just sitting there, waiting to be discovered. There is probably no greater case of a course waiting to be discovered than Sand Hills; it's one of America's great links courses, even though it's fifteen hundred miles from any ocean! In an interview with *Golf*

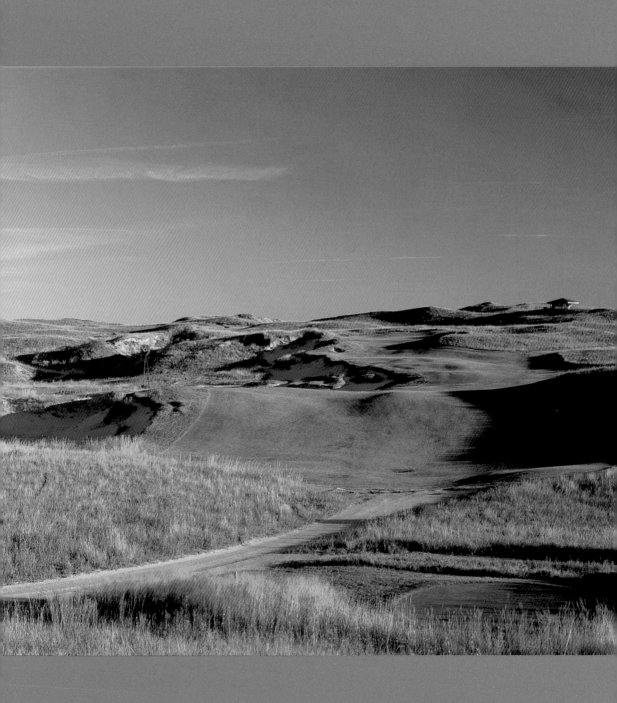

Travel Information, codesigner Ben Crenshaw said, "All we had to do was route the holes and build the greens. We moved so little dirt, it was amazing." Indeed, it's been rumored that only 5,000 cubic yards of dirt were moved—less than it takes to build some elaborate tee boxes! While there may have been little need to move dirt, Crenshaw's design partner, Bill Coore, underscored the challenge that was faced: "We had to create a course equal to the potential of the land—a daunting task to say the least! To have constructed anything less than an extraordinary golf course on that site would have been a failure."

"Sand Hills was about as pure a golf experience as I can imagine," continued Steve Mona. "There's no tennis, no swimming pools. Just golf. The whole project was guided by an extremely minimalist philosophy. I don't even recall there being benches or ball washers on the tees! The rounds I played there were with two close friends who really appreciate pure golf. I'm sure some people would dislike the things that we really appreciated. Every time I see Ben Crenshaw now on the tour or at an industry event, I can't help but talk about Sand Hills with him."

Though fashioned from the prairie in 1995, Sand Hills seems as timeless as St. Andrews. In *Classic American Courses,* Mike Strachura notes that "the unadorned holes are refreshingly unlike any others in the world, yet viewed for the first time, they appear fundamentally and instinctively reflective of golf's soul." Steve agrees. "It's a great golf course from start to finish," he said. "There are simply no bad holes out there." Winding around and over the dunes, the Sand Hills layout allows the wind that made this land to frequently come into play. Many of the greens are unobstructed in front, which permits for the bump-and-run approaches that the gales often necessitate.

"Holes seven and eight really stand out for me," Steve continued. "They're back-to-back par fours, very short—about two hundred and eighty and three hundred yards, respectively. A longer hitter could hit the green on either, but if you miss you'll get in trouble. Big trouble. I played number seven with a five-iron and an SW. The green was treacherous. On number eight, I hit a four-wood and an SW. The fairway is a little more generous on the eighth, but it narrows down quickly. Though they're short holes, they are wonderful, in a natural, understated way.

Another hole that stands out for the few who have made it out on Sand Hills is the par 3 seventeenth. From an elevated tee, the green rests 150 yards away, encircled by blowout bunkers. Layers of dunes climb in the background, providing a cutaway tableau that perfectly encapsulates the Sand Hills experience. The hole is situated on a ridge, making

OPPOSITE:
Inspired in part by Prairie Dunes, Sand Hills is perhaps golf's greatest inland links.

DESTINATION

25

every tee shot susceptible to the vagaries of the breeze. To accentuate the importance of gauging the wind for this delicate approach, a small windmill is set behind the green.

"There's a routing plan in the golf shop that shows more than a hundred holes," Steve said. "They have so much land, they could've built six more courses. Instead, they built one truly great one. I don't think I've ever experienced such incredible solitude. On the first day we played we had the course to ourselves, and it was the quietest place I've ever been. There were no sounds of human progress, no cars or anything. On the back nine, you might hear a cow now and then, but nothing else. It was so quiet that I almost couldn't concentrate."

STEVE MONA is chief executive officer of the Golf Course Superintendents Association of America, the leading professional organization for the men and women who manage golf courses in the United States and worldwide. He's served in this capacity since 1993. Steve has worked in the golf industry his entire career. Before joining the GCSAA, Steve served as executive director of the Georgia State Golf Association. He's also served at the Northern California Golf Association and the United States Golf Association. Mona's contributions to golf have been well recognized. In 2001 *Crittenden Golf Inc.* magazine selected him as one of golf's top twenty-five most dynamic movers and shakers. In 1999 *Golf Digest* listed Steve as one of the golf industry's most powerful people in golf. Only one person younger than Steve, Tiger Woods, was ranked higher. In 1997 the Kansas City Society of Association Executives named him Association Executive of the Year.

If You Go

▶ **Getting There:** Sand Hills Golf Club is near the tiny town of Mullen, Nebraska. The closest major airport is in Denver, five hours to the west.

▶ **Course Information:** Sand Hills is a par 71 layout and plays 7,089 yards from the back tees (there are only two sets of tees here). The course is extremely private, with a membership of only two hundred; members have declined to have the course rated. If you can somehow find your way onto the course, greens fees are $150.

▶ **Accommodations:** The club maintains some small cabins on the premises for visiting members and their guests. Meals are taken in the clubhouse and, according to Steve Mona, are excellent.

CHANNEL GEMS

RECOMMENDED BY **Jan Kees van der Velden**

Golf historians generally agree that golf as we know it today is a gift from the nation of Scotland. The Scots had the notion of digging a hole for a target, and they created the rules that provide the backbone for the game we now play. However, evidence strongly suggests that some of the precepts of the game, and even the name, were imported across the North Sea from the lowlands of Holland. The late golf historian Steven J. H. van Hengel uncovered references to "colf" as early as 1297, when the townsfolk of Loenen aan de Vecht played four "holes" of the game to commemorate the anniversary of the relieving of the Kronenburg Castle. Colf was one of several stick-and-ball games played in the low countries in the Middle Ages. Something of a combination of hockey and golf, these games involved advancing a rock or other round object toward a distant large object—a large rock or a cemetery gate, for example. In some versions of the game, opposing teams would take turns whacking the object back and forth. The fact that Holland and Scotland were trading partners at the time lends further credence to the theory that some elements of golf may have been exported to Scotland.

One could debate claims to the genesis of golf endlessly. Whatever your feelings on who created the game, those who have traveled to the Netherlands agree that a fine experience awaits you . . . and that the golf experience to be found on the three fine coastal courses between The Hague and Amsterdam rivals some of the finest to be found across the Channel: Royal The Hague, Noordwijk, and Kennemer. Considering the geography of the area, this shouldn't come as a great surprise. The gently rolling dunes along the Netherlands coast—and, for that matter, the coastline of Belgium and northern France— is quite reminiscent of the linksland in Scotland, and equally conducive to the construction of golf courses, whether links or heathland layouts. Some of the noteworthy courses

here were designed by architects from Great Britain, no doubt finding similarities with the sites back home.

For Jan Kees van der Velden, the ideal exploration of the Continent's Channel courses would begin in northwestern France, with stops at Belle-Dune, Le Touguet La Mer, Hardelot Les Pins, and Golf de Wimereux. "Le Touguet La Mer is one of the jewels of French golf, a course that every golf visitor to France should, no, *must* play!" Jan exclaimed. Moving north, there are worthy stops along Belgium's brief coast, including Royal Golf Club Oostende and Royal Zoute Golf Club, home to many Dunhill Belgium Opens. "Nick Faldo called Le Zoute a hidden gem, and with this remark he was spot-on," Jan continued. "It was battered pretty badly during World War One, but it was nicely restored. Although it's not very close to the North Sea, it's a great example of how a seaside course should be. In my opinion, it's one of the best seaside courses in Europe. It's a shot maker's course. You'll need every club in the bag."

Farther north, we come upon the first of the three Netherland Channel gems, Royal The Hague Golf and Country Club. "This is the first—and last—royal golf club of the Netherlands," Jan explained. "Her Majesty Queen Beatrix gives this honor to only one club. The honor was bestowed in 1993, on the club's hundredth anniversary. Originally, it was a nine-hole course. It was soon expanded to an eighteen-hole layout but was so severely damaged by the Nazis in World War Two that restoration was impossible." In 1947 the club moved to another course, a couple of miles down the road in the town of Wassenaar, which was finished just before the war. The current course, designed by Harry S. Colt and Charles Allison in 1939, has a classic links feel, ambling over rolling fairways between gorse and stands of pine. Though the North Sea is not visible from the course, the wind is a constant factor. (Speaking of wartime damage, Jan mentioned that the Domburgsche Golf Club in the province of Zeeland was hit hard by Royal Air Force bombardments in the final years of World War II, and that some of the bomb craters now serve as deep bunkers!)

Moving a bit north, one comes upon Noordwijk Golfclub, which dates back to 1915. "Until 1972, the club played on a charming nine-hole course, just outside the seaside town of Noordwijk," Jan said. "A new eighteen-hole course was opened in 1972 in the dunes north of town, designed by an Englishman named Frank Pennick. This is probably Holland's finest course."

Set along the beaches of the North Sea, Noordwijk rolls up and down tall dunes toward greens protected by heavy mounding and occasional pot bunkers, touches that would make any Scotsman proud! Few of the holes offer any protection from the relentless wind; the player with a strong ground game will excel here. On a beautiful day in the summer of 1991 the late Payne Stewart and Sweden's Per-Ulrik Johansson lowered the course record to 62, ten under par.

Continuing up the coast, a half hour west of Amsterdam in the popular seaside town of Zandvoort, you'll reach Kennemer, the last of the gems of the Netherlands coast. "Kennemer is the only twenty-seven-hole seaside course in the Netherlands," Jan continued. "It was founded in 1910 as a nine-hole course in the town of Santpoort. In 1928, the club moved to an eighteen-hole layout in its present location by Harry Colt. Nine holes were added in 1985 by Frank Pennick." The three nines at Kennemer can be played in any combination, though when the Dutch Open stops here, golfers play a composite course. The dunes at Kennemer are not as hilly as those on Noordwijk, but the course is more heavily bunkered. It might bear the closest resemblance to a Scottish links of the three Netherlands venues discussed here, were it not for the scattered stands of pine.

"Though we have some wonderful courses in the Netherlands, golf is just beginning to get popular," Jan said. "The number of courses has doubled in the last ten years. More and more youngsters are becoming acquainted with the game through a program that's introducing physical education teachers to the principles of golf, so they can pass them along. You need heroes to capture the general public's attention. We have three players on the European Tour now, and having a Dutchman win the Dutch Open in 2003 certainly attracted interest. Golf isn't an elite sport in the Netherlands, but it still has the ring of an elite sport, and this is seen by some as a negative. It will take time to over-come this, although presently there are a quarter of a million golfers registered with the Netherlands Golf Federation. And we expect that this number will grow ten percent a year."

JAN KEES VAN DER VELDEN is the editor in chief of both *Golfers* magazine (the Dutch affiliate of *Golf Digest*) and *GOLFjournaal*, the official magazine of the Netherlands Golf Federation. In 1984 he was introduced to the game while writing as a freelancer for a Rotterdam daily. In 1989 he quit his job as a teacher and started writing on golf full-time for the magazines mentioned above. In 1993 he took over as editor in chief. Jan is also

the golf commentator for a Dutch radio station, and he covers the game for a TV station in the Netherlands. He is married with two daughters and lives in the small town of Heemstede—twenty minutes from both the Kennemer G&CC and the Noordwijk GC. He still hasn't found the time to lower his handicap below eighteen.

If You Go

▶ **Getting There:** Schiphol Airport is midway between The Hague and Amsterdam and is served by most major carriers. An added bonus is that plane travel from the United States to Amsterdam tends to be more reasonable than travel to other European cities. Amsterdam and The Hague may also be reached by train from Paris, Prague, Frankfurt, Cologne, and Milan.

▶ **Course Information:** Royal The Hague Golf and Country Club (+31 70 517 9607) plays 6,719 yards from the back tees to a par 72, with a slope rating of 126. Greens fees are approximately 120 euros. Tee times are necessary, and a handicap certificate of twenty-four is required. The par 72 Noordwijk Golf Club (+31 252 37 37 61) plays 6,829 yards from the championship tees, with a slope rating of 135. Greens fees are approximately 100 euros. The Kennemer Golf and Country Club (+31 23 571 2836), Van Hengel + Colt 18, plays 6,881 yards to a par 72, with a slope rating of 139. Greens fees are approximately 100 euros. While most clubs in the Netherlands are technically private, day-fee guests are quite welcome, especially on weekdays. Most courses are walking only; carts are generally not available. Fortunately, the terrain is quite flat.

▶ **Accommodations:** Both The Hague and Amsterdam are major sightseeing destinations—even without the golf courses—and the seaside resort towns of Katwijk, Noordwijk, and Zandvoort offer a pleasant taste of small-town Netherlands life. The Netherlands Board of Tourism and Conventions (www.holland.com/us) provides a broad overview of available lodging. In The Hague, Jan recommends Hotel Des Indes (www.desindes.nl); near Kennemer, consider the Amstel Hotel in Amsterdam (www.amsterdam.intercontintal.com); for Noordwijk, he recommends Hotel Huis ter Duin (www.huisterduin.com).

TAHOE GEMS

RECOMMENDED BY **Vic Williams**

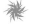

The Reno–Lake Tahoe region bills itself as America's year-round vacation destination, and with bountiful natural wonders—in addition to some very man-made pleasures in the form of the casinos that line the Nevada side of the lake and downtown Reno—the region makes good on its promise. Renowned for its many downhill ski resorts, Tahoe's recreational bounty now extends to golf. "In the past decade, the Reno-Tahoe area has doubled its golf inventory," Vic Williams said. "In the area from South Lake Tahoe across the Sierra Nevadas to Carson City on the Nevada side and up to Truckee west of the lake and farther north on Route Eighty-nine, there are over fifty golf opportunities. There's also tremendous variety, from desert golf to alpine courses. Even when it's snowing up in the mountains, there are many winter days when you can play east of the Sierras."

Hard-pressed to choose a favorite, Vic selected three that reflect the diversity of the Reno-Tahoe golf experience. "Edgewood Tahoe, on the south shore of the lake, is a classic resort-style course. Considering the relatively short season they have, it's amazing what they can do in terms of conditioning. By the time the Celebrity Golf Championship begins in July, Edgewood is in incredible shape." (This nationally televised tourney brings many sports legends, including Michael Jordan, Mario Lemieux, and John Elway to Nevada.) Edgewood Tahoe was built in 1968 by George Fazio, uncle to Tom and Jim Fazio and almost winner of the 1950 U.S. Open [he lost to Ben Hogan in a tie-breaker round]. The site of Edgewood-Tahoe along the eastern shore of America's second deepest lake was once a station for Wells Fargo and the Pony Express, and was also used to graze cattle. The land's owner, Brooks Park, operated a fishing and hunting lodge there but saw other possibilities and recruited Fazio to help him realize his vision.

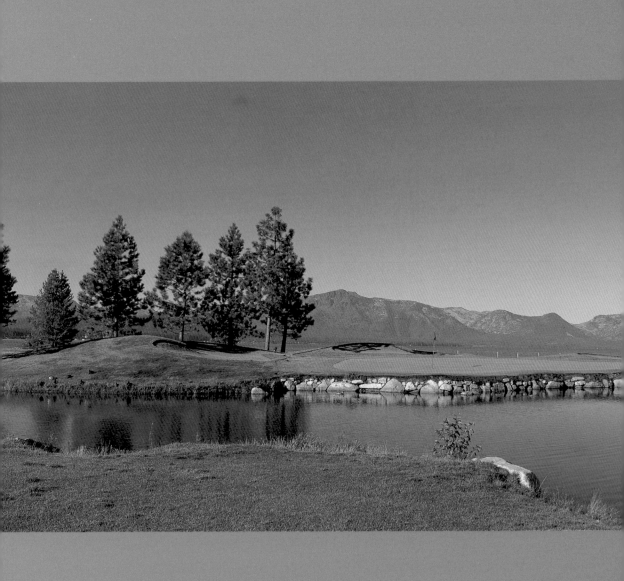

The lake and the encircling Sierras are in view from every hole at Edgewood Tahoe. The final 3 holes conclude right along the shoreline and will stick in your mind as vividly as a Sierra sunset. The 547-yard par 5 sixteenth looks down a chute of pines to a green that's framed by Lake Tahoe in the distance; the 6,200-foot altitude will help players of modest means cut the hole down to size. The 207-yard par 3 seventeenth plays south along the lake, with perpetually snowcapped Mount Tallac across the water. The 572-yard par 5 finisher is reachable in two for big hitters who can play out over the trees on the left, but eagle seekers need to carry a pond on the left front of the green . . . something that former basketball star Bill Laimbeer failed to do on four occasions during one Celebrity Golf Championship.

OPPOSITE:
The eighteenth green at Edgewood Tahoe is guarded by a pond in front; a larger pond called Lake Tahoe is in the background.

Next, we'll cross the Sierras to Genoa Lakes Golf Club, in the Carson Valley. "Genoa is a first-rate parkland course," Vic continued. "It blends very well into the landscape of the valley, which is generally much drier than on the west side of the lake." Where the environment around Lake Tahoe is alpine in the ski-resort sense of the word, the eastern side of the Sierras has more of a big-country feeling, with expansive views of the mountains to the west and Nevada's great open spaces to the east. Co-architects John Harbottle III and PGA Tour veteran Peter Jacobsen designed Genoa Lakes in 1994 and made every effort to optimize the big perspectives the routing offers up as it winds along the Carson River and through a series of wetlands; indeed, water comes into play on 13 holes, so you'll want to choose the tees that best suit your game to avoid much watery disappointment. While many forced carries make the course quite challenging from the back tees, generous bail-out areas around the greens permit a more conservative, alternative approach. Freel Peak, reaching nearly 11,000 feet, looms in the west, perhaps most vividly on the 441-yard par 4 eighteenth, where it stands behind the clubhouse.

To conclude this Tahoe Triple Crown, we'll head west across the Sierras to the California town of Truckee, home of Coyote Moon. "Coyote Moon is a newer course, but probably one of the best alpine golf experiences around. Though it's only five minutes from Interstate Eighty, it seems a zillion miles away." Coyote Moon was designed by Brad Bell, a former PGA Tour player, and opened in 2000 on 250 acres above the town of Truckee. Set among towering pines and immense granite outcroppings, Coyote Moon offers occasional glimpses of snowcapped peaks and no vistas of houses, as none are present on the site—a rare phenomenon in recent California golf development. Each hole is isolated from the next by the pines, offering a wonderful sense of serenity.

Elevation changes are great, as the course is carved out of a hillside. Most holes have generous landing areas off the tee and funnel down to well-guarded greens, giving the illusion of a course that seems tighter than it actually is.

For Vic, Coyote Moon really hits its stride on the back nine. "There's a stretch—holes number twelve through fifteen—that are just excellent." The twelfth is a 492-yard par 5 that plays uphill to a green that's set into a granite outcropping. Number 13 is a 206-yard par 3 that drops precipitously down to a green that's guarded by a ravine and Trout Creek. Boulders support the green, which seems as if it was carved into the edge of the ravine. As golf writer Doug Saunders has aptly pointed out in a course review on GolfCalifornia.com, "Hitting the green on this hole can make up for all of the bad shots you may have already had." After a short par 4 that can be easily reached with two-iron shots, you reach the main workout for the day—the 601-yard, uphill par 5 fifteenth. On top of playing into the prevailing wind, you have Trout Creek to clear at 150 yards out from the hole. Number 15 will likely leave you out of breath.

Blame it on the elevation!

VIC WILLIAMS is publishing partner and managing editor of Reno-based *Fairways & Greens* magazine (www.fairwaysgreens.com), which covers golf, travel, and lifestyle for the American West and beyond. An avid golfer for thirty years and a twenty-one-year resident of Reno, Vic has watched the region grow from a sleepy golf outpost to one of the nation's top-ranked recreation destinations. In 2004, Vic spent several hours with Donald Trump at his new course in Los Angeles, and also covered the 2004 Ryder Cup and 2000 U.S. Open at Pebble Beach. He writes occasionally for *Nevada* magazine and the *Reno-Tahoe Visitor*.

If You Go

▶ **Getting There:** The Reno-Tahoe International Airport has regular service from most major carriers. South Lake Tahoe and Genoa are roughly forty-five minutes from the airport; Truckee is a bit closer. Should you find yourself in Sacramento, California, or the Bay Area on business, the Tahoe region is approximately two or four hours' drive away, respectively.

▶ **Course Information:** Par 72 Edgewood Tahoe (888-881-8659; www.edgewood-tahoe. com) plays a long 7,445 yards from the championship tees and carries a slope rating of 144. Greens fees range from $150 to $200, depending on the season. The Genoa Lakes Golf Club (775-782-4653; www.genoalakes.com) plays 7,263 yards from the championship tees to a par 72, with a slope rating of 132. Greens fees range from $60 to $120. Par 72 Coyote Moon (530.587.0886; www.coyotemoon.com) plays 7,061 yards from the back, to a slope rating of 138. Greens fees range from $95 to $150.

▶ **Accommodations:** There's a panoply of accommodations available in the Reno-Tahoe area, from chain motels to ritzy lodges. Most of the properties offer golf packages in season, and with a number of other good courses in the region—plus skiing through May, fly fishing in the summer, hiking, mountain biking, horseback riding, and more—there are few reasons not to take advantage of the package option.

DESTINATION

27

LAS VEGAS PAIUTE
GOLF RESORT, WOLF COURSE

RECOMMENDED BY **Tim McDonald**

✴

Madmen and prophets have historically been drawn to the desert. If that desert happens to be situated near Las Vegas, Nevada, you can add golf course developers to the list. Defying the logic of water scarcity and baking summer heat, greater Las Vegas is now home to more than seventy courses. As the Vegas target market shifts back from family-friendly to high-roller, we can expect more courses to be built.

Las Vegas is home to some infamous layouts, including Tom Fazio's Shadow Creek, a course open to MGM Mirage guests with greens fees rumored to reach as high as $500. While many famed designers have left their verdant mark upon the Nevada desert, the work of Pete Dye was notoriously absent until 1995, when the first of the three courses at the Las Vegas Paiute Golf Resort was built. The resort is built on high desert land that was once the ancestral home of the Paiute Indians. The land had fallen out of tribal hands, but in 1983 the Paiutes negotiated a trade—10 acres of property situated in what is now downtown Las Vegas for 4,000 acres of untamed land, a half hour northwest of the Strip. The first and second courses at Paiute, Snow Mountain, and Sun Mountain are benign by Dye standards, docile desert flowers.

The Wolf, however, is a different animal.

"I went out to Nevada to do a series of stories on Las Vegas golf," Tim McDonald said. "The Wolf was the first course I played, and I fell in love with it. The setting is fantastic, and worth the price of admission. Though you're just thirty minutes north of the city, you're far removed from the noise and the traffic. So many courses wind through residential areas. There are no houses out there at Paiute, hardly anything but desert."

The Wolf rests at 3,000 feet above sea level, encircled by the stark Spring Mountains. Golf balls travel a bit farther in the air at this elevation, and most players on the Wolf will

OPPOSITE:
The Spring
Mountains
provide a stark
contrast to the
vivid greens
at the Las
Vegas Paiute
Golf Resort.

wish that the course were a few thousand feet higher; it measures 7,604 yards from the back tees, making it the Silver State's longest course. No advances on the golf club technology front will bring the Wolf's 480-yard par 4s in the birdie range of the average twenty-handicapper anytime soon. The setting is desert spectacular as the fairways bend around yuccas and Joshua trees and in and out of arroyos. Gardens of mission poppies provide a sharp contrast to the earth tones of the desert floor, which in turn are a perfect counterpoint for the almost unnaturally vivid green of the fairways—a green that's enhanced by the looser water regulations in place on the reservation land. Against this, the mountains shift in color as the sun makes its way across the heavens.

Pete Dye's layout is a fitting complement to the setting. Those little Dye touches—pot bunkers, railroad ties, and the like—are here, but special care has also been taken to showcase the rugged terrain. The fairways on the Wolf are especially interesting. While forgivingly wide (if you're not on the fairway, you're in the desert, which means you're dropping or hitting again), they're contoured to the point of seeming rippled. "You never seem to have an even lie out there," Tim remarked. There tends to be a steady wind funneling through the mountains, which can mitigate or further confound the length issues. The greens are generously large, but hard and fast; shots rolled in will likely roll off. Thanks to plentiful water rations and a generous upkeep budget, the Wolf is impeccably maintained—no small feat amid these unrelenting environs.

Two holes toward the end of the track stand out in most players' minds. The first is the par 3 fifteenth, which measures 182 yards from the back tees. It's a tribute to Dye's island green seventeeth at TPC Sawgrass, except this hole has a larger green (with three tiers) and is surrounded by boulders; there's always a chance that a shot hit short will bounce *forward* onto the green, but don't count on it! The seventeenth, one of the aforementioned monster par 4s (clocking in at 486 yards from the back), demands that you steer clear of an arroyo in the middle of the fairway and then carry a second arroyo to reach the green in regulation. Most will gleefully lay up.

"In my opinion, Pete Dye is one of the most innovative architects of our time," Tim continued. "There's never a dull moment on any of his courses, and that's very true of the Wolf. The Wolf has a different feel than the other Paiute courses. Dye's personality really shines through. Every shot you take, you feel his presence. You can feel what he wants you to do as you think through what you may be able to do and what you can't do. He makes you think a lot, and makes you use every club in the bag. Though it's quite long,

DESTINATION

28

Wolf has enough tee options to make it a bit more manageable. My group played the middle set of tees. Even from there, the course beat us up pretty good, but I don't mind getting beaten up for a reason. That was how it was out there. I was challenged, but it wasn't challenge without purpose."

TIM McDONALD has been a journalist for more than twenty years, working for a variety of newspapers and as a foreign correspondent for the Associated Press. He has won many national awards for his work. In his sports writing career, Tim has covered every professional sport and was an NFL beat writer for five years, as well as a columnist. He now is National Golf Editor for TravelGolf.com, is married, and lives in Lee, Florida, on the banks of the Withlacoochee River.

If You Go

▶ **Getting There:** The Las Vegas Paiute Golf Resort is thirty minutes northwest of downtown Las Vegas, on U.S. Highway 95.

▶ **Course Information:** The Wolf Course is par 72 and measures 7,604 yards from the tourney tees. Greens fees are $129 to $195, depending on the season. Rates at the Snow Mountain and Sun Mountain courses range from $99 to $165. Since it's removed from the asphalt congestion of downtown, the environs of greater Paiute run a bit cooler in the summer, making a morning or late afternoon round conceivable. There's a pleasant nineteenth hole that offers mountain vistas and light fare as well as a cigar lounge. More information is available at 866-284-2833; www.lvpaiutegolf.com. Tee times can be made through TravelGolfVegas (800-470-4622) and Las Vegas Golf Travel (866-514-4653).

▶ **Accommodations:** While there are potential plans for a lodge at Paiute, ground has not been broken as of this writing. It's best to opt for downtown, where over a hundred thousand rooms—lodging to fit any taste—are available. The Las Vegas Visitors and Convention Authority (702-892-0711; www.lvcva.com) is one place to start. A number of operators offer golf packages, including TravelGolfVegas (800-470-4622; www.travelgolfvegas.com).

DESTINATION

28

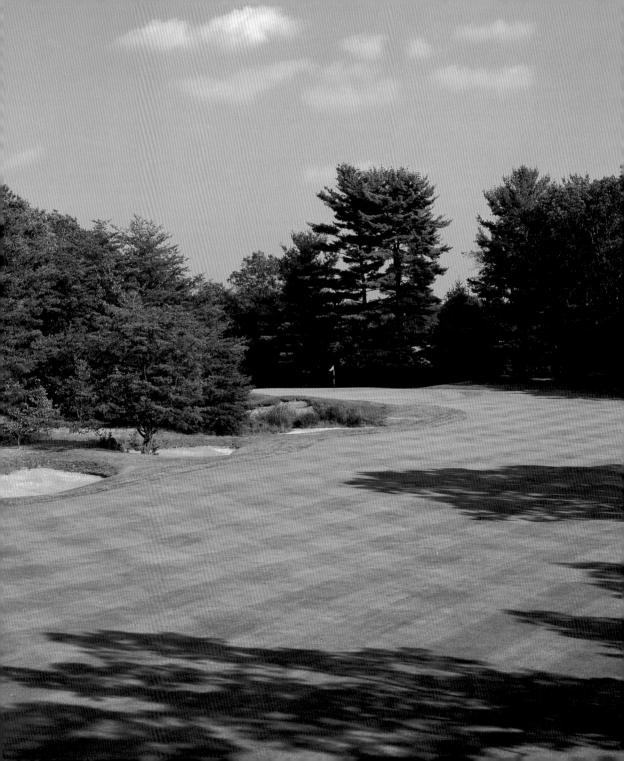

PINE VALLEY GOLF CLUB

RECOMMENDED BY **Mark King**

Pine Valley has been called many things in its nearly ninety-year history. A 184-acre bunker. A terrifying collection of death-or-glory shots. The sternest examination in target golf. For Mark King it was simply fantastic. "I've been fortunate enough to play a fair number of famous courses," Mark said. "But I've never played anything like Pine Valley. The experience is enchanting, from the moment you drive in the gate. When you think 'authentic golf,' Pine Valley should spring to mind. It's by far the most special golf course I've ever played."

The immediate surroundings of Clementon, New Jersey, do not arouse the senses in the same way as, say, the environs of Pebble Beach. Today, the suburban scrubland, dotted with the detritus of strip malls and a water-slide park, seems more at peace with an early Springsteen ballad than the kind of Wordsworthian ode that Royal County Down might have inspired. Yet the ground here spoke to George Crump, a wealthy Philadelphia hotelier who had been conscripted by his cohorts to find a site for a new golf course, as their home course in town had grown tiresome, and the course they enjoyed in Atlantic City was inconvenient for day outings. After many forays around greater Philadelphia, Crump reported the following findings to his cronies: "I think I have landed on something pretty fine. It is fourteen miles below Camden, at a stop called Sumner on the Reading R. R. to Atlantic City—a sandy soil, with rolling ground, among the Pines."

George Crump was a talented player but, like Jack Neville at Pebble Beach, had absolutely no experience designing or building golf courses. Still, his eye was dead-on. The land he eventually secured had bordered the ocean thousands of years before, and despite the trees, it was very linkslike in nature. Crump showed the site to a number of designer contemporaries and they recognized its potential. On seeing the site,

OPPOSITE:
The dogleg left twelfth hole lacks the bewildering scrub wastelands that bedevil players on many other holes.

DESTINATION

29

135

C. B. MacDonald said, "Here is one of the greatest courses—if grass will grow." MacDonald, H. S. Colt, A. W. Tillinghast, William Flynn, Hugh Wilson, and George S. Thomas, among others, conferred with Crump on Pine Valley and took or were given credit for some design decisions. But the majority of the work was done by Crump, who also financed much of the course's construction. It's been said that Crump eschewed the drafting table, preferring to determine his designs by hitting shots on the fledgling course. Pine Valley was his bailiwick, and Crump lived on the premises from 1913 until his death in 1918. Sadly, he never had the chance to play the full 18, which wasn't completed until a year after his passing.

In a world of increasingly diabolical designs, Pine Valley stands apart as a study—no, a dissertation—in punitive design. Some have said that Pine Valley has no fairways, no rough, and few bunkers in the traditional sense of the word. Rather, the course is one large hazard of sand, scrub, impenetrable woods, and creeks and ponds, with tee boxes, greens, and the occasional island of grass to provide sanctuary for the very-well-struck ball. This is something of an exaggeration, as the fairways are generously wide at times . . . though reaching them can be another matter. A story recounted in James Finegan's wonderful history of Pine Valley tells of a Philadelphia businessman trying to negotiate a steep bunker while playing with Crump in 1915. He's reputed to have said, "George, why in the name of common sense did you build these bunkers so high? If I fall off here, I'll break my neck." Crump is said to have replied, "Now you've got it. We build them so high that the dub [novice] golfers would all break their necks. This is a course for champions, and they never get into trouble." With unrelenting forced carries of up to 200 yards, waste areas like the infamous "Hell's Half Acre" across the fairway of the seventh hole (it actually exceeds an acre, and is 115 yards long), and devilishly slick and sloped greens, champions *can* get in trouble here, too.

The individual holes of Pine Valley read like a who's who of great golf holes. The opening three have been called the best opening holes in golf; the closing three have been called the best finishers. And so on and so forth. Where some courses will forgive the power hitter for occasional sprays or reward the accurate player for a lack of might, Pine Valley demands both power and precision. Nowhere is the demand for this elusive combination more evident than on the 448-yard par 4 thirteenth, one of the holes completed after Crump's death but true to his vision of architecture that requires the player to think soundly and execute solidly. At the tee, the player is faced with the first

major decision—to play safely to the right side of the fairway, thus giving up any hope of reaching the green on the approach, or to play up the left side of the fairway. Either driving option must carry the obligatory wasteland of sand and scrub that marks nearly every Pine Valley tee shot. If the player opts for the right side of the fairway, he can hit it fairly close on the next shot, pitch on, and have a two-putt for bogey—a damn good score on this hole. If one opts for the left and cracks it a healthy 250 or 260 yards, he's faced with a 190-yard play that must carry the lion's share of a 140-yard scrubland that borders the left side of the fairway and green. Death or glory, indeed.

For a scratch player like Mark King, Pine Valley held mostly glory. "It was a wonderful experience, every hole. There was just a special feeling I had when I was playing there."

MARK KING graduated from the University of Wisconsin, Green Bay, in 1981 with a bachelor's degree in business administration. He began work at Taylor Made as a territory representative, a position he held until 1986. Mark was then promoted to regional sales manager, where he worked for two years until he advanced to national merchandising manager. He held this position through 1989 and then served as vice president of sales, where he guided Taylor Made sales teams from 1990 through 1998. In 1998–99 Mark served as vice president of sales and marketing at Callaway Golf Ball Company. In the summer of 1999 Mark returned to Taylor Made to serve as president of the newly formed Taylor Made–Adidas Golf Company. He has two daughters and lives in Southern California. His hobbies include sports, speaking, and selling.

DESTINATION

29

If You Go

▶ **Getting There:** Pine Valley Golf Club is in Clementon, New Jersey, across the Delaware River and roughly fifteen miles southeast of Philadelphia.

▶ **Course Information:** Pine Valley measures 6,667 yards from the championship tees and carries a par of 70 and a slope rating of 153. It's also one of America's most exclusive courses. While guests are occasionally permitted in the company of members, no greens fees are published.

▶ **Accommodations:** Many chain motels are available in the greater Clementon area, and are highlighted at www.visitsouthjersey.com. In Philadelphia, the Rittenhouse (800-635-1042; www.rittenhousehotel) is first-rate, with rooms beginning around $350.

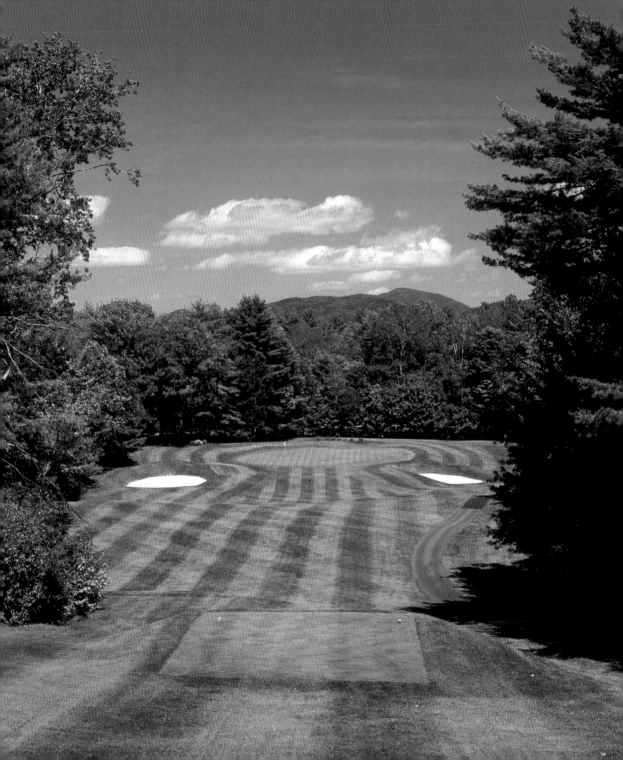

THE SAGAMORE

RECOMMENDED BY **Dennis Blake**

Up in the Adirondack Mountains of northeastern New York, there exists a certain type of resort that transports one back to an earlier, perhaps simpler, time. There's usually a grand hotel, a lake for water sports, a day camp for children, and—if you're lucky—a genteel little golf course. These resorts were the sorts of places where well-to-do families from Manhattan or Philadelphia might "summer," a verb that speaks to the general indolence and relaxation of the escape.

The Sagamore is prototypical of such resorts, resting on a small private island in Lake George, within easy striking range of the healing waters and horse racing hijinks of Saratoga Springs. What separates the Sagamore from its brethren is that instead of hosting an afterthought golf course, it's home to one of Donald Ross's great courses, a layout that's changed very little from its inception in 1928. (Some $75 million was invested in 1985 to restore the course, but architect Geoffrey Cornish worked from Ross's original blueprints.)

"My family vacationed up there for as long as I can remember, pretty much all of my life," said Dennis Blake. "The grounds of the hotel are just unbelievable. It's what I imagine the country home of some English nobility might have been like in Victorian times. My parents and my brothers all like to tee it up, and the course at Sagamore is one of our favorites."

The Sagamore course is set in the hills, a few miles away from the resort. It's routed through a thick pine forest, dotted with white birch and accented with occasional plots of heather, perhaps a nod to Ross's youth back at Royal Dornoch in Scotland. The first hole nicely sets the stage for your outing. From the elevated tee, a fairly tight fairway opens to expose the green 415 yards in the distance, with a spectacular backdrop of Lake George

OPPOSITE:
The densely
wooded Donald
Ross design at
the Sagamore is
relatively short,
but the fair-
ways are tight
and the greens
are tricky.

DESTINATION

30

and the Adirondack foothills. The Sagamore departs a bit from many of Ross's parkland layouts, as the land forced him to deal with considerable elevation changes. "There are many elevated tees at Sagamore, which you don't find on many Ross layouts," Dennis continued. "Sometimes when a course has lots of elevation changes, you can encounter some wacky holes. That's not the case at Sagamore. The holes were dropped into the landscape very elegantly. There's nothing artificial about it. Like so many other Ross courses, everything feels very natural. Each hole is pretty well sheltered from the next, so you don't see a lot of other golfers on the course. It's just you and pine trees. You're in your own world."

Like many Ross designs, Sagamore is not particularly long, and it seems rather docile in terms of hazards. Yet the trees close in more often than most players would like, and keeping the ball in play is a constant challenge. Likewise, the greens demand close inspection. "There are swales on some greens, but generally they have very subtle breaks," Dennis advised. "There aren't any Tillinghast elephants buried under the greens. When you're lining up your putt, you need to look around you. The sway of the land adjacent to the green will give you a sense of where the ball will go.

"The finishing holes at Sagamore are very fulfilling. The seventeenth is a shortish par five—around five hundred yards from the blues. It's slightly uphill, but still reachable in two for a big hitter. The challenge is, the fairway is narrow, all the way up. It's like a bowling alley, with nothing but lumber left and right. The good news is, there's lots of room to roll your approach shot on. The eighteenth is a long par four, also uphill. Eighteen has one of the biggest greens on the course, with a big hogback. There's a pretty fountain behind the hole and a stone clubhouse with a comfortable bar and great steaks. It's a nice way to end a round."

While the Sagamore golf course is worthy of more than one round, it would be a shame to limit your outdoor activities to the links. The resort offers sailing, kayaking, and windsurfing on the lake, fine tennis courts, and proximity to numerous hiking trails in Adirondack State Park. Should you overdo it on the links, the Sagamore spa offers many treatments to comfort your muscles . . . though they can't heal the slice that kept you in the woods much of the afternoon!

DENNIS BLAKE has worked around golf almost all of his life. Currently, he serves as director of public relations and pro tour for the Top-Flite and Ben Hogan Golf Company.

Before joining Top-Flite, he served as the Pro Tour representative for Callaway Golf. Dennis was assistant golf professional at Somerset Hills Country Club in Bernardsville, New Jersey, the course where he cut his teeth on golf; he also served as assistant pro at Lost Tree Golf Club in North Palm Beach, Florida. Dennis was featured in *GOLF Magazine*'s *Full Swing Handbook*; in 1993, he was the New Jersey Maxfli Junior State Champion.

If You Go

▶ **Getting There:** The Sagamore is located on Lake George in Bolton Landing, New York. Bolton Landing is roughly one hour north of Albany International Airport, which is served by many major carriers. Should you fly into greater New York City, the resort is about four hours north by car. The Sagamore can also be reached by train on Amtrak (800-872-7245; www.amtrak.com). The golf season is generally mid-April through October.

▶ **Course Information:** The Sagamore is a par 70 layout, measuring 6,821 yards from the blues. Greens fees are $105 during the week for hotel guests, $110 on weekends. Twilight rates are available and should be considered, as early evenings can be magical above the lake.

▶ **Accommodations:** The Sagamore is stately, to say the least, and provides a full range of activities for the whole family. Summer room rates begin at $389. For more information, call 800-358-3585 or visit www.thesagamore.com. Many dining options are available, ranging from the AAA Four-Diamond Trillium restaurant to Mister Brown's, a rustic pub. You can also enjoy dinner while touring the lake on *The Morgan*, a replica nineteenth-century touring vessel. "Classic Golf Getaway" packages are available mid-week through the season and include three days of golf plus two nights' accommodation. Prices start at $410 per person, based on double occupancy. Horse racing enthusiasts should note that the ponies are running at Saratoga Springs (518-584-6200) from late July through Labor Day.

DESTINATION

30

TRUMP NATIONAL GOLF CLUB

RECOMMENDED BY **Donald Trump**

When asked to recommend a favorite golf course, Donald Trump did not need to look far afield. "I have two courses in particular that I'm familiar with and find the best in the world. They are Trump International Golf Club in Palm Beach, Florida, and Trump National Golf Club in Briarcliff Manor, New York."

The Donald is not known for doing things in a halfhearted way. So when he decided to build a golf course in Westchester County, outside Manhattan, the golf community expected something big. Trump National Golf Club does not disappoint.

Trump National was constructed on 200 acres in Briarcliff Manor, on the former site of the Briar Hall Country Club—"a terrible golf course," in the opinion of then prospective architect Jim Fazio, but a site with great potential. Fazio, in a big-thinking style that must have tickled Mr. Trump, recommended that two houses across a ravine that bounded the Briar Hall property be purchased and torn down to make room for a new green and tee. In a scene right out of *The Apprentice*, Mr. Trump immediately dispatched one of his executives, Carolyn Kepcher, to make an offer on the houses, and Fazio (elder brother of fellow architect Tom Fazio) was hired. This was in 1997. Five years and $30 million later, the largest excavation project in Westchester County was completed, and Trump National opened its fairways to members in 2002. A $15 million clubhouse is slated to be completed in 2005.

Some great courses are set upon land that seemed to be made to host a golf course. Other courses are set on sites that require a bit of extra effort to give the appearance that the layout is at one with the land. Trump National would fall into the latter category. To blend the routing into the rolling terrain, architect Jim Fazio moved more than three million cubic yards of earth; for those unfamiliar with the land's past, the course appears as

OPPOSITE:
The par 3 thirteenth hole at Trump National cost $7 million to build, thanks to its 101-foot waterfall.

DESTINATION

31

143

though it's been here for generations. Several brooks (man-made) tumble through the course, which is also dotted by lakes, courtesy of Mr. Fazio. The former course was home to a number of majestic maples, and most of these were preserved in the land's reincarnation, helping to foster that old-course feel.

As you might imagine, $30 million can buy a pretty nice golf course. The steps to each tee box are hewn from sturdy blocks of granite; meticulously crafted stone walls of granite quarried from the site are scattered around the layout. Two-hundred-foot suspension bridges span ravines at several junctures in the course, perhaps inspired by one of the bridges jutting from Manhattan to the outer boroughs, bridges that can be viewed from the penthouse at Trump Towers. Trump National's large greens are fashioned after the putting surfaces at Augusta National and, when cut closely enough, could very well pass the PGA's Stimpmeter test for hosting a championship. At 7,291 yards from the blacks and with an unrelenting host of hazards that have pushed the slope rating to a dizzying 153, the course should pose enough challenges to attract a major event in the next decade.

And then there's the thirteenth hole, without a doubt the most extravagant par 3 hole ever built. Its price tag, placed at over $7 million, would buy you several golf courses in some markets, with an intact clubhouse and perhaps a few luxury homes thrown in. The hole plays 218 yards from the tips and requires a long carry over a pond to a sizable green that's cut into the hillside. What makes the thirteenth cost in the seven figures is the edifice that wraps around the back of the green: a 101-foot waterfall that cascades over a small mountain of black granite. Five thousand-plus gallons of water cycle over the falls every minute, deafening any second thoughts about the break one's putt might take.

A minimalist architect like Tom Doak might consider taking up a new vocation—or approaching the hole with dynamite in the night—when presented with the spectacle of number 13. But artifice accepted, it is indeed spectacular, and in keeping with the over-the-top showmanship the world has come to expect from Donald Trump, who is a five-handicapper and a passionate player.

When asked what features he would include if he were to build a course to complement his game, Mr. Trump replied, "I would only build spectacular water hazards, because that would be worth the price, as I always find myself in them."

DONALD J. TRUMP is the very definition of the American success story, continually setting the standards of excellence while expanding his interests in real estate, gaming, sports, and entertainment. He is the archetypal businessman—a deal maker without peer and an ardent philanthropist. Mr. Trump's portfolio of properties include Trump Tower, Trump Parc, Trump Palace, Trump Plaza, the Trump World Tower, Trump Park Avenue, Trump International Hotel and Tower, Trump World Tower (all in New York), the Trump Plaza Hotel and Casino on the Boardwalk, the Trump Marina Casino Resort in the Marina District, and the Trump Taj Mahal Casino Resort (all in Atlantic City). Donald Trump owns several golf courses, including the National Golf Club in Westchester County and the Trump International Golf Club in Palm Beach, Florida; new courses are under development in Los Angeles and Bedminster, New Jersey. He has also published seven books, including *Trump: Think Like a Billionaire*, and is the star and producer of the popular television program *The Apprentice*.

If You Go

▶ **Getting There:** On a good traffic day, Trump National in Briarcliff Manor is within half an hour of downtown Manhattan, just off the Taconic Parkway. It's also a short cab ride from the Scarborough stop on the Metro-North train line along the Hudson River, via Grand Central Station.

▶ **Course Information:** Trump National plays 7,291 yards from the blacks and has a slope rating of 153. At the time of this writing, there are some memberships left, at a price tag in the neighborhood of $300,000. For more information, call 914-944-0900 or visit www.trumpnational.com. If you're not ready to join but have a well-placed friend who can get you out on the course, you might encounter celebrities like Jack Nicholson and Clint Eastwood or politicos like Bill Clinton, all of whom are members.

▶ **Accommodations:** The Trump International Hotel and Tower (888-448-7867; www.trumpintl.com) is situated on Central Park West, offering easy access to all the Big Apple has to offer. Rooms begin in the vicinity of $450. If you're looking to escape the city for a few days, consider one of greater Westchester's many bed and breakfasts at the Historic Hudson Valley Web site (http://www.hudsonvalley.org/web/plan-hote.html).

DESTINATION

31

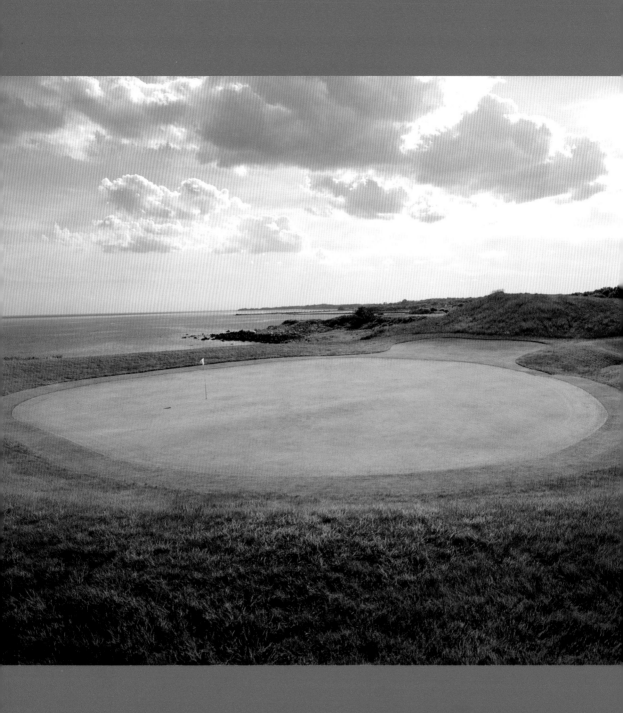

FISHERS ISLAND CLUB

RECOMMENDED BY **Mike Keiser**

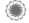

Mike Keiser has some definite opinions about modern golf course architecture. "For the last fifty years, designers have focused on building bomb-busters," Mike said. "There's something that they've either overlooked or ignored. For many players, they just aren't much fun to play." Mike has a decided preference for classic designs, and one that recently made a strong impression is the Fishers Island Club.

Fishers Island lies at the outer edges of Long Island Sound, southwest of Montauk. Though only two miles off the coast of New London, Connecticut, Fishers is part of New York; its ownership had been contested through the 1800s but was finally determined once and for all in 1879. Despite the island's territorial affiliation, the approximately three hundred year-round residents tend to associate themselves more closely with Connecticut; it's uncertain how well they identify with the extremely affluent who call the island their summer home. The island setting is wonderfully exploited by the course. "There's an ocean view on all eighteen holes, from the tee and the green," Mike recalled. "The tourist in you loves that." Indeed, the vistas of the rocky New England shoreline, of spinnakers billowing as sailors tack toward the open sea, can at times distract from Fishers's elegant design.

The Fisher's Island Club is the work of Seth Raynor, a man who had no training in golf course architecture, never traveled to Scotland to see the work of the old masters, and by all reports had little interest in playing golf. Raynor was working as a surveyor in the Long Island town of Southampton in 1908 when he was retained by America's first great golf course architect, Charles Blair Macdonald, to help with a little project called the National Golf Links of America. Raynor proved an eager and accomplished apprentice, and his collaboration with Macdonald would last until Raynor's death in 1926, a year

OPPOSITE:
Fishers Island's
famed fourth
hole, dubbed
"Punchbowl,"
requires a blind
second shot
over a large
hummock.

DESTINATION

32

147

before Fishers Island Club opened. (His grave and Macdonald's lie a few yards apart in Southampton, home of the National.) Like Macdonald, who'd spent a great deal of time in Scotland, Raynor was inclined to adapt classic holes from the great British links, though he was imagining them through Macdonald's gaze. Simulacra of the Redan (fifteenth at North Berwick), the Alps (seventeenth at Prestwick), the Road Hole (seventeenth at St. Andrews), and the High Hole (eleventh at St. Andrews) are present on all of his layouts.

Raynor had the opportunity to work on several seaside sites, but Fishers Island was unquestionably the most dramatic. The privileged few who play the course concur that he made the most of it. Twelve holes are routed along the rocky coastline. In fact, the constant backdrop of blue—and, in some cases, the Connecticut shore—make gauging the distance for approach shots especially challenging. The regular presence of a healthy breeze off the Atlantic further confounds club selection. Many of the pushed-up greens slope precipitously off the sides and the back; if one is to miss, better to miss short. While the greens are firm and can be tricky to hold, there's almost always a fair path to the putting surface, though players will have to approach from the correct angle.

There are a number of wonderful holes at Fishers Island. The par 3 second, a 170-yard Redan hole, is one standout; a Redan hole is characterized by a green that is fortified with long bunkers in front, is wider than it is deep, and angles diagonally away from the tee box, sloping front-to-back and right-to-left. The Fishers Island Redan is fronted by a pond to punish overambitious club selection. The par 3 fifth, a 225-yard Biarritz hole, bordered by unsavory bunkers, is also a gem; "Biarritz" alludes to greens with a deep gully bisecting the middle, a popular feature at Willie Dunn's Biarritz Golf Club in France. Most visitors, however, would place the fourth hole, dubbed the Punchbowl, at the top of their Fishers Island list.

From the tee at the 397-yard Punchbowl, one can see the faint outline of a tall stake that rests to the right of the fairway, with the blue of the Long Island Sound in the distance. Players should take note of this stake, as it will soon come into play. Your tee shot must carry to a plateau fairway, where a steep mound stands between you and the green, obscuring any vision of the putting surface. Assuming you've reached the fairway, you'll take aim at the stake with—well, depending on the wind, it could be with anything from a short-iron to a five-wood. (This approach shot is actually Raynor's gesture to the Alps hole at Prestwick.) Your heart is filled with hope and fear as you reach the crest of the

mound to see where you lie. Even if your ball is nowhere in sight, the sudden appearance of the green that juts into the sound provides a moment of exhilaration. "It's great fun to reach the top to find where you're at, and to ring the bell at the green to let golfers behind know that you're finished," Mike recalled. "It's a great throwback kind of hole." Even if you're on in two, the fun is just beginning. The namesake Punchbowl green is 12,000 square feet, providing ample opportunity for putting frustration.

"Courses like Fishers Island inspired me to try and create minimalist courses that are true to classic design concepts," Mike continued. "When I started, I had no idea whether there would be enough people interested in such courses to sustain them. Apparently, there are."

MIKE KEISER started Recycled Paper Greetings with his college roommate from a small, two-bedroom bungalow apartment in Chicago shortly after graduating from Amherst College. Today, RPG is the industry leader in alternative cards and has set new standards in retailer service and card design. Mike diversified from the greeting card business in 1988 to devote time to golf course development, adhering to his minimalist philosophies. One of his resorts, Bandon Dunes in southern Oregon, is considered among the finest 54-hole assortments in the world. His most recent golf course development is Barnbougle Dunes, on the northeastern coast of Tasmania.

If You Go

▶ **Getting There:** Fishers Island is best reached via ferry from New London, Connecticut. The Fishers Island Ferry (860-442-0165; www.fiferry.com) provides regular service.
▶ **Course Information:** Fishers Island Club (www.fishersislandclub.com) plays to a par 72 and measures 6,566 yards from the back tees. It is very private, but guests are allowed on the course with a member from Memorial Day to Labor Day. Should you get the opportunity, greens fees are a bargain at $50.
▶ **Accommodations:** Roughly 80 percent of Fishers Island is private, and there are no inns or hotels on the island. You'll probably want to stay in the greater New London, Connecticut, area. The Queen Anne Inn (800-347-8818; www.queen-anne.com) is a pleasant option, but the area abounds in quaint inns; contact Bed and Breakfasts of the Mystic Coast (877-699-8579; www.thebbmc.com) for more information.

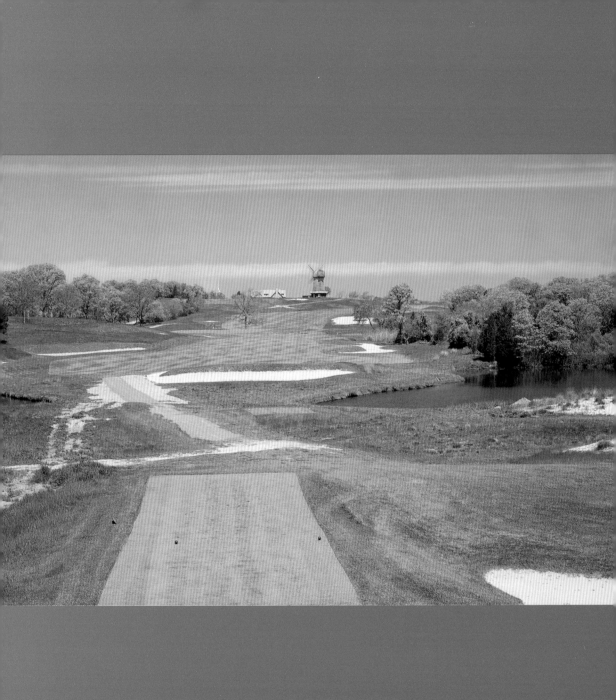

NATIONAL GOLF LINKS OF AMERICA

RECOMMENDED BY **Tom Doak**

✦✛✦

Some years after the creation of the National Golf Links of America, Charles Blair Macdonald declared the project a success: "The National has now fulfilled its mission, having caused the reconstruction of all the best known golf courses existing in the first decade of this century in the United States, and, further, has caused the study of golf architecture resulting in the building of numerous meritorious courses of great interest throughout the country." Immodest, perhaps. But for true connoisseurs of the art of golf course design, Macdonald's summation is 100 percent on target.

"The National Golf Links is where golf course architecture truly got started in America," said Tom Doak. "The project, at its conception, was to build the best eighteen holes in the country. Some holes are copies of Macdonald's favorite holes from other courses, famed layouts in Scotland. The holes he created are not complete replicas— they're adapted to the rolling terrain of the National. They go far beyond replication to stand on their own as timeless, classic holes."

C. B. Macdonald was a great student of the game of golf. Reared in Chicago, he attended St. Andrews University in Scotland in the early 1870s, where he befriended Old Tom Morris. Under Morris's tutelage, Macdonald developed into a fine player (in 1895 he would become the first amateur champion back home). Macdonald designed the first 18-hole course in America in 1893, the original Chicago Golf Club, and after coining the term "golf architect" in 1901, he began making notes for what he deemed "the ideal course." Much tromping about Long Island in search of a site with sandy soil and an absence of trees eventually exposed a 250-acre plot near Southampton along Peconic Bay. Like Donald Ross at Pinehurst Number Two, Macdonald was never completely happy with his masterpiece and tinkered with the National Golf Links until his death.

DESTINATION

33

OPPOSITE: The iconic windmill at National Golf Links was requested by a member, who C. B. Macdonald billed for the added expense.

Tom Doak has spent a good deal of time walking the National, learning to appreciate its subtle wonders. "I grew up across the Long Island Sound in Connecticut," Tom continued. "I used to go out there in the fall. The staff didn't care if I wandered around after September. The course is beautiful in the fall. There aren't many trees, but the bushes have lots of color. For me, part of the appeal of the National is its rich history. But it's also a beautiful seaside setting, and there are lots of great golf holes there."

Until the National was created in 1911, American courses were rudimentary at best. Macdonald changed all that, bringing strategy squarely into the game. Take the par 4 420-yard eighth hole, styled after Willie Parks's twelfth hole at Sunningdale (Old Course). Bunkers angle across a section of the fairway, beginning on the left and ending in the center, leaving a split fairway. Shorter hitters can avoid the bunker by laying up along the right side, though they'll face a longer second shot over some menacing green-side traps. Stronger players can risk playing over the bunkers on the left and will be rewarded with a clearer shot to the green. Macdonald had great insight into his playing public, and he strived to design for them, not against them. He once said, "I try not to make the course any harder, but to make it more interesting, never forgetting that 80 percent of the members at any club cannot on average drive more than 175 yards. So I always study a way to give them their way out by taking a course such as a yachtsman does against an adverse wind, by tacking."

There are no weak holes at the National, but there are a few so well conceived that they stand out above the rest. One is the 197-yard par 3 fourth, "one of the greatest par threes in the world," in Tom's opinion. This is Macdonald's first Redan hole, based on the fifteenth hole on the West Links at Scotland's North Berwick links. In *The World's 500 Greatest Golf Holes*, Brian McCallen explains that the term "Redan" is "derived from a fortification fronted by long deep trenches, which was assaulted by the British during the Crimean War." True to the risk/reward credo, players have the option of bailing out with their tee shot to the right, then pitching on for a chance at a two-putt bogey. More adventurous or gifted players can gun for the pin, damning the torpedoes that lurk in the long, deep bunker that guards the front of the green, though if they overgun there's a ten-foot-deep bunker waiting to swallow their ball on the other side. On sunny days, Peconic Bay shimmers in the distance, indifferent to the putts that slide haplessly by the hole on this considerably pitched green.

The 368-yard par 4 seventeenth is another favorite of regulars at the National.

The National's iconic windmill is on display to the left of the tee; the story goes that a member wanted a windmill built and that Macdonald said, "Fine," built it, and proceeded to bill that member for the added cost. A wide expanse of fairway is visible from the tee, though a small desert of sand must be carried to reach it. One must make decisions—should you/can you carry the bunkers on the left to gain the best perspective of the green? Or should you favor the right and its shorter carry, and hazard the blind second shot over a bunker-riddled mound? Is the wind your friend or foe? The National will not tell you; you'll have to look into your heart and fathom this for yourself.

"I've had a half dozen designers who have worked for me over the years," Tom reflected. "Once I 've taken them there to play, every one of them has come away saying that the National is their favorite course."

TOM DOAK graduated from Cornell University and took off for Scotland, where he spent a summer caddying at St. Andrews. He then traveled the next seven months, playing and studying every course of note in the U.K. and Ireland. He discovered a challenging, natural outdoor sport played by people of all ages, on exciting courses, which had cost nothing to build and which were affordable for all to play. When he returned to America he set out to build courses that reflect the ideals of the game as the Scots still play it. After three years working on construction projects for Pete Dye, he had the opportunity to create his first solo design, and he hasn't looked back. Among Tom Doak's most noteworthy designs are Pacific Dunes in Oregon, and Cape Kidnappers in New Zealand.

If You Go

▶ **Getting There:** Southampton, New York, an elite retreat on Long Island immortalized in F. Scott Fitzgerald's *The Great Gatsby*, is two hours from Manhattan by car or by train, via the Long Island Rail Road (www.mta.nyc.ny.us/lirr/).

▶ **Course Information:** The par 73 National Golf Links of America plays 6,873 yards from the back tees, with a slope rating of 141. A very private course, the National does permit guests in the company of members, at a fee of $175.

▶ **Accommodations:** Southampton thrives on visitors and you'll find a large selection of quaint inns and bed and breakfasts here and in the neighboring burgs of East Hampton and Bridgehampton. Many of them are listed at www.southamptonchamber.com.

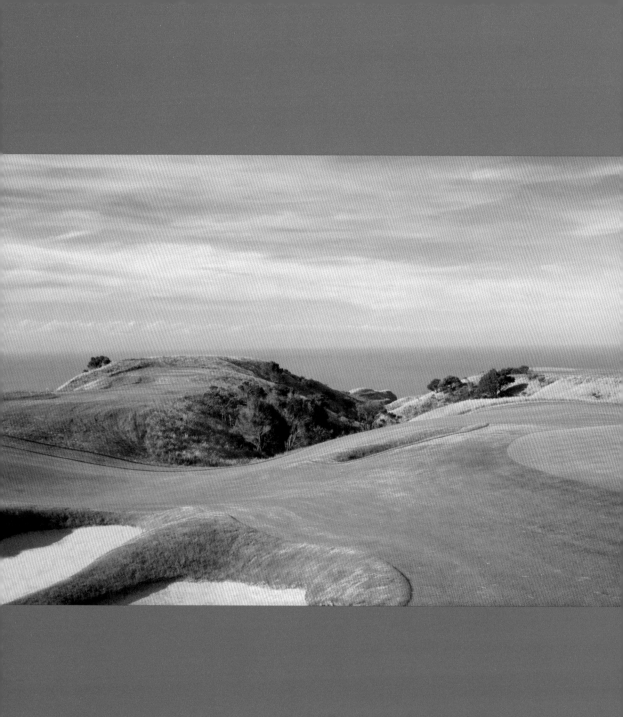

CAPE KIDNAPPERS

RECOMMENDED BY **Eamon Lynch**

�֎

A few years back, hedge fund magnate Julian Robertson was visiting Bandon, Oregon, where he hoped to play a few rounds on the renowned Bandon Dunes course. On the second day of his visit, he was bumped from Bandon to play Pacific Dunes. The story goes that Mr. Robertson was not very happy about the change in venues, as he hadn't traveled across country to play this upstart course. By the end of his round, however, he'd set his heart on having Pacific's creator—Tom Doak—fashion his second course in New Zealand, Cape Kidnappers.

Cape Kidnappers is perched high above the crashing waves of Hawke's Bay, on the central eastern coast of New Zealand's north island, near the towns of Napier and Hastings. The region was first seen by Western eyes in 1770, when Captain James Cook reached these shores in his ship, the *Endeavor*. Cook named the spit of land after an incident when some resident Maoris, who had canoed out to the ship to trade some goods, attempted to kidnap his Tahitian guide and translator. Eamon Lynch was one of the first writers to witness the grandeur of golf at Cape Kidnappers, when he joined Tom Doak on site in late 2003. "The setting might be the most spectacular I've seen for a golf course. The road from the two-lane highway to the course twists and turns skyward for five miles, and only when you reach the pinnacle do you have a real sense of how high you've climbed.

"What I recall most—other than the course itself—was a drive Tom Doak and I took for a couple of miles across the property. Toward the sea is New Zealand's largest gannet colony. Looking away from the sea you get a rugged, heaving landscape with pockets of sheep scattered around for as far as the eye could see. Only then did I appreciate what a five-thousand-acre sheep ranch in New Zealand is really like. On a site like this it's easy

OPPOSITE:
Cape Kidnap-
pers is the
second truly
great golf
course created
on the north
island of
New Zealand
by Julian
Robertson.

DESTINATION

34

155

for the window dressing to spoil the view, but everything here is so understated that the course and the terrain remain the prime attraction. This place is about golf the way Bali is about beaches."

Cape Kidnappers is anchored around seven fingers of land that extend down from the clifftop and hang over Hawke's Bay. "The course is very Doak in that you really have no sense that a convoy of bulldozers came in here to build it," Eamon added. "If you look closely to either side of the ninth fairway you'll see that quite a bit of dirt was moved to fill in a mini gorge, atop which the fairway now sits. Otherwise, every hole seems very much at peace with the property." With every hole providing an ocean view, Cape Kidnappers indeed rests upon a prime property. And the country around Napier, the heart of one of New Zealand's emerging winemaking regions, is a spectacular place to visit. The climate is more Mediterranean than Middle-Earth, and in addition to viewing the gannet colony, visitors can wander peaceful beaches, swim with dolphins, and bask in the warmth and cheer of New Zealand's people.

There are a number of wonderful holes at Cape Kidnappers, holes that are destined to grace golf calendars and remain for many years after with those lucky enough to make this trek. Two especially stand out for Eamon Lynch, beginning with the 594-yard par 5 fifteenth, which is aptly named "Pirate's Plank." "From the fairway, the hole seems to drop off the end of the earth. If Galileo were standing here, he might reconsider whether in fact it is possible to fall off the side of the world. If your approach shot leaks left, you'd better hope you find the bunker there. Otherwise it's a hell of a lob shot from the beach four hundred feet down." In his notes for the course, Doak points out that if you do pull your approach shot, your ball will have nearly ten seconds of hang time before it reaches the ocean below.

Another standout hole is the 206-yard par 3 sixth. "I recall walking across a wooden bridge from the tee toward the green," Eamon said. "I looked down and it was a sheer, white-knuckle drop into a ravine that would be the ultimate unplayable lie. Again, this is a classic Doak design characteristic. You always get the sense that you're playing a course that doesn't have a manufactured minimalism, that the character of the property was not compromised in building the course."

During his visit to Cape Kidnappers, Eamon was given a special window to the crafts-manship of a modern master. "We were on the front nine, playing up on the seventh hole. Doak played a nice shot from a greenside bunker, using the slope of the green to

run the ball around to the pin. When I complimented him on it, he grinned, dropped another ball in the same bunker, then played out on a more aggressive line directly at the pin. The ball followed the slope all the way back into the same bunker. Standing on the green, it looked sloped, but nothing as crazy as that. I thought it was pretty neat to see the architect demonstrate the near hidden tricks to the course. It's a bit like having da Vinci show you an intentional but near invisible pimple on the *Mona Lisa*."

EAMON LYNCH is an editor at *GOLF Magazine*. Previously a staff writer at the New York *Daily News*, he has contributed to a wide range of publications, including *Sports Illustrated, TV Guide, Travel + Leisure Golf,* and *Maximum Golf (RIP)*. Eamon was born in Northern Ireland, graduated from the Queens University of Belfast, and now lives in Manhattan.

If You Go

▶ **Getting There:** Most visitors will reach Hawke's Bay by air. Air New Zealand (+64 9 357 3000; www.airnewzealand.com) operates a number of regularly scheduled flights daily from Auckland and Wellington to Napier, as well as service from Los Angeles and San Francisco to Auckland. Representatives from Cape Kidnappers will meet your flight upon request.

▶ **Course Information:** Cape Kidnappers plays 7,137 yards from the back tees and has a par of 71. Greens fees in the high season (October 1–April 30) are $400 NZ, which at press time equates to $285 in U.S. currency; in the low season (May 1–September 30), they are $300 NZ (or $215).

▶ **Accommodations:** Hawke's Bay Wine Country is a popular getaway region for Kiwis, with a hospitably sunny climate and a host of outdoor recreation options, from surfing to trout fishing. It has also emerged as one of the three major winemaking regions in New Zealand. Hawke's Bay is definitely the kind of place where one can take a nongolfing companion and hear few recriminations! The Cape Kidnappers Web site (www.capekidnappers.com) and the Hawke's Bay Wine Country Web site (www.hawkes baynz.com) list a wide range of local accommodations, some of which are situated on the grounds of local wineries. Birders, of course, will certainly wish to leave a day to visit the gannet colony near the golf course.

DESTINATION

34

SEDGEFIELD COUNTRY CLUB

RECOMMENDED BY **Jim Baker**

For most of us, the experience of a great golf course is shaped by what we take in with our eyes; the vistas of sea or mountain scapes; the framing of a hole by ancient cypress or gaping bunkers; the play of green against golden prairie grasses.

The visual splendors of a golf course are beyond the reach of nonsighted players. Yet the blind or visually impaired golfer's appreciation for the game—and the competitive urge many golfers share—is not affected in the least by a lack of eyesight, as evidenced in conversation with Jim Baker, president of the United States Blind Golf Association. "If you play well on a course, you like it," Jim said. "I'd have to say that Sedgefield Country Club is one of my favorite venues, as that was where I won the United States Blind Golf Association National Championship in 2001."

Situated in North Carolina's piedmont region in Greensboro, Sedgefield Country Club is a classic Donald Ross design, and it stands as one of the most historic clubs in the state. The site was initially part of a 4,000-acre hunting preserve. In 1923 the land changed hands, and thanks to the golf ambitions of a local businessman named A. W. McAlister, the club was born, with Ross completing construction in the fall of 1925. For forty years, Sedgefield co-hosted or hosted the Greater Greensboro Open. "I think the Open went away simply because the course became too short to host a professional event, given the new equipment advances," Jim offered.

"Older courses like Sedgefield intrigue me. Back in the twenties, they didn't have sophisticated earth-moving equipment. The result was that you got a course that really reflected the topography of the site. When you're blind, you really feel the hills. Sedgefield has lots of roll in the fairways, and there aren't many level lies on the course. Unlevel lies make it tough for anyone to get his balance on and make a good swing.

I think it's especially tough for blind golfers. On the flip side, I think that blind players have an advantage if it's necessary to hit over a hazard. I don't focus on the hazard. I just try to hit the ball the appropriate distance, whatever my coach suggests. I just want to hit it straight, wherever we decide to hit it."

How, one might ask, does a blind person play golf? Having walked a round with Jim, I can say that it's simply not much different than the manner in which a sighted person plays—and this is an amazing thing. The blind golfer has a coach, who acts largely as a caddie—though in addition to sizing up distances and selecting clubs, the coach sets the player's line for the shot and helps the player address the ball. Naturally, the coach tracks the ball in its flight. Once on the green, the coach paces off the distance of the putt and gives the player a line, then places the putter head behind the ball. In the course of the round I walked with him, Jim hit a drive 230 yards, duffed a chip or two, put an eight-iron on the green on a par 3, clearing a pond in the process, and generally two-putted. He could tell before I could when he hadn't hit a shot cleanly, chided his coach (his brother Mike) for misreading the break on one green, cursed after a chunked shot, and knocked back a few beers in the clubhouse after paying off his debt for some friendly bets with the other twosome.

In short, it was just another round of golf.

"I went blind in 1986 and didn't play for a while," Jim said. "I was a nine-handicap player before I lost my sight. Then I heard about the United States Blind Golf Association, and got back into it. There are different divisions for golfers with different levels of sight—two for those who are visually impaired and one for totally blind players. I would say that a majority of our members had played golf when they were sighted. Some of the better blind players shoot in the low nineties, or low hundreds. I'm a twenty-eight handicap now. One of the biggest challenges I face is coordinating schedules with the fellows who coach for me. Sometimes it's tough to find time for one player to practice. A blind golfer needs to find time for two.

"We have the United States Blind Golf Association National Championship once a year," Jim continued. "We usually have thirty-five or forty players who participate. The venue shifts from year to year. In 2001, the folks at Sedgefield invited us over. The format in the tournament is thirty-six holes of stroke play. On the first day, I shot 101; the next closest competitor had a 107. The next day I shot 105, and the second place guy shot 104. I finished with a bogey and par, which was a nice way to go out."

JIM BAKER has worked in Nashville as a bank recruiter since 1987. Originally a Seattle resident, Jim graduated from the Ohio State University Dental School in 1984 and practiced dentistry in Ohio before going blind in 1986. In 1991 Jim took up the game again and now plays to a twenty-eight handicap while participating in the United States Blind Golf Association (www.blindgolf.com) sanctioned tournaments. The victory at Sedgefield (with coach Kyle Seeley) was Jim's first championship victory; in September 2003, Jim and Kyle finished second in the Totally Blind (B1) Division of the USBGA National Championship held in Portland, Oregon, with a 36-hole score of 197. In January 2000 Jim helped start and continues to head up a Blind and Vision Impaired Golf Program involving students from the Tennessee School for the Blind and some adults from the Nashville area. He became president of the USBGA in September 2002 after serving on the USBGA board of directors for seven years. You can find him practicing and playing golf throughout Nashville, but primarily at the Springhouse Golf Club, which is associated with the Opryland Hotel.

If You Go

▶ **Getting There:** Sedgefield Country Club is in Greensboro, North Carolina, in the heart of the piedmont region. Piedmont-Triad International Airport is served by most major carriers, including Delta (800-221-1212; www.delta.com) and U.S. Airways (800-428-4322; www.usairways.com).

▶ **Course Information:** Par 71 Sedgefield Country Club measures 6,737 yards from the back tees and plays to a slope rating of 130. The course is private but has reciprocal agreements with several clubs. Greens fees for guests are $40 for an accompanied guest, $75 for an unaccompanied guest.

▶ **Accommodations:** Greensboro Area Convention and Visitors Bureau (800-344-2282; www.greensboronc.org) lists a wide range of lodging options.

DESTINATION

35

PINEHURST NUMBER ONE

RECOMMENDED BY **Jaime Diaz**

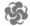

One can make the case that Pinehurst Resort in the Sandhills region of North Carolina is the original home of golf in America. Many make the pilgrimage to Pinehurst to pay homage to the courses here. "I grew up in San Francisco, playing a little course called Lincoln Park with my dad," Jaime Diaz recalled. "It's a unique place, right in the middle of a San Francisco neighborhood, with terrific views of the Golden Gate Bridge. It's a very short, intimate little course. I think that the attachment I have to Lincoln has fostered a fondness for other courses that give me that similar intimate feeling. That was what I found out at Pinehurst Number One."

Pinehurst was the dream of James Walker Tufts, a wealthy Bostonian who saw the mild climate, sandy, well-drained soil, and pine-scented air of eastern Carolina as a healthy antithesis to New England winters. Tufts purchased 5,500 acres of land—considered of little value by local farmers—for a dollar an acre and hired landscape architect Frederick Law Olmsted (of New York's Central Park fame) to design a village. The town Olmsted laid out stands mostly intact today. Golf came to Pinehurst in 1897, when Tufts and Dr. D. Leroy Culver, an amateur architect from New York, laid out the first 9 holes of Pinehurst Number One—at first just 2,561 yards. The course had sand greens and was described by the *Pinehurst Outlook* in 1898 as "60 acres of thoroughly cleared land, well fenced in and covered with a thick growth of rye, which will be kept short by a flock of more than 100 sheep." In 1899, the course was expanded to 18 holes and 5,203 yards.

Golf was still in its infancy in the United States, and most courses were situated in northern climes. Pinehurst Number One's layout—and the general absence of snow in the eastern Carolinas—attracted golf aficionados from the north, including John D. Rockefeller and President William McKinley. When English golf legend Harry Vardon

conducted a series of golf demonstrations at Number One in 1900, Pinehurst was on its way to being on the world golf map.

Then when James Walker Tufts convinced Scotsman Donald Ross to leave his first American gig in Boston and set up shop at Pinehurst that same year, the resort's future preeminence was assured.

Ross came to the New World with a stellar links pedigree. He had grown up playing Royal Dornoch and, having cultivated an interest in the finer points of the game, apprenticed for a time with Old Tom Morris. At St. Andrews he learned a good deal about club making, greens keeping, and golf course design. After a stint at greenkeeping back at Royal Dornoch and a brief stop in Boston at Oakley Country Club, Ross was lured to Pinehurst, which must have been reminiscent of his Dornoch home. A fine player, Ross briefly held the course record at the original Pinehurst Number One with a score of 71; later he would redesign the course, sculpt three more courses at Pinehurst, and design or remodel nearly four hundred more around the eastern United States, including Seminole and Oakland Hills. Creating so many course designs made it unfeasible for Ross to spend much time on the ground; indeed, many of his designs were created after only one or two visits to a site, and a few with no visits at all. Yet despite a lack of familiarity with the details of the land at a given site, his designs showed incredible attention to detail. Ross's architectural ethos is felt nearly everywhere golf is played in America, but his soul hovers close to Pinehurst, where he lived and worked in a cottage behind the third hole at Number Two.

Pinehurst Number Two was clearly closest to Donald Ross's heart, yet Number One was no forgotten stepchild. After his initial efforts reworking the back nine, he implemented changes on the front and made further changes to the course in 1913, 1937, 1940, and finally in 1946, shortly before his death. The simple yet strategic philosophy that marked Ross's later design work is very much in evidence on Number One, which is all the more remarkable when one considers that this was for all intents and purposes his first design. Recalling his Scottish heritage, Ross made liberal use of bunkers, both across the fairway and around the green. While players are often allowed a safe path to the green, they are generally punished for an overly aggressive approach. Writer and golf course architect Daniel Bucko has written of Ross designs that "better players find it hard to score on his courses while the rest of us can just enjoy the wonderful straightforward golf." This is certainly true of Number One.

"Pinehurst Number One is short and manageable, but it still very much has the character of Pinehurst around it," Jaime said. "Many of America's early golf greats played there. In this respect, it's our version of St. Andrews. And because it's more manageable, it's something you can play with your wife, or your dad, or a friend who's not quite as skilled. Number One is kinder to players who can't hit as far. That's not to say it's easy, but it's certainly more friendly than Number Two. It makes my dad feel good to play there, because he can still make many of the greens in regulation. A hole like the seventeenth, a short uphill par five, is like a parting gift, because it's fairly easy for players to make par—or even birdie.

"Moments on an intimate course like Lincoln Park or Pinehurst Number One draw you closer to the person you're with," Jaime continued. "There are moments when you feel like you own them; it's like, 'I'm taking over this little course.'"

It's a good feeling.

JAIME DIAZ has covered golf for *Sports Illustrated* and the *New York Times* and, currently, for *Golf Digest* and *Golf World* magazines. Jaime's books include *An Enduring Passion: The Legends and Lore of Golf* and *Hallowed Ground: Golf's Greatest Places.*

If You Go

▶ **Getting There:** The Pinehurst Resort is seventy-five miles from the Raleigh/Durham International Airport, eighty-seven miles from the Piedmont Triad International Airport, and a hundred and twelve miles from the Charlotte International Airport.

▶ **Course Information:** Par 70 Pinehurst Number One is modest in length, measuring 6,128 yards from the blues, with a slope rating of 116. Several golf packages are available. The Donald Ross Package entitles you to one round of golf per day, accommodations, dinner, and breakfasts (two-night minimum); rates begin at $299 per night/per person (based on double occupancy) in the winter, and $478 in the spring and fall. For more information and reservations, call 800-ITS-GOLF or visit www.pinehurst.com.

▶ **Accommodations:** There are three primary residences on the property—the Four-Diamond, Holly, and Carolina hotels, and the slightly more everyman lodge, the Manor.

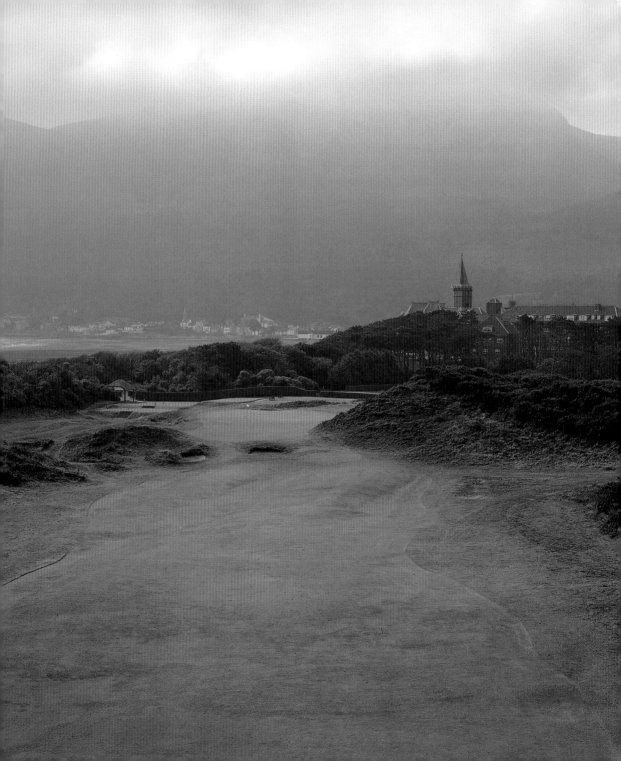

ROYAL COUNTY DOWN

RECOMMENDED BY **Damian Pascuzzo**

Old Tom Morris—greenskeeper, club maker, golf champion—was a busy man. Between all his other activities centered around St. Andrews and the Old Course, he managed to contribute to the design of some thirty links golf courses in Scotland, England, and Ireland, including Muirfield, Carnoustie, Prestwick, Royal Dornoch, Lahinch . . . and what some consider to be his finest piece of work, Royal County Down. Minutes from the 1889 meeting of the nascent Royal County Down Golf Club show that Mr. Morris was to be awarding no more than £6.50 sterling for his efforts. Most agree that the club got a decent bargain; even Old Tom may have felt good about this engagement, as he generally was not paid more than five pounds for his services. The course was modified a few times over the years, first by George Combe during his oversight of the course in the early 1900s, then by H. S. Colt in the 1920s. Though changed, the track still summons the spirit of its creator.

Royal County Down rests thirty miles south of Belfast, in the hulking shadow of the Mountains of Mourne and abutting the shores of Dundrum Bay. Though close to Northern Ireland's largest city, the course affords a sense of isolation and is considered one of the world's most beautiful and challenging venues. Bernard Darwin, the father of golf-course writing, said this of Royal County Down: "I now say that I have seen nothing finer, either as a test of the game or from the point of scenic splendor." A contemporary golf writer, Joel Zuckerman, referred to Royal County Down as "a green and golden moonscape. It's something otherworldly, with massive gorse covered hills in different hues of indigo and dark green, with terrifying blind tee shots and gaping acreage of sand."

OPPOSITE:
Framed by the Mountains of Mourne and the Slieve Donard Hotel, the par 4 ninth at Royal County Down is one of golf's most picturesque holes.

DESTINATION

37

Damian Pascuzzo came upon Royal County Down in 1999 on a trip with his colleagues from the American Society of Golf Course Architects. "Traditionally, we meet every year somewhere in the United States to play and compare notes. Every five years, we go to England, Scotland, or Ireland for a week. I think that seeing these wonderful courses provides great food for thought—even inspiration—for most of us. The day we played Royal County Down the weather was just spectacular, though being on the Irish Sea, that's certainly not always the case. That day, the dunes seemed monolithic, the fairways seemed large-scale—everything had a sense of grandeur. The absence of housing is also noteworthy. The whole links had the feel of a public green."

There are several characteristics that distinguish Royal County Down. First, there are a number of blind tee shots and several blind approaches. In these cases, the path to safety is shown by small white rocks set out before the tee box. A second prominent characteristic is the course's abundance of bunkers, 129 to be exact; many are adorned with a fringe of heather and marram grasses, which adds a beauty that belies the hazard's ill portent. Last, there's the gorse and the deep fescue rough. One always wishes to keep it in the fairway, but at Royal County Down, one *really* wants to keep it in the fairway; though stunning to behold when in its bright yellow bloom, the gorse is not your friend.

The course is set in two loops of 9 that return to the clubhouse. The first 3 holes head northward out along the beach, which is blocked from view by a series of dunes. After a benign par 5 come two long par 4s. If the wind is up, even a strong player hitting wood-wood will be hard-pressed to reach these greens in regulation; this is not a flag-ruffling wind but a bend-the-flagpole-in-a-ninety-degree-angle kind of wind. Thanks to the breeze and the hard turf that provides a great deal of roll, players will often do well to keep the ball low for bump-and-run approaches. For those comfortable with a land game, there's almost always a path to the green.

Royal County Down's most famous hole is the ninth, a monstrous 486-yard par 4. Your tee shot is played along the line of the aforementioned white rocks, over a heather-covered hill. As Brian McCallen has put it, "The view from the hill's summit is the reason golfers carry clubs to Newcastle. Beyond the attractive white clubhouse is the red brick steeple of the Slieve Donard Hotel. Backdropping the rooftops of town are the Mountains of Mourne, which really do sweep down to the sea." As challenging as it is beautiful, the ninth is a fitting close for one of golf's great front nines. For Damian, the hole that holds a special memory is the 212-yard par 3 fourth. "You start from an elevated tee, as you do

DESTINATION

37

on many of the holes at Royal County Down. You're looking out over a sea of gorse, with three mountain peaks and the hotel spire out in the distance. Between the yellow of the gorse, the green of the mountain, the red of the spire, and the blue of the sea and sky, it was a Technicolor dream."

DAMIAN PASCUZZO is a partner in the golf course architecture firm Graves & Pascuzzo, based in El Dorado Hills, California. A past president of the American Society of Golf Course Architects, Damian counts the Ranch Golf Club (Southwick, Massachusetts), La Purisima Golf Course (Lompoc, California), Indian Pond Country Club (Kingston, Massachusetts), Maderas Country Club (Poway, California), and the Bridges at Gale Ranch (San Ramon, California) among his original designs. His renovation work includes La Quinta Country Club (La Quinta, California), Blackhawk Country Club (Danville, California), and the Lakes Country Club (Palm Desert, California). Damian is a graduate of Cal Poly–San Luis Obispo, with a bachelor of science in landscape architecture.

If You Go

▶ **Getting There:** Royal County Down is situated in the town of Newcastle, approximately thirty miles south of Belfast and ninety miles north of Dublin. Direct flights to Belfast are available from Newark, New Jersey, on Continental (800-231-0856; www.continental.com). Eastern Airways (+44 8703 66 91 00; www.easternairways.com) has service to Belfast from a number of UK airports.

▶ **Course Information:** Royal County Down measures 7,037 yards from the tips and has a par of 71. Greens fees range from £55 in the winter months to £130 in the spring and summer. The course has a limited number of tee times available for visitors; visit www.royalcountydown.org, or call +44 28 4372 3314.

▶ **Accommodations:** The Slieve Donard Hotel (+44 28 4372 3681; www.hastingshotels.com) is the preferred resting place for Royal County Down visitors. This four-star hotel offers 130 rooms, restaurant, bar, pool, and Jacuzzi, among other amenities. Horseback riding, sailing, and fishing are available. Rates here begin at £125. Another nearby option is the Burrendale Hotel (+44 28 4372 2599; www.burrendale.com), with sixty-eight rooms. Rates here begin at £75.

DESTINATION

37

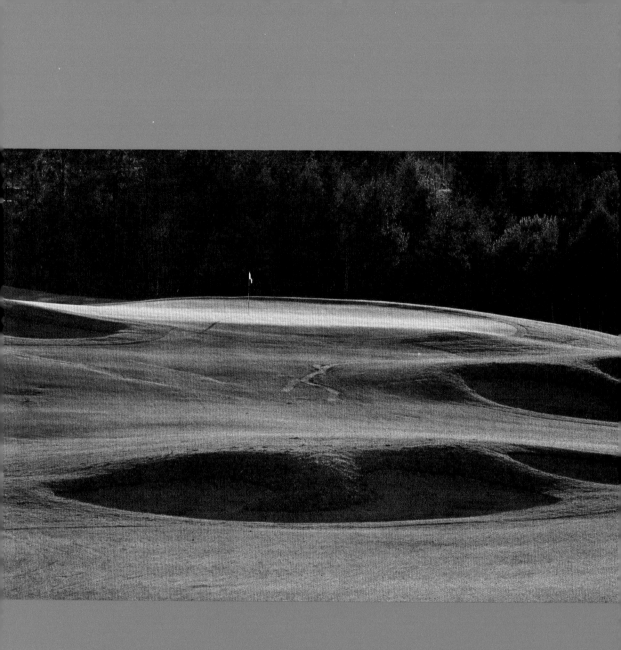

MIKLAGARD GOLF CLUB

RECOMMENDED BY **John Strawn**

Not long ago thieves managed to make off with Norway's most famous painting, *The Scream*, by Edvard Munch, snatching it in broad daylight from a museum in the heart of Oslo. The Norwegians were as offended by the thieves' brazen methods as by their crime. "Almost as easy as robbing a kiosk," editorialized one national paper. Contemporary Norwegian society is so orderly and hostile to ostentation that anything shameless unbalances the national equilibrium.

The Scream actually exists in several versions, and for most people it symbolizes what it must feel like in mid-January in a country where in the middle of winter the sun comes out for only a few hours a day. The psychological state depicted in the painting seems an understandable response to months of darkness. The flip side of those long, dark Norwegian nights is the immaculate daylight of the Norwegian summer, where golfers can enjoy the pleasure of teeing off at ten P.M. and still expect to finish 18 holes before sunset. The light is soft and low and mesmerizing. Playing in Oslo for the first time, John Strawn recalls remarking to his playing partner on the beautiful sunset. "He pointed out that we were in fact looking east—at the *sunrise*," John said. "'Oops,' I observed."

For John, a fine place to embark on a seminocturnal round is Miklagard Golf Club outside of Oslo, the first course in Scandinavia to earn a Peugeot Golf Guide score of 18, a remarkable tribute for a course that is only four years old. Peugeot refers to Miklagard as "a majestic course," which the club's members would likely regard as excessive praise, as Norwegians are a modest bunch.

Miklagard is built on rolling countryside outside of Oslo and features expansive vistas of the surrounding woods and fields, with only farmhouses and barns in view from the course. During the seven months or so each year that Miklagard is open for play, mem-

OPPOSITE:
Though a young course, Miklagard is already considered one of Scandinavia's finest tracks.

DESTINATION

38

bers enjoy a course that has introduced a new level of strategic design to Norwegian golf. The first of Robert Trent Jones, Jr.'s Scandinavian designs, Miklagard takes advantage of both the topography and the larger setting.

"It's a big, brash course," Jones said of Miklagard. "I wanted to create a course as impressive as Norway's Viking history." "Miklagard," in fact, is the Viking name for the city of Istanbul, where Viking traders created a thriving commerce during the Middle Ages by designing ships that could be carried on portages across the steppes and forests of Russia and into its rivers for the trip down to the Black Sea and on into Istanbul. The Vikings were fierce warriors, as everyone knows, but they were also savvy traders who pioneered commerce between the people of the North and the great commercial entrepôts of what's now the Middle East, connecting Norway to the luxury goods of the Silk Road.

"Jones has described Miklagard as an inland links, if there is such a thing," John continued. "Others have referred to it as an open parkland course. The roughs are left in tall native grasses, such as fescues that go off color in the summertime, to contrast to the bright greens of the turfgrass, providing a look very much like that of a seaside course in Ireland or Scotland. The greens are seeded with creeping bent grass and putt firmer and truer than any other greens in Norway."

Miklagard's second hole is a prime example of Jones's strategic design concept for the course. Players on the tee face an uphill drive, with options to aim for either a lower right-side fairway or an upper left-side fairway. The upper fairway gives a better view of the green—in fact, players can't really see the green surface from the right side—but the drive on the left side is guarded by a large bunker, and players who challenge the left side may well lose a shot to the hazard. On the positive side, players who carry the bunker will have a great chance at birdie, since they will have both a good look at the pin placement and a choice of either running the ball up or flying it to the green, while players choosing the safer low road on the right side can reach the green only with a high, soft shot.

After your round at Miklagard, you might wish to pay a visit to the Norway National Museum in Oslo, where another version of *The Scream* is on display. "Many golfers I know are certain it must be a self-portrait of a hacker," John offered, "a perfect expression of how one feels watching a drive sail out of bounds off the eighteenth tee after what has been up until then a career round."

JOHN STRAWN is CEO of Robert Trent Jones II, Golf Course Architects, and the author of *Driving the Green* as well as numerous articles on golf. He has also worked as a general contractor in his hometown of Portland, Oregon, and as an assistant professor of history at Reed College in Portland.

If You Go

▶ **Getting There:** Miklagard is roughly twenty minutes north of Oslo, and close to the Gardermoen International Airport. Oslo is served by many major carriers from the United States, including Continental (800-523-3273; www.continental.com), Icelandair (800-223-5500; www.icelandair.com), SAS (800-221-2350; www.scandinavian.net), and American Airlines (800-433-7300; www.aa.com).

▶ **Course Information:** Miklagard plays 7,335 yards to a par 72. Though it's a private club favored by many of Norway's top players, Miklagard also welcomes outside play. Greens fees range from 550 NOK ($90 U.S.) to 900 NOK ($145 U.S.). As at most Scandi-navian venues, walking the course is encouraged. Tee times can be made at +47 63 94 31 00.

▶ **Accommodations:** Overlooking a grand fjord and equally blessed with both abundant cultural attractions and untrammeled wilderness areas *within* the city limits, Oslo is one of Europe's great capitals. You'll find a broad range of accommodations at www.visitoslo.com; more information on touring Norway is available at www.visitnorway.com.

DESTINATION

38

HIGHLAND LINKS

RECOMMENDED BY **Bob Vokey**

✥

"Any golf course is nice when you're on vacation," Bob Vokey said, ruminating on a recent trip to the Maritime Provinces of Canada from his home in southern California. "But when you come upon an assembly of courses like you find at Cape Breton, it's really something special. I hadn't even planned to play golf on the trip, and didn't have my clubs. When I got a little taste of the courses there, I rented some clubs and headed out."

Surrounded by the Atlantic Ocean and the Gulf of St. Lawrence and blessed with both pine-covered mountains and verdant valleys, Cape Breton, Nova Scotia, is recognized as one of the most beautiful islands in the world. In addition to its natural wonders, Cape Breton is celebrated for its rich Gaelic culture, historic villages . . . and golf courses. Dubbed the Fabulous Foursome by the island's tourism interests, the courses include Bell Bay, Le Portage, Dundee, and Highland Links. All four venues offer water vistas of the Bras d'Or Lakes or the Atlantic and rolling, heavily wooded terrain. The Highland Links goes one step farther to offer a layout that's considered by some to be Canada's finest.

Highland Links, designed by Stanley Thompson and opened in 1939, exists in part because of Thompson's achievements in the province of Alberta a decade earlier. There, at the behest of the Canadian National Railroad and the Canadian Pacific Railroad, respectively, Thompson delivered Jasper Park and then Banff Springs. Both courses were recognized as among the best in the world at the time, and are still highly regarded today. The Canadian National Park Service understood how successful the courses had been at attracting visitors to these remote though scenically splendid outposts, and imagined that adding golf to the assortment of outdoor activities already available on the island could do the same for Cape Breton—with the added benefit of providing employment for

OPPOSITE: Architect Stanley Thompson had workers pile fieldstone on what would become the fairways of Highland Links, creating distinctive undulations.

DESTINATION

39

173

hundreds of men in the waning years of the depression. A site was selected in Cape Breton National Park on the northern tip of the island, and Thompson, with his construction supervisor Geoffrey Cornish (who would later be renowned as a designer in his own right), set to work on what he would call his "mountains and ocean" course. Construction on a grand hotel, the Keltic Lodge, was launched at the same time, ensuring that visitors would have first-class accommodations before and after their golf.

Stanley Thompson was a master at exploiting the natural beauty of the fabulous sites that he was blessed to work with. He routed holes with an eye toward the available vistas, and his designs were often as grand as the land itself. The site at Cape Breton had much to offer, and Thompson was up to the task. "At Highland, each hole has an individual perspective, and many have views of the sea," Bob said. "There are no parallel fairways, as each hole is carved out of the forest. It's a wonderful effect. Even walking between holes—and there are some long stretches between the green and the tee—the views are spectacular." At Cape Breton, Thompson pulled off a crafty maneuver. He created both a great seaside course *and* a great mountain course, without compromising the continuity of the overall schema.

Highland Links begins out on a peninsula in the Atlantic, adjacent to the Keltic Lodge, and the first 6 holes play near the salt. "Many modern courses begin with a few easier holes to warm up," said Joe Robinson, Highland's pro for thirty-three years. "That wasn't Thompson's plan. Our two toughest par fours hit you right out of the gate. To make matters worse, you start out cold, as there's no practice area at Highland." The 445-yard second hole, named Tam O'Shanter (because Thompson thought the green resembled the Scotsman's hat), plays sharply downhill, with a broad playing area that exposes a bay and a wooded hillside. The fairway has many undulations, a common feature at Highlands. "There was a lot of fieldstone in the area when Thompson was constructing the course," Joe continued. "Rather than carrying it off, he had the workers pile it in mounds on the fairways and covered it with topsoil. It's hit-and-miss out there. You might hit a great shot out there and have the ball take a bad bounce and end up with a terrible lie."

The short 325-yard fourth is called Heich O'Fash (i.e., heap of trouble), and the knob of a green, guarded by traps whose shape mimics the hills in the background, demands a very precise pitch to cheat adversity on what would seem from its modest yardage to be an easy hole. The seaside 6 reach their apex at the 537-yard par 5 sixth hole, dubbed

Mucklemouth Meg (named for a young lady who, as legend has it, could swallow a turkey egg whole). The fairly generous fairway on this gentle dogleg right is guarded on the left by thick stands of trees and on the right by a pond. Decisions must be made on the second shot; while a big hitter can potentially get to the green in two, the fairway tightens near the putting surface, bringing a series of bunkers on the left and deep rough on the right into play.

At hole number 7, the routing moves inland, into the valley formed by the Clyburn River, beginning with a 570-yard par 5. "Number seven is called Killiecrankie, which translates into 'long narrow path' from the Scots," Joe Robinson explained. "You stand on the tee, and it looks like you're going down a bowling alley. People take out a driver because of the distance, but you're better keeping it in play with a long-iron. It's not a hole you can reach in two. When you get to the green, the rolls and contours are something else. You've begun the hole only when you begin putting. Overall, I believe Highland has as good a set of par fives as you'll find anywhere."

The path remains inland through holes 8 to 12. The Clyburn River flows along number 12; during the fall, anglers cast to Atlantic salmon, some approaching 40 and 50 pounds, in a clear pool along this stretch. After a teasing view of the ocean on number 13, you return to the coast in earnest on the fifteenth, with a 540-yard par 5 named Tattie Bogle. The name translates as "potato pits"; course notes explain that potatoes were once placed in hillocks and covered with a thatch. The hillocks in this case speak to the wildly rolling fairway, which seems more prone to induce nausea than the seascape that lies beyond the green. Whether or not you play your drive correctly off the hillside on the left of the fairway to catch the bounce needed to get to this green in two, you'll appreciate the prospect of Whale Island that frames the green on your approach.

BOB VOKEY is widely considered golf's wedge design guru. Born in Quebec, he has followed a circuitous route, both geographically and on a career path, which now has him as director of wedge development with Acushnet, the multifaceted company that includes the Titleist brand. Golf clubs were always a hobby for Bob, whose dad was a tool-and-die maker; his interest in building golf clubs came from tinkering in his dad's shop. By the early 1970s, a hobby had developed into a small golf club shop in Anaheim, California. Stints at TaylorMade and Founders Club followed before Bob landed with Titleist in 1997. He is a fixture at many PGA Tour events, "working the trenches" on the range as

professionals prepare nearby. Bob's wedges are favored by many PGA players and thousands of weekend players around the world.

<div align="center">**If You Go**</div>

▶ **Getting There:** Highland Links is situated in the town of Ingonish in the Cape Breton Highlands National Park, on the northern end of Cape Breton Island. Air Canada (888-247-2262; www.aircanada.com) offers daily flights to Halifax, Nova Scotia, from a number of North American cities, with connecting flights to Sydney, which is on the island. Travelers can also reach Yarmouth, Nova Scotia, via boat from Portland (800-845-4073; www.scotiaprince.com) or Bar Harbor (888-249-7245; www.catferry.com), Maine. Train service from Halifax to Sydney is available from Via Rail (888-842-7245; www.viarail.com). From Sydney, it's another two hours by car, though the ride may be one of the most scenic you'll find anywhere.

▶ **Course Information:** Par 72 Highland Links plays 6,592 yards from the blues and has a slope rating of 141. Greens fees range from $65 to $83 (CAD), depending on the season. You can reserve a tee time at 800-441-1118; more information is available at www.highlandlinksgolf.com. Cape Breton is a popular golf destination, and many packages are available. Information on the Bell Bay, Dundee, and Le Portage courses is available at www.golfcapebreton.com, or by calling 866-404-3224.

▶ **Accommodations:** The Keltic Lodge (800-565-0444; http://signatureresorts.com/resorts.asp?resort=1) was built to accommodate Highland Links golfers and still sets a high standard for Cape Breton lodging. Rooms begin at $119 (CAD) for two guests. A number of excellent packages are available, including the Tee Off Package, which includes one night accommodation and greens fees, from $104 (CAD) per person, based on double occupancy. The lodge has several restaurants and complete resort amenities. Atlantic salmon fishing is available in a few rivers in the Highlands National Park, including the Clyburn River, which runs through the course.

BANDON DUNES

RECOMMENDED BY **Dave Pelz**

Back in 1998, more than a few people thought Mike Keiser was crazy when he opened Bandon Dunes on the rugged southern coast of Oregon. It was too isolated, not on the way to much of anything. The course's architect, a twenty-nine-year-old Scotsman named David McLay Kidd, had never designed a course before. And no golf carts would be allowed; instead, players would be encouraged to hire caddies, many of whom had been displaced from their livelihoods by declines in the region's lumber and fishing industries.

As it sometimes transpires when mad adventures in art and science are allowed to run their course, something truly wonderful emerged. From its opening, Bandon Dunes was hailed as a links wonder, an honest importation of Scottish golf lore to the Pacific, some six thousand miles west of the game's homeland. Early on, Bandon Dunes incorporated the rather presumptuous slogan, "Golf as it was meant to be," and some snickered. But the course had the goods to back it up. One wag even quipped that Bandon Dunes was destined one day to host an open—the British Open!

Short-game guru Dave Pelz was smitten with Bandon Dunes on his first visit because of its similarity to true links golf. "I've long been a fan of links golf and have spent a great deal of time in Ireland and Scotland," Dave said. "It always thrills me to work with a player to teach the ground shots. There are so many occasions when playing low shots is more effective than the target golf approach that typifies the American game. Many of the great short plays in the game are bump-and-run shots. If you know how to do it, it can be a lot better than flopping it. These kinds of shots are not taught much anymore. A friend of mine, golf writer James Achenbach, and I were talking about great bump-and-run courses one day. James, who lives in Portland, said, 'You've got to come see me. We'll go down to Bandon.' I went out with my sons and James and we played nonstop for three

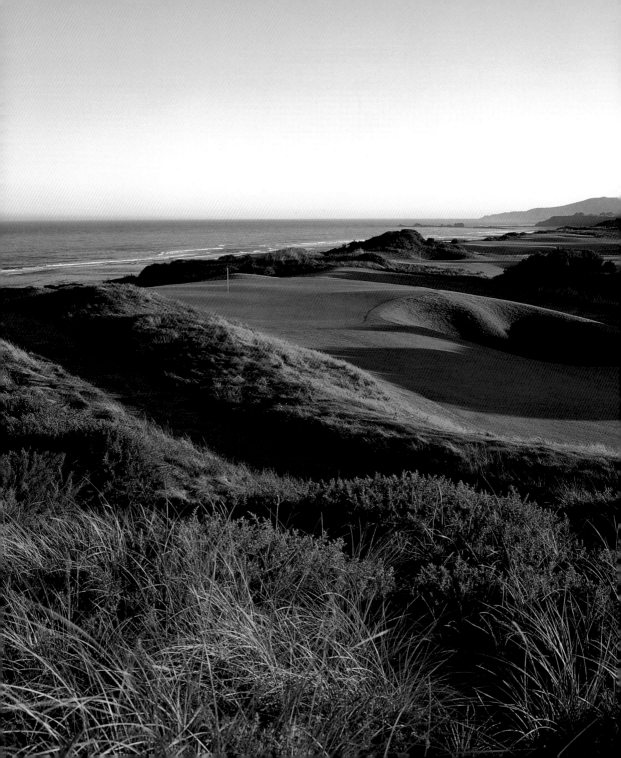

days. I loved it, because Bandon gives you all the ground shots—long and short."

The site of Bandon Dunes is as fine a linksland as any in the United States. Lying just below the southern terminus of the Oregon Dunes National Recreation Area, the land's rolling, sandy turf adjoins a pristine beach that's unadorned by condos, clubhouses, or concession stands—part of the project's "golf as it was meant to be" credo. Young Mr. Kidd, who had grown up around Gleneagles in Scotland, where his father served as greenskeeper, quickly recognized the potential of the site. "From the moment I stepped out on these wild, wind-shaped sand dunes, I knew this would be the opportunity of a lifetime," Kidd recalled in his course notes. "I imagined the routing having the structure of a symphony—a strong start, a sense of anticipation, small crescendos, and an incredible finishing sequence along the Pacific. The course had to provide not only a challenge to every skill level, but also a sense of adventure and an exploration of this great landscape. As on true links courses, each hole offers several strategies to reach the green. Although the fairways and greens are large, the best line of attack requires accuracy, which can always be tricky."

While the threat of pit bunkers, thick gorse, and the Pacific are always looming on Bandon, the course is not vindictive. Average players who hit relatively straight can have a satisfying round, and perhaps even end their round with the ball they began with. The holes amble through the dunes, curving at times to expose broad vistas of the Pacific where, depending on the season, salmon or crab boats ply the waters off the beach. The dogleg fourth, which plays slightly downhill and to the right, provides such an "Oh wow!" moment . . . even if the drive that tries to cheat a few extra yards by cutting the right doesn't quite clear the heather.

For Dave, the holes at Bandon that forced his group to contend with the wind—and thus deploy their wind-cheating ground game—proved the most satisfying. "I remember number five and number six along the water; number five was a particularly strong hole. We must have had a forty-mile-an-hour wind blowing across the fairway. To curve a tee shot and land it below the green then run it up was fantastic. The par threes are all very strong, too. If it hadn't been so windy, I would've tried to fly the ball into the green on the threes, but with the conditions as they were, I ran it up. I would rather hit a partial three-iron halfway to the green and watch it roll up than hit a full four- or five-iron. It's such a thrilling play, and Bandon gave me this shot again and again.

OPPOSITE:
With the creation of Bandon Dunes, the ethos of British and Irish links golf was successfully imported to the Pacific Coast.

179

DESTINATION

40

"Bandon's layout and the setting there on the coast really mimic the conditions you experience in Scotland," Dave continued. "I've played Whistling Straits, which certainly looks like a links course, but it doesn't play completely like one because they have bent grass in front of the greens. Bandon not only has the looks but plays like a true links. I don't think I hit more than fifteen or twenty percent of my shots in the air there. Getting back into that mode of play—keeping your drives down, hitting shots that would release and run, and use the ground contours to get to the green—this is an experience that true lovers of the game shouldn't miss in the United States, even if they've experienced it abroad."

DAVE PELZ is golf's foremost authority on the short game and putting. He has committed his working life to research and teaching, helping golfers worldwide lower their scores. With his uniquely analytical approach to the game, the former NASA scientist has proven that improving skills within 100 yards of the hole is the fastest route to lowering handicaps and has designed instruction to teach those shots properly. The game's top playing professionals, such as Phil Mickelson, Vijay Singh, Steve Elkington, and Mike Weir, rely on Pelz's advice while thousands of amateurs attend his popular Scoring Game schools and clinics each year. Golfers tune in religiously to his *Dave Pelz Scoring Game* shows on the Golf Channel, as well as his monthly articles in *GOLF Magazine*. Author of some of golf's best-selling instructional books, Dave has also parlayed his passion for the game and expertise in research into club design and training-aid development as well as short-course design and the production of instructional videos and DVDs. Dave is listed annually among the top ten teachers in the world by both *GOLF Magazine* and *Golf Digest*; *Golf Digest* named him one of the twenty-five most influential instructors of the twentieth century.

If You Go

▶ **Getting There:** Bandon Dunes Golf Resort is situated on the southern Oregon coast, approximately 250 miles from the Portland International Airport. While most visitors fly into Portland, there are commercial flights available into North Bend/Coos Bay, Oregon, twenty-five miles north of Bandon, which is served by Alaska Airlines (800-252-7522; www.alaskaair.com).

▶ **Course Information:** Par 72 Bandon Dunes is 7,212 yards from the tips and can play much longer if the wind is up. Greens fees for resort guests range from $70 in the winter season to $175 from May through October. Both Bandon Dunes and Pacific Dunes are walking-only facilities. A caddie is encouraged to help interpret the course's contours and winds; trolleys are also available. For tee times and other course information, call 800-742-0172.

▶ **Accommodations:** Bandon Dunes has a variety of understated but elegant lodging options available, from lodge rooms to cottages. Rates begin at $90 in the low season, $180 in the high season. Golf/lodging packages are available, especially in the off-season. For a rundown of lodging options, visit www.bandondunesgolf.com or call 800-345-6008. The atmosphere at Bandon is splendid; people are accommodating but not sycophantic; they seem genuinely appreciative that you've made the trek to visit them. While this section of the Oregon coast caters to summer vacationers seeking to frolic on the dunes, Bandon's focus is decidedly on golf, and nongolfing visitors who don't enjoy long walks on the beach may find little diversion.

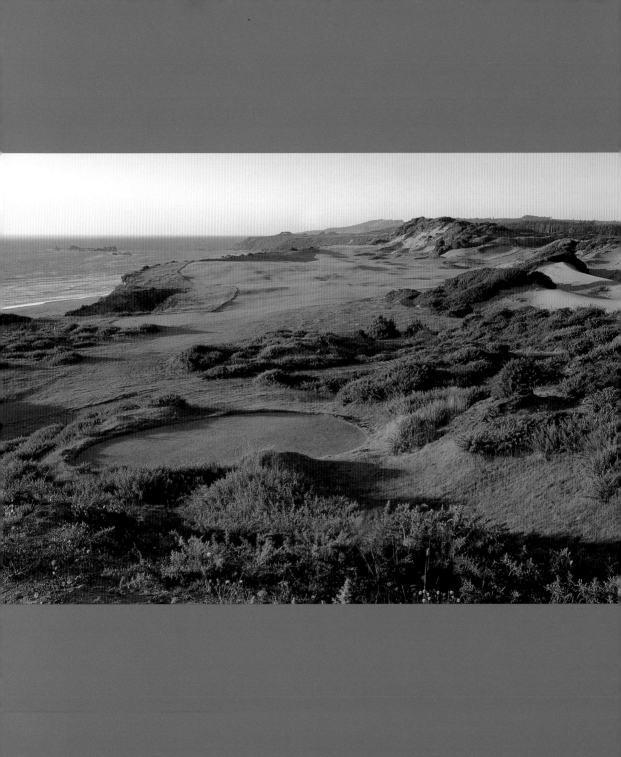

PACIFIC DUNES

RECOMMENDED BY **Brian McCallen**

Brian McCallen recalls when he first learned about the existence of Bandon Dunes. "I received a postcard showing a glorious golf hole, links-style, with white spray splashing up in the background. The back of the card talked about a new course. I called and asked if the photo had been airbrushed. They replied, 'No, that's part of the course we're building.' I made plans to go out."

Brian made the trip later that spring and came away fairly astounded. "I was impressed with the design, and the surroundings were spectacular." When he learned that a second course was in the works—and that Tom Doak would be designing it—he was extremely curious. At the time, Doak was considered something of an enfant terrible among the golf course designer fraternity. He had strong opinions and wasn't afraid to voice them, even if that meant alienating some of his peers. "Tom is keenly intelligent, had studied all the classic courses in Great Britain and beyond, and always had good reasons for what he was saying," Brian recalled. "Still, he didn't have a product that gave credence to his strong opinions. That is, until Pacific Dunes opened."

What separates a masterpiece from a great piece of art is attention to detail, and the same can be said for golf course design. "When I first learned to scuba dive, my instructor advised me to not look for whales, but to focus on the small but remarkable facets of the reef," Brian said. "I think that applies to Pacific Dunes. Look at the undulations around the green, how the bunkers fit into the land. Pacific Dunes is a masterpiece. What Doak didn't do in terms of moving land is as important as what he did do. Though Tom has an encyclopedic knowledge of the world's great courses, he doesn't replicate famous holes. Instead, he uses strategic elements from great holes to augment what's there in front of him. On one level, there's nothing new under the sun in golf course design.

OPPOSITE:
Flanked by raw dunes on the right and the Pacific on the left, hole number 13 at Pacific Dunes is one you will not soon forget.

DESTINATION

41

Everything is just a recycling of old precepts and concepts. This being said, a great architect can amplify what's been done when given a great setting."

The palette that Doak was given at Pacific Dunes is indeed spectacular. The track is perched 100 feet above an untrammeled beach and the Pacific, hewn from giant sand dunes and thick fields of gorse; the gorse was transplanted from Scotland in the nineteenth century to help stem erosion. Thick, thorny, and largely impenetrable, the gorse at Pacific has claimed many a ball. A story that circulates among the caddies tells that one slightly inebriated golfer went into the gorse after an errant shot, became lost, and was finally found bleeding a half hour later by a team of caddies, his clothes and ego in tatters. In the spring and fall, one may look west to view pods of gray whales migrating to and from Alaska. To the south and east, the mountains of Oregon's Coast Range poke into view. There are no car horns and few other sounds of civilization; the calls of seabirds, the gentle thud of the surf, and the occasional boat whistle provide a harmonious sound track. "It's very pure out there," Brian added. "It's not commercial at all."

"I suspect that any golfer would have found some of the same holes, like the par four thirteenth along the ocean," Doak wrote in his notes for Pacific Dunes. "But it was an enormous responsibility to find the best possible routing on a site of such potential. The rippling fairways are mostly as we found them. So are the natural bunkers at the second, seventh, eleventh, thirteenth, sixteenth, and eighteenth holes, which guided our routing. Our layout is short enough to give every golfer hope, but its rugged nature will test every facet of your game."

There is reason for hope at Pacific Dunes. At 6,633 yards from the back tees, it's not a grip-it-and-rip-it course. If the wind is down, it can be hospitable even to higher handicappers. If the wind is up, it's still hospitable to golfers, but less so to low scoring. Choices abound. While there's little question that one must carry the sandy wasteland that rests between the tees and the fairway on some holes, whether or not to try to fly the little pot bunker on the right to gain a slightly better approach to the green is less certain . . . especially after one has misjudged distance or the wind to realize that that little pot bunker is actually rather deep and steep! Pitching into the greens poses questions too. Thanks to Mr. Doak's mysterious, wonderfully sloping putting surfaces, perception and reality are often hopelessly at odds. Seemingly perfect chips roll back to your feet, while a shot pitched well right of the pin comes to rest in gimme range.

"Because of the wind, Pacific Dunes is a different course each time," Brian continued.

"That's part of its allure. No one cares that it's not seven thousand yards long, and that they probably won't ever play a major professional event there. Pacific is an amateur's course, designed for match play. It's not about the pencil-and-scorecard approach. The greens are tough. It's not hard to hockey-puck the ball around and run up some big numbers. You roll the ball a bit long of the green, it may roll down a twenty-foot slope. You're never unhappy, even when you're fluffing the ball around. It's just a fun course to play. And you can't say that about many of the courses that make it on the 'must-play' lists."

BRIAN McCALLEN, a contributing writer to *Golf Connoisseur*, served as a senior editor at *Golf Magazine* from 1987 to 2003, creating several major franchises for the publication and establishing himself as one of the top golf and travel writers in the nation. The Gold and Silver Medal Resort awards program recognized the nation's (and later the world's) leading properties, while the Top 100 You Can Play list was a definitive biennial round-up of America's best public-access facilities. Both topics led to book projects at Harry N. Abrams, *Golf Resorts of the World* (1993) and *Top 100 Courses You Can Play* (1999). A third Abrams book, *Emerging Golf Destinations*, an international review of the world's most exciting new places to play, will appear in 2006. He also wrote the Top 18 chapter in *The 500 World's Greatest Golf Holes* book (Artisan, 2000). Brian has appeared on CNN and PGA Tour radio as a golf and travel expert. His golf and travel features appear in *Golf Connoisseur, Travel + Leisure Golf, Town & Country*, and many other publications. He lives with his wife and two daughters in Stonington, Connecticut.

If You Go

▶ **Getting There:** Bandon Dunes Golf Resort is situated on the southern Oregon coast, approximately 250 miles from the Portland International Airport.

▶ **Course Information:** Pacific Dunes is 6,633 yards from the back tees and plays to a par 71. Greens fees for resort guests range from $70 in the winter season to $175 from May through October. For tee times call 800-742-0172.

▶ **Accommodations:** Bandon Dunes has a variety of understated but elegant lodging options available, from lodge rooms to cottages. Rates begin at $90 in the low season, $180 in the high season. Golf/lodging packages are available, especially in the off-season. For a rundown of lodging options, visit www.bandondunesgolf.com or call 800-345-6008.

DESTINATION

41

VILAMOURA, VICTORIA GOLF CLUB

RECOMMENDED BY **Fernando Nunes Pedro**

Mention golf and the Mediterranean, and many will think of Spain's Costa del Sol. But a bit farther west on the Iberian peninsula, not *quite* on the Mediterranean, rests an equally attractive golf destination—the Algarve region. Situated on the extreme southern coast of Portugal, the Algarve has gorgeous beaches, year-round sunshine, and, by last count, twenty-nine golf courses, including such notables as San Lorenzo, the tracks at Quinta da Lago, Quinta da Rio, and the five courses at the granddaddy of Algarve golf, Vilamoura. The courses of the Algarve see more than one million rounds of golf a year, played mostly by visitors from northern Europe. "Portuguese people are big soccer fans and still see golf as an elitist pursuit," said Fernando Nunes Pedro, "even though there are only three private courses in the whole country. There are only ten thousand Portuguese golfers."

The newest course in the Algarve—and one that's already considered among the best—is the Victoria Golf Club at Vilamoura. The course has special meaning for Fernando, for he nurtured the course from its earliest stages. "I've been involved in golf course construction for a long time, as a project manager and general coordinator of operations. For the first time in my career, I was asked to produce a golf course from the beginning. It took me almost six years of long, hard, and marvelous work from start to finish. Reviewing proposals from a list of eleven golf course designers from around the world, I proposed that Arnold Palmer design Victoria. Curiously, Lusotur Group chairman André Jordan and Arnold shared the same birthday, September tenth. We took this as a premonition, and chose Mr. Palmer.

"The enthusiasm, professionalism, and warm personality of all the individuals involved in the project made it extremely rewarding. I will always remember a dinner

186

with Mr. Palmer, the man and the legend. Mr. Palmer was telling us the difficult aspects of his life at the beginning of his career with Winnie on a caravan crossing America, playing golf. All of us were crying. And I started to say to him, 'Mr. Palmer,' and he replied, 'Arnie! Call me Arnie!' and I said, 'I cannot' and he said, 'You must!' I offered him my book about golf, and he offered me his last book, and we traded dedications. I'll never forget that dinner."

One of the main challenges in building Victoria was surmounting the shortcomings of the site. It was remarkably flat and had once been agricultural land. Working with Fernando, the Palmer team achieved small miracles, creating abundant mounding and a series of lakes that are connected by cascades. "The land had been significantly degraded by the previous agricultural work," said Vicky Martz, a member of the Palmer team. "With the mounding, we tried to emulate the mountains around Vilamoura. There were existing wetlands at the bottom of the property, and we designed one of the lakes to tie into that. Now the natural ecosystem spills into the course, enhancing the land."

"Mr. Palmer defined Victoria as a soft-links course," Fernando continued. "It doesn't rest close to the sea but the sea is visible, and it doesn't have many trees. Some bunkers are white sanded, and the naturalized bunkers have yellow sand. Some look very sophisticated and manicured, and others look very natural. The greens are also very distinctive, and quite large. I asked Bob Holcomb, who was responsible for shaping the greens, to be creative. He obliged, and no two are alike."

"The two nines are very different," Vicky Martz continued. "The front nine has some natural undulations and is very in keeping with the natural terrain. When you come to the back, the water comes into play on many holes, and thanks to the waterfalls and lakes it has very different feeling. Most players enjoy the contrast."

When asked about a favorite hole, Fernando paused. "You play the course once and you don't forget the design of any hole. If I had to choose a favorite stretch, it would probably be the eleventh, twelfth, and thirteenth—I've begun calling it the Victoria Corner. The holes are placed around a large lake and look deceptively simple. But they must be played carefully, as the water is in play every shot. All three holes have large beach bunkers coming from the water. The twelfth is a long par five, very dangerous against or with prevailing wind. In the middle of the fairway there are some Roman ruins from the first century. The short par three thirteenth can be played safe to the right if you feel confident about chipping close to the pin on a very large green, without rolling off

into the lake. A pin position on the left doesn't leave many birdie opportunities, given all the water and beach bunkers in front.

"On the Victoria Corner, many championships will be decided. If things are not going your way, you'll find pleasant distraction in the hundreds of bird species that frequent the lake, including the rare sultana chicken."

FERNANDO NUNES PEDRO was born in Angola, where his family had large coffee, banana, and palm oil operations. After three wars and four years of military service, he left Angola for Brazil with his wife and three sons. After establishing several successful import/export businesses, Fernando was invited by the real estate investor André Jordan—who had read Fernando's golf articles in the *Expresso* newspaper—to help operate the Quinta da Lago golf course. After Quinta da Lago was sold, Fernando established himself with a golf company, publishing the *Strokesaver*, organizing golf competitions, and representing some of the most famous golf course architects in Europe. André Jordan invited him to join Lusotur Group, which operates the resort at Vilamoura. He has served as a board member for all golf activities at Vilamoura since 1996, having overseen the refurbishing of the Old Course in Vilamoura and the creation of Victoria. Fernando is the author of *Golf in Portugal* and hundreds of articles on the topic. He currently serves as CEO of the golf course owners association of Portugal.

If You Go

▶ **Getting There:** The Algarve region of Portugal rests along the southern coast of the country. Most visitors who don't have time to take in Lisbon fly into Faro, the provincial capital. Service is available from many carriers, including Continental (800-525-0280; www.continental.com) and British Airways (800-247-9297; www.ba.com).

▶ **Course Information:** Par 72 Victoria plays 7,140 yards from the men's tees, making it Portugal's longest course; it has a slope rating of 122. A round at Victoria runs 150 euros. More general information on golf in the Algarve is available at www.algarve-golf.com, or by calling the Portuguese Golf Federation at +351-214-12-3780.

▶ **Accommodations:** Vilamoura is a resort community with a broad range of lodging, from luxury hotels to furnished apartments. Options are outlined at www.vilamoura.net.

DESTINATION

42

188

DURNESS GOLF CLUB

RECOMMENDED BY **Ty Wenger**

A majority of American golfers who make the voyage to Scotland aim for the region of Fife and the mecca of St. Andrews. A somewhat smaller percentage range farther north to visit Gleneagles or Carnoustie, south to Muirfield, or west to Turnberry. Fewer yet will go to the Highlands to take in the magnificent Royal Dornoch. Ty Wenger made it there. "It almost changed my sensibility of golf courses," he recalled. "It was the least pretentious 'top fifteen course' I've ever seen." Though the estimable Dornoch made a deep impression, Ty came away most taken with the less famous courses he encountered—most notably, Durness.

"When I visited the Highlands, my assignment was to use Inverness as a launching point and write about the courses around there," Ty said. "Durness was not exactly nearby, but I had seen this picture of the ninth green there on the cover of a book and my interest was piqued. Every time I had the chance to chat with someone in a pub or with the secretary at a course, I'd ask about the other courses in the area. Whenever Durness was mentioned, their eyes would light up. 'You've got to take the trip, you're in for a treat' was the universal sentiment. I had to convince my wife to wake up early, drive two hours on a scary road, walk the course with me, and drive back. I picked a good wife—she was ready."

The Durness Golf Club has the notoriety of being the northernmost golf course on the mainland of the United Kingdom; at the height of summer, one can tee off in the middle of the night and finish before breakfast! It's an unassuming 9-hole layout with a couple of sets of tees, measuring a modest 5,555 yards for two loops, and was designed by three local members—Francis Keith, Lachlan Ross, and Ian Morrison—in 1988. "I'd heard that they'd held the local club championship the previous night, and I arrived on a

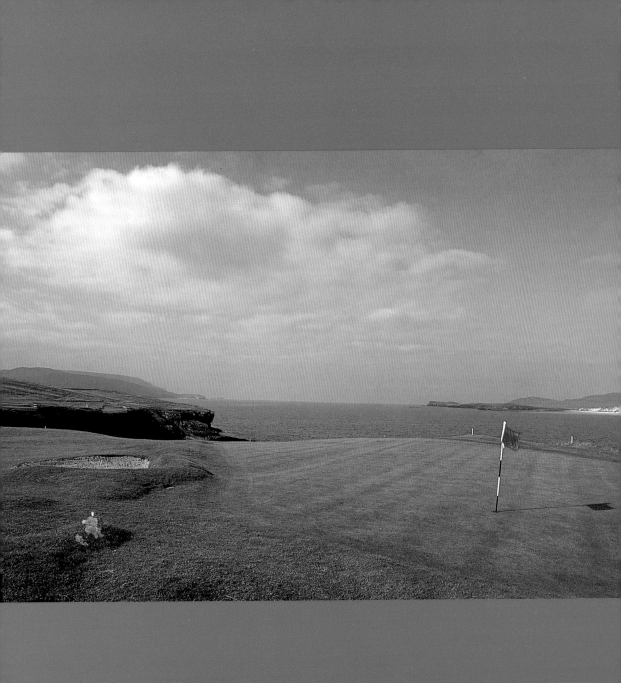

Saturday," Ty said. "It was sunny, sixty degrees, but there was not a soul there, just me and my wife. They have an honesty box—you drop your money in a slot. The sheep outnumbered the people by manyfold. At the time I was thinking, 'Back home, people would sleep in their cars to play a course like this.'"

After a few unremarkable par 4s at the outset, Durness begins to get very interesting. "On the third, the fairway collapses away from you, leaving a huge downhill shot. When you come over the ridge, you see the mountains. I heard my wife, Cheryl, go 'ohhh' and I figured we were on to something. On the fourth, the terrain begins to feel more linksy, with more humps and hollows. The fairways and greens start undulating like a stormy sea. At this point, there's still not another human being on the course. Finding the tee boxes was a bit of a challenge. The little signs weren't much use. We followed the worn path."

The sixth hole at Durness might be the course's most challenging, and it's much more Harrisburg than Highlands. A par 5, it winds almost 180 degrees around a lake, with risk/reward options at every step of the way. The eighth brings you back to the North Sea, where you hit a blind drive over an enormous hill. "When you get over the hill, you have the sense that the green drops off the face of the earth," Ty said. "All you see is water. It's emotionally staggering. You're giddy with the beauty.

"On the hundred-and-fifty-yard par three ninth hole, there's nothing but the North Sea on the left. The wind howls off the water, and the cliff drops off precipitously. At high tide, you have to go over the sea. There's not much of a bailout. This was the hole from the book cover. You've got to aim out over the water and let the wind bring it back to the pin. Give it up to the gods, as it were. I was proud to walk away with a par. That was an hour and a half of golf. An hour and a half that gave me twice the satisfaction that I normally get from walking off any 'championship' course in the U.S."

But Durness is only the beginning. The small golfing pleasures of the Highlands are many. There's the Brora Golf Club, which has a full-time greenkeeping force of sheep and cattle. "The course is somewhat known for the electrical wire around the greens to keep sheep and cattle off," Ty said. Brora is a links layout, with the original holes laid out by Old Tom Morris in 1891. The course was completed in the 1920s by James Braid, who also laid out Gleneagles and Carnoustie.

"Once you get over the whole notion of the electrical wires, you realize the course is spectacular," Ty continued. "Thanks to the sheep, the rough is very playable. Otherwise it

OPPOSITE:
The par 3 ninth
at Durness
is a fitting
conclusion to
a memorable
9-hole track
in the Scottish
Highlands.

DESTINATION

43

would be like Dornoch." A visitor's curiosity about the electrical wires eventually got the best of Ty. "I had to do the field test on the first green. I felt compelled to touch the electric wire—how bad would the shock be? I put my hand on the first one, and there was nothing. I didn't realize that they don't have the electricity on all the time. On the eighteenth, a long uphill par three, I striped a three-wood to just in front of the green. My ball was literally underneath the wire. Again, there was no one out on the course, and I didn't know if there was a local rule for it. I figured there was no juice in the wire, so I pushed it back with my knee and took my putter back and it touched the wire, and I got zapped and dropped the club. I didn't hit the ball, and I'm wondering, 'Do I have to take a stroke?'"

There are too many fine little courses in the Highlands to give them proper due here. A few others that stood out for Ty were Tain, which features an Alps hole (which the locals call the Dolly Parton hole, as the second shot must be played blind over two large mounds) and Golspie, a little links course whose players have battled erosion along the course's shore holes by building massive stone piles. While certain shots—and certain shocks—will long stick in Ty's mind, his experience in the Highlands has made him contemplative about the place of golf in his homeland. "In the United States, many golf courses seem to be perceived as an economic engine. They don't start as golf courses but as part of a development. No aspect of golf in the Highlands speaks to money. The golf courses in the Highlands were started because a bunch of people in the town wanted to play golf. They don't have names like the Evil Witch. They're named for the towns. You don't realize how much your golfing soul is in need of repair until you get to the Highlands. St. Andrews, Gleneagles, et cetera, are great courses, but courses like Durness are different. They haven't been turned into theme parks. In this day and age, when nothing seems pure, the Highlands are pure. It makes me want to put more money into the honesty box, like a charitable donation."

TY WENGER is the senior editor for travel at *Travel + Leisure Golf* magazine. Previously, he served as a senior editor at the women's magazine *Marie Claire* and as features editor at the former men's magazine *P.O.V.* He was the founding editor in chief of *Link*, a million-circulation national college magazine. Prior to that, he was editor in chief of *U., The National College Magazine*, a million-and-a-half-circulation publication. He graduated from Ohio State University in 1991 with a degree in journalism. By his own estimate, he

43

has played more than two hundred golf courses—and counting—throughout the continental United States, Hawaii, Great Britain, Canada, and Mexico.

If You Go

▶ **Getting There:** The largest town in the region is Inverness, which is served by British Airways (800-AIRWAYS; www.britishairways.com) from numerous points in the United Kingdom and BMI (www.flybmi.com), which offers flights from Heathrow in London to Inverness.

▶ **Course Information:** An added boon to the Highlands golf experience is that the courses are extremely reasonably priced. Durness (+44 0 1971 511364; www.durness golfclub.org) is a 9-holer with two sets of tees. It plays 5,555 yards to par 70. Greens fees are £15. Brora (+44 0 1408 621417; www.broragolf.co.uk) has 18 holes and plays 6,110 yards to a par 69. Greens fees range from £28 to £33. Tain (+44 0 1862 892314; www.tain-golfclub.uk.co) has 18 holes and plays 6,404 yards to par 70. Greens fees are £30 to £40. Golspie (+44 0 1408 633266; www.golspie-golf-club.co.uk) is 18 holes, measures 5,890 yards, and plays to par 68. Greens fees are £25. Detailed information about all the courses in this region is available at www.golfhighland.com.

▶ **Accommodations:** While the Highlands have not been overrun with American golfers, residents are not immune to the attractions of their region, and an infrastructure exists to support visiting players. While Inverness (www.visit-inverness.com) is the largest town in the region, the smaller towns all offer lodging of some sort. Golf Highland (+44 0 1847 889373; www.golfhighland.com) offers a comprehensive rundown of available options, from guesthouses to country estate hotels. Nearby Speyside is home to Scotland's "Whisky Trail," and connoisseurs of fine single malts may wish to squeeze in a few tastings; Visiting Distilleries (www.visitingdistilleries.com) can help you plan your sampling itinerary. Fly fishers may wish to try their luck for Atlantic salmon in the famed River Spey, a bit south.

DESTINATION

43

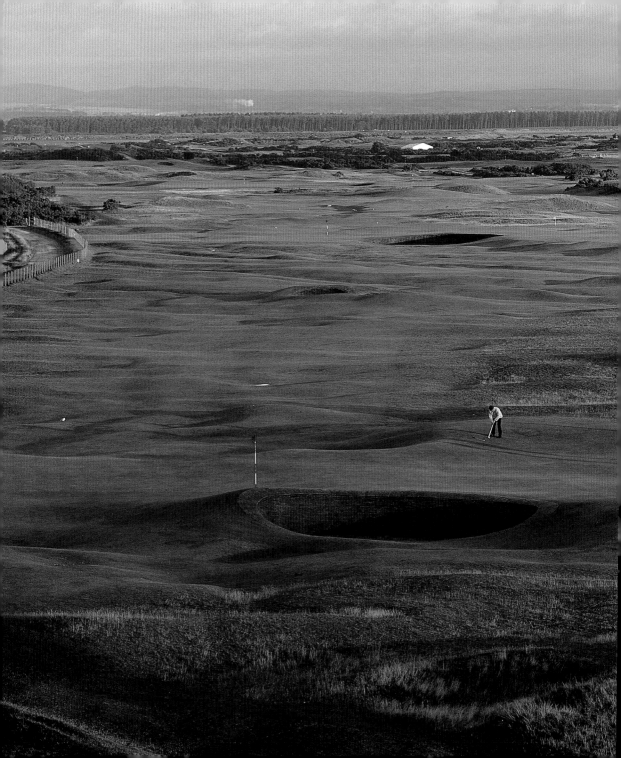

THE OLD COURSE

RECOMMENDED BY **Kevin Cook**

❧

One story regarding the birth of golf goes something like this: A group of shepherds watching over their flocks along the eastern coast of Scotland in the late 1400s or early 1500s became bored. Armed with the tools of their trade—namely, crooks—and acting on the natural male instinct to hit things—in this case, pebbles (or, as some have suggested, dried sheep dung)—the first informal match was played. The relatively barren, rugged turf of the coast proved to be well suited for the pursuit of a pastime where controlling the direction of a small projectile could be challenging. It's believed that a favorite gathering place of these very early linksters was the turf that would one day become the Old Course at St. Andrews.

Now, some five hundred years later, nearly every soul who's picked up a club and been smitten by the game dreams of one day making "the pilgrimage" to have his or her picture snapped upon on the Swilcan Bridge, with the venerable Royal and Ancient Clubhouse looming in the background. "Most things that are five hundred years old are resting under glass in a museum," writer John Barton has posited. "This course is still alive, and you walk in the footsteps of five centuries of players." Despite its absolute and indelible association with the game of golf, the Old Course is something of a surprise for many Americans. First of all, it's smack in the middle of the charming university town of the same name—a town that would be appealing even if it *weren't* the home of golf. Second, the Old Course—and, for that matter, the other five municipal courses oper-ated by the town—doesn't look much like an American's vision of a course, much less a vision of one of the greatest courses in the world. There are no trees, and the topography, viewed from afar, seems mundanely flat; in the 1820s, the course narrowly escaped becoming a rabbit farm. Sam Snead, in passing the Old Course by train en route to the

OPPOSITE:
The notion of
double greens
was conceived at
St. Andrews—
along with
many of the
other precepts
of the game!

DESTINATION

44

195

British Open in 1946, remarked,"That looks like an old abandoned golf course." This slight aside, Snead went on to win the championship, which has been held here twenty-seven times, most recently in June 2005.

"It's a little shaggy out there," Kevin Cook said, recalling his first round on the Old Course. "There aren't any fountains, and it's not as closely manicured as many players have come to expect. On a course that's hosted so many championships, you expect the greens to be lightning fast. Here, the greens are a little slower. But the subtle character of the course and the very tangible sense of history you feel on the course are wonderful."

The Old Course was not designed so much as it evolved, shaped by the whims of the wind off the North Sea and the suggestions of those who have played and loved it; the latter group included Daw Anderson, Old Tom Morris, and Dr. Alister MacKenzie. Originally, it consisted of 22 holes, 11 out and 11 back. In 1764, some holes were combined, reducing the track to a total of 18, which of course would later become the game's standard and thankfully give birth to the concept of the nineteenth hole. St. Andrews also set the standard for a true links layout: 9 holes, one after another, heading in one direction (in this case north); then 9 holes coming back to the clubhouse. Pack a few PowerBars if you're setting out on the Old Course, as there is *very little* in the way of a refreshment stand between the ninth and tenth holes.

Another interesting facet of the Old Course is the presence of double greens; 14 holes share seven greens. After the course had been reduced to 18 holes, golfers played to the same holes out and back. As the game grew in popularity, second holes were added to many of the existing greens to expedite play; holes for the front nine were equipped with white flags, those for the second nine with red flags. It's not uncommon for first-timers to aim for the wrong pin and find themselves with a dainty 83-yard putt for par!

No one would separate the joy of playing the Old Course from the wondrous history of the links. Every bunker, every swale of sod seems to have a name and a story. History aside, the Old Course is still an amazing layout. The fuzzy fairways have multitudes of undulations, making every lie an interesting one. Should you go astray, you'll encounter thick stands of gorse and heather. "If you just go in and hack it out, the Scots will applaud you," Kevin said. Even shots square in the fairway are vulnerable to dismay, as bunkers are peppered somewhat randomly around the course. The most memorable sand pit is unquestionably the Hell Bunker on the "Long" hole, number 14; you'll spot this one, as it's quite large. "If you go in and are playing with locals, they'll give you a benediction, for

you may not come out," Kevin added. Many greens are obscured by dunes or mounds, making semiblind approach shots common. And you'll do well to make your approach by land with the bump-and-run method, as the hard greens can be difficult to hold with lobbed shots.

Kevin offered a few more reflections on St. Andrews that might serve pilgrims well. "If possible, try to get out there early. If you go out at dawn, you'll get to play with Scotsmen who know the course and will help you with the lay of the land. The Scots play fast, and you should too. They think Americans play as if we're all on TV. Playing with the Scots adds a multicultural element to the game, too. For instance, they call a grounder off the tee a scalded cat. I told my partners that we call it a worm burner in America, and it was the funniest thing they'd ever heard.

"The wind and weather can make a huge difference out there," Kevin continued. "You could begin in warmish sunshine and end in sleet. Dress in layers and consider getting a caddie to help you with distances. Caddies can also guide you away from the random bunkers. Be conscious of which flag you're aiming at on the double green holes. In the passion of the moment, the double greens can be confusing."

Walking up the eighteenth fairway after crossing the Swilcan Bridge, it's not difficult to imagine yourself in the final round of the British Open. Indeed, as the course is near the center of town, you'll often have a wee gallery as you make your approach. "On the eighteenth, I busted a drive," Kevin recalled. "My Scots partners called it 'a big American drive.' A number of people who were waiting to go out and play—and probably a few others—were gathered around the green. I was only a sand wedge away . . . and of course I completely skulled it. I guess there's something to the bump-and-run strategy, as the ball rolled through the Valley of Sin [an undulation in front of the green] and ended two feet from the cup. With everyone looking on, I lipped the putt."

KEVIN COOK has written and edited golf stories for more than twenty years. Kevin's golf fiction has been widely anthologized; one of his stories appears in *Golf's Best Short Stories,* and a *Golf Digest* piece on Mac O'Grady won an award from the Golf Writers' Association of America in 1998. He has served as a senior editor at *Travel + Leisure Golf* and *Sports Illustrated,* and as editor of *GOLF Magazine,* and was also the lead columnist for *Maximum Golf.* A graduate of Butler University in Indianapolis, with a degree in English, Kevin lives in Manhattan with his wife and two children.

DESTINATION

44

▶ **Getting There:** Many visitors to St. Andrews fly into the international airport in Edinburgh. From Edinburgh, it's approximately one hour by car or train. Kevin pointed out that more and more courses are being built around St. Andrews and expressed concern that the region may experience a level of growth that could change the overall ambience. His advice: "Go before this happens!"

▶ **Course Information:** The Old Course measures 6,609 yards from the back tees and has a slope rating of 128. During the high season (April 18 to October 16), Old Course green fees are £115; during the shoulder season (April 1 to 17 and October 17 to 31), rates are £80; and during the low season (November 1 through February), rates are £56. During low season mats must be used from the fairway. Golfers hoping to secure a tee time on the Old Course can apply from September onward in the year before they wish to play and will know within four weeks whether or not they have a confirmed tee time. Apply via e-mail at reservations@standrews.org.uk. Roughly 50 percent of all starting times over the year are put into the daily ballot (lottery), which is drawn every day for next day's play, except Sunday; the Saturday draw is for Monday play. Players should telephone +44 1334 46 66 66 or apply in person before two P.M. on the day before play. On Sunday, the course is closed, and the people of St. Andrews use the linksland as a park. Imagine that happening on Augusta National! There are five other courses in the St. Andrews network, all quite good. Before leaving St. Andrews, be sure to pay your respects at the grave of Young Tom Morris in the courtyard cemetery.

▶ **Accommodations:** While a university town at heart (St. Andrews University is one of the oldest institutions in Europe), a low-key hospitality industry has sprung up to serve visiting linksters. Accommodations range from bed and breakfasts (starting around £40 per night) to five-star hotels. The Scores Hotel (+44 1334 47 24 51) looks out over the eighteenth fairway and is well regarded. An overview of possible accommodations can be found at www.visit-standrews.co.uk and www.stayinstandrews.co.uk. Golfers looking to go top-shelf might consider the Old Course Experience (www.oldcourse-experience. com). The package includes prime tee times on the Old Course, three nights' accommodation in an upscale hotel, two dinners, and lunch after each round in the St. Andrews Links Clubhouse. The price in April is £1,350; June through September rates are £1,650.

44

LEOPARD CREEK COUNTRY CLUB

RECOMMENDED BY **Gary Player**

"There are many great golf courses around the world," Gary Player declared. "When you try to think of a course that's a must-play, you look for something completely different. Most people will agree that Leopard Creek gives visitors something very different, something most golfers have never experienced before."

That something is the chance to interact—at times, quite closely—with the wild animals of the bushveld, while experiencing a course that's ranked as one of South Africa's finest.

Leopard Creek Country Club rests on the banks of the Crocodile River and borders the southern boundary of Kruger National Park, in the Mpumalanga Province in northeastern South Africa. Rocky hills ("koppies," in the local parlance) envelop the course, providing a stark contrast to the emerald green of the fairways. The club was created by tobacco magnate Johann Rupert, who recruited Gary Player to design the centerpiece golf course; the course opened in 1996. No expense was spared in the construction of the track, which was built with the stated goal of creating a South African equivalent of Augusta National. Leopard Creek is extremely exclusive, with membership by invitation only; current members include Gary, Jack Nicklaus, and Ernie Els. While membership is only in the realm of dreams for most of us, guests at the Malelane Sun Hotel (which is on the property) may apply for the opportunity to play on weekdays at a price that's fairly modest for those bearing American dollars.

The Leopard Creek development takes pride in the gentle cohabitation of the golf course and homes with the bush country and its residents. "We'll get up for breakfast some mornings and see thirty elephants grazing fifteen meters from our dining room window," Gary said. "You can see and hear hippos with their babies in the streams

DESTINATION

45

around the property. Sometimes you'll even come across giraffes on the grounds."
Giraffes are among Leopard Creek's more amiable visitors. Members warn guests to
show discretion in pursuing wayward shots into the rough, as the region is home to four
species of poisonous and extremely dangerous snakes: black mambas, Egyptian cobras,
black-necked spitting cobras, and African puff adders. You'll also want to be prepared to
drop a provisional ball should your first shot come to rest near the water, as the Crocodile
River does not take its name from whimsy, and resident hippos can also be quite danger-
ous (they're reputed to take more human lives than any other mammal in Africa). "When
the course was first constructed," Gary recalled, "we had to close it for five days because
some lions got in through a broken fence. After all, the lion's motto is 'If you can't beat
'em, eat 'em!'"

Thanks to its exclusivity, one might play an entire round at Leopard Creek without
encountering any other two-legged mammals. The amenities are equal to the course;
players are offered an ice-cold towel at the turn to freshen up, and you have the option to
order pâté for a mid-round snack.

When asked to name a favorite hole, Gary didn't hesitate a moment. "The thir-
teenth—a par five—is my favorite hole by far. The Crocodile River runs all along the left
side of the hole. Across the river, there are twenty-two million acres of Kruger National
Park. The green hangs out over the river at a height of more than seven stories. You
might be putting out and look down and see a crocodile thrashing about with an ante-
lope. If you sat on the green for a few hours with a pair of binoculars and a sandwich and
some Cokes, you'd see things you'd never imagined seeing. We South Africans love our
game preserves. There's a great thrill in seeing the animals in their natural habitat."
Wildlife encounters aside, the hole is also a good test of golf. The fairway is slim, and a
stream must be carried with your second shot to set up properly for your approach.

The 535-yard par 5 ninth hole and the 475-yard par 4 eighteenth are two other peren-
nial favorites of Leopard Creek regulars. The downhill ninth plays to an island green. The
eighteenth also plays downhill to a peninsular green that juts into the lake on the left; the
pin is often placed at the outer left portion of the green, goading players to bet it all. The
lake shared by both greens is home to a number of hippo and the occasional croc.

No visit to the Mpumalanga Province—no matter how excellent your round at
Leopard Creek—is complete without a closer look at the game reserve and its inhabi-
tants. For Gary, it's part of the program. "When I take American guests to Leopard Creek,

we get up early and go out in the bubble Jeep—a Jeep covered with Plexiglas, so you have a complete view out—and drive through the game reserve. We'll see lions just five meters away, as well as leopards, elephants, and water buffalo. We'll come back to the big thatched-roof clubhouse and have a great breakfast, and an elephant will walk by ten meters away. After breakfast, we'll play golf."

An outing at Leopard Creek is indeed something different!

GARY PLAYER is one of the legends of golf. Since turning professional in 1953, he has garnered 163 career championships and worldwide career earnings of more than $12 million. Gary's major championships have included three Masters (1961, 1974, 1978), three British Opens (1959, 1968, 1974), two PGA Championships (1962, 1972), and the U.S. Open (1965); his Senior Major Championships have included three Senior PGA Championships (1986, 1988, 1990), two Senior U.S. Opens (1987, 1988), three Senior British Opens (1988, 1990, 1997), and the Senior Players Championship (1987). Gary's interests outside of playing golf include breeding thoroughbred racehorses; farming; physical fitness; the Player Foundation benefiting children's education; and a successful business enterprise, Black Knight International, which includes Gary Player Enterprises, Gary Player Design, Gary Player Golf Academy, and Gary Player Golf Equipment. A native of South Africa, Gary has received numerous honors in his fifty-year career, including induction into the World Golf Hall of Fame in 1974; South African Sportsman of the Century award; the 2000 PGA Tour Ambassador of Golf Award; and the 2003 Laureus Lifetime Achievement Award. Most recently he was awarded the Order of Ikhamanga (by President Mbeki of South Africa) for excellence in golf and contribution to nonracial sport in South Africa.

If You Go

▶ **Getting There:** Leopard Creek Country Club is near the town of Malelane in the Mpumalanga Province of South Africa. It's a four-hour drive from Johannesburg, which is served by many major carriers, including Swiss Air (877-FLY SWISS; www.swiss.com), BMI (+44 1332 854854; www.flybmi.com), and South African Airways (+27 11 978 5313; www.flyssa.com).

▶ **Course Information:** Leopard Creek plays 7,316 yards from the championship tees to

DESTINATION

45

a par 72. While Leopard Creek is extremely private, guests of the Malelane Sun Hotel may be granted weekday playing privileges. In addition, a number of operators offer golf tours of South Africa, and many of these tours include Leopard Creek on their itinerary.

▶ **Accommodations:** The Malelane Sun Hotel (+27 13 790 3304; www.southernsun. com) offers an excellent opportunity to experience the thrill of the bushveld, with all the amenities of a top-notch hotel. It's also your best bet for gaining access to Leopard Creek. The hotel overlooks Crocodile River, where hippos and crocodiles may be seen from special viewing decks. The Sun Hotel offers nature drives through Kruger National Park, where you'll have an excellent chance of viewing at least a few of Africa's so-called big five: lions, leopards, water buffalo, elephants, and rhinos. The Malelane Sun Golf Package includes dinner, lodging, breakfast, and a round of golf at Leopard Creek, for R1475 ($250 U.S.). For perhaps the most spectacular Leopard Creek experience available, consider the Executive Helicopter Challenge, from ABC of Golf (+27 82 461 5721; www.abcofgolf.com). For approximately $3,000 U.S., a Eurocopter EC120 will pick you up in Johannesburg, fly you north to play the Merensky Estate course, put you up overnight at the nearby Elephant Lodge, then fly you to Leopard Creek for a round.

HARBOUR TOWN GOLF LINKS

RECOMMENDED BY **Joel Zuckerman**

It was fifteen years after graduating from college that Joel Zuckerman moved to Savannah, Georgia, and realized his calling. "I saw an ad in the Savannah newspaper for a golf writer," Joel recalled. "I had never written a golf course review but had read plenty of movie, restaurant, and book reviews, and loved golf. I applied and got the job. It turned out to be a unique opportunity to access courses that were otherwise too expensive or inaccessible. I didn't know how long the job would last, so I immediately started playing the best courses I could and writing reviews. The first course I wanted to get on was Harbour Town, the symbol of golf in the low country, the mythic course with the iconic lighthouse. I was invited by the pro. And I've been back many times since." (Incidentally, Joel held on to the job!)

In the past thirty years, Hilton Head Island has emerged as a major golf destination, with more than thirty public and private courses, many of which are deserving of merit. This wasn't the case in 1969, when Pete Dye, collaborating with Jack Nicklaus, completed work on Harbour Town. With its beaches, beauty, and low-key atmosphere, Hilton Head had much to recommend it as a vacation retreat. Still, Harbour Town helped make the island what it is today. It also ushered in a new era of golf design. Many of the courses that opened their fairways in the post–World War II era were—well, they were somewhat lacking in inspiration and imagination. With Harbour Town, Dye seemed to capture the revolutionary—if not psychedelic—gestalt of the late sixties and unleash it on the turf. Bunkers in designs never quite encountered before flank fairways leading to heart-shaped greens. (Though there are only fifty-six bunkers on the course, their often gargantuan proportions make sand seem omnipresent.) Along the way, trees don't merely guard fairways but, on occasion, rest in the center of them. It can be safely said

DESTINATION

46

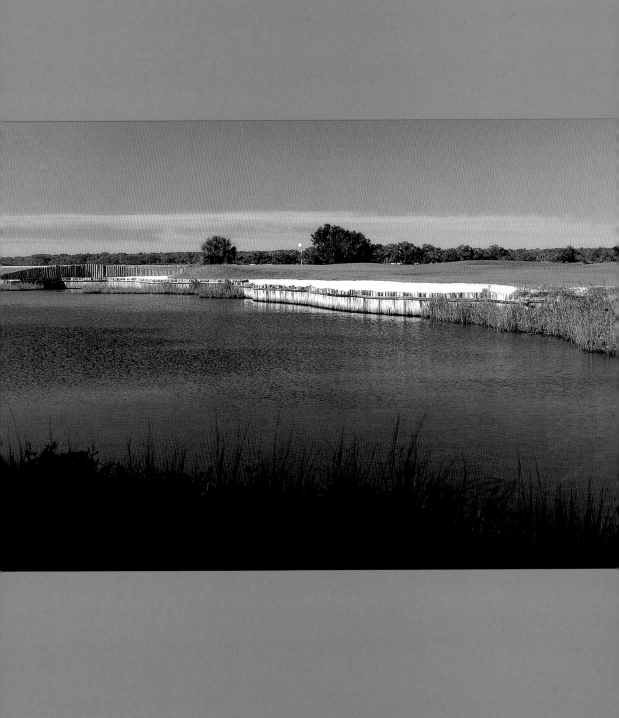

that Harbour Town expanded the consciousness of both designers and players, then and now.

That Harbour Town is considered such a design masterpiece is all the greater testament to Dye's magic. While the backdrop of Calibogue Sound is certainly aesthetically pleasing, it comes into play on only the last few holes. The most noteworthy characteristic of the site was its brain-numbing flatness; the highest point on the course is only six feet above the lowest. What the site did have going for it was an abundance of beautiful hardwoods, and these trees were exploited in subtle and not so subtle ways. "Instead of moving massive quantities of dirt, Dye massaged the earth in a subtle way, turning the holes, and positioning them so the live oaks draped the entrances to the green," *Golfweek* architecture editor Bradley Klein has said. The use of overhanging trees on many of the holes gives a sense of the course being much tighter than it actually is. "The twisting and turning corridors offer lots of interesting shot value," Joel added. "You can be on the fairway but have no shot at the green if you're not on the *right* part of the fairway. To play it well, you've got to be able to both draw and fade the ball. Still, it's a very playable course." To this point, there are only four forced carries on the course, all on the par 3s, though water in the form of creeks, ponds, and marshland is a constant presence. If you play Harbour Town smart and don't take untoward risks, even players of a middling sort can escape with their dignity intact.

For Joel, there are several things that make Harbour Town stand out. "The layout is extremely intriguing, a radical departure from what was being done at the time. I can't think of any other course that's so highly regarded and that's so rife with town homes, condominiums, and the like. Despite this, and despite the fact that the green complexes are small and rather flat, it's a sensational design. Players are so entranced by the golf that the condos don't matter. Another aspect of Harbour Town that's very special is that it gives the average player a chance to walk the same links where the heroes of golf have walked and triumphed." The people who've won here compose a who's who of champions, beginning with the first winner, Arnold Palmer. After Palmer's win in 1969, other victors at Harbour Town have included Hale Irwin, Johnny Miller, Jack Nicklaus, Davis Love III, Tom Watson, Nick Faldo, Fuzzy Zoeller, Payne Stewart, and Greg Norman. Norman's victory in 1988 was especially poignant, because he had flown a young cancer victim named Jamie Hutton to Hilton Head to watch Norman play, on the boy's behest. Norman won by one shot.

OPPOSITE:
The eighteenth at Harbour Town is one of the game's most frequently photographed holes, but the par 3 seventeenth (shown here) is a great test of golf.

DESTINATION

46

Anyone who has watched the closing round of the MCI Heritage has thrilled to the final trio of holes, as strong as any on the PGA Tour. The sixteenth is a shorter par 4 that doglegs to the left and encapsulates much of Pete Dye's inventiveness in this layout. Three pines on the right section of the fairway must be skirted, but not so much as to put your ball in the 130-yard-long bunker that stretches all the way to the green. Depending on pin placement, you may have to contend with the bunker again on your approach. The seventeenth, a 185-yard par 3, requires a carry over water as well as over a 90-yard strip bunker that borders the pond and the green. At least the bunker will save some shots from the drink.

It is the eighteenth hole at Harbour Town, with its red-and-white-striped lighthouse standing guard above the green, that makes the course instantly recognizable. "It's as potent a symbol of golf as the Lone Cypress at Pebble Beach and the Royal and Ancient Clubhouse at St. Andrews," Joel stated. The eighteenth finally brings players to Calibogue Sound, after a long trek through the woodlands; longer hitters may very well choose to play their tee shot out over the salt marsh to cheat a few yards off this 452-yard par 4. The lighthouse offers succor not just to seafarers; it actually provides the proper line for both your tee and your approach shots . . . should you opt to play it like the pros.

JOEL ZUCKERMAN has been called "one of the Southeast's most respected and sought-after golf writers" by *Golfer's Guide Magazine*. An award-winning travel writer, Joel is based in Savannah, Georgia, and Park City, Utah. His course reviews, player profiles, essays, and features have appeared in more than eighty publications internationally, including *Sports Illustrated*, *GOLF Magazine*, *Golfweek*, and *Continental Magazine*. His first book, *Golf in the Lowcountry—An Extraordinary Journey Through Hilton Head Island & Savannah*, was released in the spring of 2003. His newest book, *Golf Charms of Charleston*, will be available in the fall of 2005. Visit www.vagabondgolfer.com for more information.

▶ **Getting There:** Hilton Head is twenty-five miles from Savannah, Georgia, and forty-five miles from the Savannah/Hilton Head International Airport, which is served by most major airlines; some regional commuter airlines offer direct service to Hilton Head Regional Airport. The Harbour Town Golf Links is situated on the grounds of the Sea Pines Resort, at the southern end of Hilton Head Island.

▶ **Course Information:** The par 71 Harbour Town Golf Links plays 6,973 yards from the championship "Heritage" tees, with a slope of 146. Greens fees are $200 for guests of the Sea Pines Resort. Two other courses, Sea Marsh and Ocean, are also part of the resort, with greens fees ranging from $70 to $98.

▶ **Accommodations:** The Inn at Harbour Town (888-807-6873; www.seapines.com) at the Sea Pines Resort is a AAA Four-Diamond hotel, offering charming surroundings and all the amenities of a full-service resort, including around-the-clock English butler service. Rates begin at $150 in the winter and at $200 in the summer. Homes and villas are also available for rent by the week. Golf packages are available, which include two nights' inn accommodations and two rounds of golf (one at Harbour Town, the second at either the Sea Marsh or Ocean course). Prices range from $250 to $418 per person, based on double occupancy, depending on the time of year. For the nongolfer, there are ample water sports opportunities, excellent tennis facilities, and all the shopping amenities of an upscale tourist destination.

DESTINATION

46

ROYAL GOLF CLUB OF SEVILLE

RECOMMENDED BY **Roberto Borgatti**

For some, a round of golf on an intriguing layout is an end in itself. For others, golf is a fine excuse for a larger adventure. "At many top golf destinations, there is little to discover outside the experience of playing golf," Roberto Borgatti said. "But visitors to the Royal Golf Club of Seville enjoy a challenging test of golf, plus the chance to discover one of the world's most beautiful and enchanting cities."

The Royal Golf Club of Seville was designed by Spanish golf star José María Olazábal at the tender age of twenty-six and opened for play in 1992. The course is situated on the southern edge of the city along the Guadalquivir River and took shape on a flat, relatively nondescript piece of land. Four lakes were created on the site, and they come into play as hazards on eight holes. More than ten thousand trees were planted in the course's first decade of life to offer shade from the strong Spanish sun. In an article on Golfweb.com, David Brice called Seville "something of a hybrid, the combination of a links style with an American standard of course maintenance. For some, the lack of hills may detract from the aesthetic qualities of the course. But for the serious golfer and those who seek more than holiday golf and are looking for a real challenge, Seville will not disappoint." Despite its relative youth as a layout, Seville has already hosted a major championship, the 2004 World Championship of Golf.

From its outset, there was little doubt that José María Olazábal's life would be somehow involved with golf. He was born the day after a golf course—the Royal Golf Club of San Sebastian—opened next door to his home. His grandfather was a greenskeeper at the course, and his parents were also employed there. Olazábal began hitting golf balls at the age of two, with a club that his father cut down to the appropriate size. His game flourished, leading to his first tournament victory at age seven (the Spanish Under 9

DESTINATION

Championship). After winning the Italian and Spanish Amateur championships at age seventeen, he turned professional in 1985. Over the next few years Olazábal won several tournaments on the European Tour and emerged as one of Europe's best players, topping the world's money list in 1990. While launching his design career, he turned his attention to testing his mettle at some of the majors. He came within a stroke of winning the Master's in 1991, and returned in 1994 to win the green blazer. As his career was truly taking off, Olazábal developed a debilitating foot injury that was later diagnosed as a herniated disk in his back. He was unable to play any competitive golf for several years, but after aggressive treatment he was able to return to the fairways in 1997 and proceeded to win two European Tour events. A second Master's victory in 1999 made it clear that Olazábal was again a contender.

Writing of the Royal Golf Club of Seville, David Brice went on to say that "Olazábal has designed a course extremely well suited to his own style of golf, where mastery of every iron is an advantage and accuracy the name of the game." Speaking of his design before the 2004 World Championship of Golf event, José María Olazábal expressed great pride that his second commission would garner such attention. "I did not think that in such a short space of time it would be able to hold such an important event. The greens are very well protected by bunkers, and that is where the difficulty and worth of the course is really apparent. I like to think that it sets an examination for all players since you need to play a variety of shots."

"There's no question that Seville is a great test of golf," Roberto Borgatti said, "while adding to this experience is the great warmth of the staff. You're made to feel very welcome here. This is the Spanish way, and the international clientele I have brought to Seville are very appreciative of this."

Though Royal Seville's four lakes and ninety-six sand traps may make for a trying day, the delights of the city provide a fine compensation. "Put simply, Seville is a celebration of life," Roberto continued. "There is always excitement in the air and festivals throughout the year, not to mention flamenco (which was born here), fine dining, excellent local wines, and bullfighting. Life is experienced outdoors in the beautiful squares and fragrant gardens. The historic city center is not just a neighborhood but extends for miles in every direction, encouraging visitors to explore. You are guaranteed to get lost in the maze of narrow streets, but you don't mind, as each corner reveals another stunning picture. With its fascinating blend of European and Moorish cultures and the region's

DESTINATION

47

natural beauty, Seville has proved inspirational for many artists and composers. More than a dozen operas were inspired by the city, including *Carmen, Don Giovanni,* and, of course, *The Barber of Seville."*

ROBERTO BORGATTI conducts golf clinics and seminars for groups worldwide (www.robertoborgatti.com). He is a much sought-after clinician for professional golf associations and regularly prepares tour players for competitions. He also conducts playing clinics for corporate outings for Fortune 500 companies. Roberto's comprehensive approach combines sound methodology, fitness training, and state-of-the art swing analysis technology. He has also coached many top junior players, including Belen Mozo Palacios. Roberto has appeared on Europe's Canal Plus as a golf instructor and collaborated with ABC television for the 2004 World Golf Championships hosted by the Royal Golf Club of Seville, Spain. He divides his time between Europe and the United States. An accomplished opera singer, Roberto speaks five languages and holds an MBA in International Management. His much-anticipated first book on golf technique, *A Swing You Can Trust,* will soon be published.

If You Go

▶ **Getting There:** The grand city of Seville is served by most major carriers. The Royal Golf Club of Seville is just two miles south of the city center.

▶ **Course Information:** The Royal Golf Club of Seville (+34 954 12 43 01; www.sevillagolf.com) plays to a par 72 and measures 6,953 yards from the championship tees. Greens fees are 85 euros.

▶ **Accommodations:** If money is no object, the opulent, centrally located Hotel Alfonso XIII (+34 954 91 70 52; www.alfonsoxiii.com) is among Seville's most treasured lodgings; rooms begin at about 200 euros. The Hotel Association, Province of Seville (+34 954 22 15 38; www.hotelesdesevilla.com) outlines many other options. If you make the trip, Roberto recommends that you take in the Cathedral of Seville and the Alcazar, a palace and gardens commissioned by Peter I in the fourteenth century and considered to be the finest example of Mudejar architecture in Spain. Roberto says that a flamenco show at the famous Los Gallos is also a must.

DESTINATION

47

VALDERRAMA GOLF CLUB

RECOMMENDED BY **Bill Hogan**

For the past decade Club de Golf Valderrama, near the southernmost tip of Spain, has been widely considered the finest golf course in continental Europe. Many draw parallels between Valderrama and Augusta National in Georgia, a recognition of the course's immaculate condition, thoughtful design, and elite membership. "Valderrama is extremely exclusive," said Bill Hogan. "Its membership is a who's who of Europe's business elite. Many royal families belong there too. While it may very well be the Augusta of Europe, there's one great difference: with a little planning, a visitor from overseas can get out there and play. You're made to feel very welcome."

The course that is now Valderrama had its first incarnation in 1974 as Sotogrande, designed by Robert Trent Jones, Sr. When a second course was built near the site in 1981, its name was changed to Las Aves. The course evolved into Valderrama—and into a world-class venue—thanks to the vision and resources of Jaime Ortiz-Patiño, considered one of the great gentlemen of golf. A Bolivian tin magnate, Ortiz-Patiño purchased the course and adjoining property in 1984, then lured Jones back to help him make the refinements necessary to bring Valderrama into the limelight. (Valderrama, incidentally, is the name of the estate that once graced the land.) The evolution from good to great occurred with great rapidity; by the late 1980s the course was hosting the Volvo Masters, one of the European Tour's flagship events. By the late nineties, Valderrama was hosting the Ryder Cup; it was here in 1999 on the par 5 seventeenth that Tiger Woods's eagle putt slid off the treacherous green, down a slope, and into the adjoining lake, taking with it any hope of victory.

Valderrama is set on gently rolling land, with fairways bordered by mature cork and olive trees. The cork trees frequently come into play, as many hang over the fairway, on

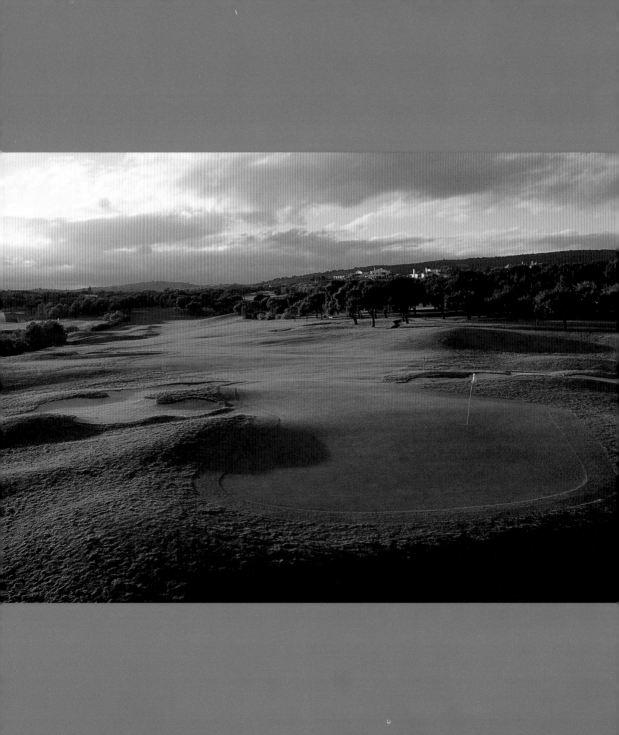

some holes, impeding approach shots from drives that lie on the short grass. (On the second hole, a large cork tree stands in the center of the fairway, providing a target—that is, if you can draw the ball appropriately.) Special care has been taken to steward the land the course winds through; 40 acres have been set aside as wildlife sanctuaries, providing habitat for birdlife, amphibians, otter, and more than twenty species of butterfly. Two prevailing winds can color a player's shot choice: the *poniente*, which comes from the land and is generally a hot breeze, and the *levanter,* which blows in cool from the Mediterranean. "It's as pretty a golf course as you'll find anywhere," Bill continued. "They've kept the standards of maintenance up to such a high level that it seems each blade of grass is individually cared for."

One should not merely play a *round* at Valderrama; one should *spend a day there,* as Bill explained. "Valderrama offers a package called the Valderrama Golf Day, and I always recommend that our clients who are visiting there take advantage of this. After all, if you could go to Augusta for a day, would you just play golf and leave? You start out by having lunch in the dining room of this extremely elegant clubhouse. The restaurant is one of the best in Spain, in my opinion. The clubhouse is also home to Mr. Ortiz-Patiño's golf museum. He's assembled one of the finest personal collections of golf antiques in the whole world. There are driving irons and feather balls from the eighteenth century. Many of these individual pieces are worth hundreds of thousands of dollars. If you get permission, you can see this private collection. For anyone with a historical bent it's worth the price of admission in itself.

"After lunch, you can play a round on Valderrama's par three course. It's modeled after the executive course at Augusta. It's a blast, a chance to warm up. If you wish, you can next visit the driving range. Then it's on to the championship course. There's a starter on the first tee—everything is very orderly, very proper. Everyone there, from Mr. Ortiz-Patiño to the general manager, Derek Brown, who's Scottish, is extremely hospitable. As you tee up, you look down and the tee box is manicured perfectly. You're frightened to take a divot. In fact, there don't seem to be any divots. Each group has a forecaddie, and you can take a cart if you wish. There are some quite famous holes on Valderrama, like number four, which is often featured on 'great golf hole' compilations. Each of the holes is distinctive. The night after you've played, you can walk through the course quite clearly in your head and recall your shots—and which ones you might have

OPPOSITE: Valderrama is so well manicured, it seems as if each blade of grass has been individually cared for.

DESTINATION

48

played differently. After your round, you return to the dining room for a splendid dinner. The whole experience of the day is extremely special."

The last four holes make for a great finish at Valderrama. "When I have groups there, we usually play a Ryder Cup–style tourney—which is to say, match play," Bill said. "Most of the matches are determined on the last four holes. Number fifteen is a downhill par three that plays over a *barranca* [gorge]. It's great fun to hit down to that green. Number sixteen is a short par four that doglegs severely to the right. On paper, it doesn't look like a whole lot. But if you're not on the right place on the fairway, you're not getting there in two."

The par 5 seventeenth has gained much notoriety in the past decade from its constant reworking by the likes of Seve Ballesteros, Roger Rulewich, and Jaime Ortiz-Patiño himself, as well as the dramatic role it's played in several tournaments. Drama and design controversy aside, it is a beautiful hole. "There's a natural amphitheater as you approach the hole, to the right of the second landing area," Bill said, "and a wall, or *gabion*, that's covered with bougainvillea. When the bougainvillea is in bloom, it's just outstanding." Strong players can reach the small green in two, but their shots have to clear a lake that guards the front and bite enough to keep from rolling into the prodigious bunkers behind.

"If the match hasn't been settled by number seventeen, number eighteen, a long par four, is a great match-play hole," Bill continued. "You can try to bomb a drive over trees on the left to give yourself a short-iron to the green. If you don't make it, however, you're in trouble. I think the smarter play is to hit three-wood or long iron to the fat portion of the fairway, and then hit another similar club up to the green."

BILL HOGAN is the president of Wide World of Golf (www.wideworldofgolf.com), America's oldest golf tour company, which has escorted golfers around the globe since 1957. He is also principal of Hogan Sports Inc. and Hogan Golf Services, a consulting company. Bill has played golf in forty-three different countries around the world and has won fourteen amateur team and individual tournaments. He serves on the *GOLF Magazine* panel that ranks the World Top 100 and USA Top 100 courses, alongside such golf legends as Arnold Palmer, Jack Nicklaus, Gary Player, and Annika Sorenstam. Bill is a member of St. Andrews in Scotland, Pasadera Country Club in California, and Barton Creek Golf Club in Texas, and serves on boards for such organizations as Virtuoso Travel

Specialists, Visit Scotland tourism bureau, Wales Tourist Bureau, and Hospice Foundation for the Central Coast. He splits his time between Austin, Texas, and Carmel, California, with his wife, Michelle, and three children, Haley, Nick, and Grant.

If You Go

▶ **Getting There:** The Valderrama Golf Club is located in the town of Sotogrande in Andalusia province; it's just a stone's throw from the Rock of Gibraltar, which can be seen from the eleventh green. Sotogrande is on the outer limits of the popular Costa del Sol region, which is a major golf destination, having more than forty courses. Visitors traveling to Sotogrande can fly into Malaga, which is served by most major carriers and is one and a half hours from Sotogrande. The city of Seville is also in Andalusia, though it's a few hours farther from Valderrama.

▶ **Course Information:** Valderrama measures 7,018 yards from the championship tees and plays to a par 71. Greens fees range from 250 to 275 euros. The Valderrama Golf Day Package offers you the opportunity to spend a day at the club and includes green fees for the Championship Course and the Short Par 3 Course, brunch, admissions to the Jaime Ortiz-Patiño Golf Museum, and enjoying a fine dinner in the main Clubhouse Restaurant. The price for the Golf Day is 400 euros. For more information, visit www. valderrama.com or call +34 956 79 12 00; tee times can be made via e-mail at greenfees@valderrama.com.

▶ **Accommodations:** The Sotogrande Estate is considered one of Andalusia's most luxurious resort areas. The Sotogrande Hotel (+34 956 695 444; www.sotogrande.com) offers 106 rooms, a fine on-site restaurant, and extensive amenities. Rates for a double room range from 147 to 219 euros.

TOREKOV GOLF CLUB

RECOMMENDED BY **Pia Nilsson**

The fact that so many great touring professionals have come from the nation of Sweden in the past decade—Annika Sorenstam, Sophie Gustafson, and Jesper Parnevik, to name just a few—should tip us off that there's some great golf to be had in Sweden. Yet few Americans think of Sweden for a European golf vacation. While it may lack the rich golf lore of Scotland and the Mediterranean sun of Costa del Sol, Sweden offers a panoply of excellent, modestly priced courses; it's hard, if not impossible, to pay more than $80 for a round. Plus there's the beautiful Scandinavian scenery and the delight-fully friendly Swedish people.

Golf has a fairly long history in Sweden. According to the Swedish Golf Federation, the first golf shots in Sweden were made in 1830 by visiting Scottish Atlantic salmon fishermen, who took time off from casting on the river Atran to hit some balls on the linkslike land near the district of Halland. It was nearly sixty years before the first Swedish course was built, in 1888, by two brothers, Edvard and Robert Sager, who developed an interest in golf while studying in England. The popularity of the game grew slowly in Sweden, with only about seven thousand people playing golf regularly by the early 1950s. But beginning in the 1980s the game exploded in popularity. In the past twenty-five years, the number of players has grown nearly sixfold. While new clubs are being built, demand is far outstripping supply; perhaps the only downfall of Swedish golf is that it can be tough to get a tee time, especially on the weekends. Considering Sweden's socialist, egalitarian leanings, it should come as little surprise that of the country's nearly five hundred golf courses, only one is private.

Instructor extraordinaire Pia Nilsson spends less of her time in Sweden these days, but when she does return she's likely to head to Torekov. "Torekov is one of Sweden's

most links-oriented courses," Pia said. "You can view the sea from all eighteen holes. In the summer, wildflowers are blooming everywhere and cows and sheep graze not far off the fairways. You can buy fresh potatoes from a local farmer straight out of the field along the sixteenth fairway. That area of Sweden is one of the oldest land masses in the country. The soil is very good there, and as a result the course is always in excellent condition. I have great ties to the course, as I began playing there when I was six years old."

The storybook fishing village of Torekov is situated on a peninsula on the southwest coast of Sweden—the Swedish Riviera, as some call it, more for the region's tourism potential than for its warm sun! The Torekov Golf Club was established in 1924. The current course, which has evolved through several redesigns since the initial nine was built in 1939, reflects the broader Swedish ethos that man should not interfere with what nature hath wrought. There are no three-story waterfalls here, and nary a railroad tie. But there are tight fairways bordered by thick rough, pot bunkers, trees gnarled and twisted by the wind, a few small ponds, and small greens that are tricky to hit and tough to hold. Unpretentious and short at just over 6,200 yards, Torekov will never host a major championship. But constant exposure to the windy vagaries of the Strait of Kattegat requires an extensive repertoire of shots. "There are many holes that stand out for me at Torekov," Pia continued. "One favorite is number thirteen, a par three that plays about a hundred and eighty yards from the men's tee. It plays right along the water, and the wind is always blowing from left to right. You want to aim at the right bunker to be safe."

As mentioned above, Sweden has all the elements for an excellent golf vacation. Should you decide to venture to Torekov, it would be advisable to leave a bit of extra time to experience some of the other fine courses the land of Saabs and Volvos has to offer. Within a stone's throw of Stockholm, there's Ullna (a favorite of Jesper Parnevik) and Bro-Bålsta, where Ms. Sorenstam is a member. Heading west, there are some wonderful tracks near Jönköping on twenty-six-mile-long Lake Vättern, including the Hooks, Jönköping, and A6. Near Torekov, on the northern section of the Riviera, there's Tylosand, Båstad, and Rya. Heading south, near the city of Malmö, there are two more jewels: Barsèbäck, which has some name recognition in Europe, and lesser-known but equally fabulous Falsterbo.

There are a few things about golf in Sweden that a prospective visitor should know. First, it is a walking game. The Swedes love the outdoors and prize physical fitness, and walking is part of the allure of the game. Carts are available on a few courses for players

with valid medical needs, but don't count on it. Another thing that's special is that it's very much a family game. "In Sweden, it's not the men getting all the best tee times, and the women getting out on Sunday afternoon and Tuesday morning," Pia said. "Families play together, with kids and sometimes grandparents included. Even tournaments incorporate all members of the family. It's not at all uncommon to see a thirteen-year-old boy playing against a seventy-five-year-old woman. Sweden has an excellent youth golf program, which allows many children to be introduced to the game at a very early age."

PIA NILSSON is a renowned golf instructor and professional player. She cofounded VISION54 (www.golf54.com), a golf instruction and life coaching company based in Phoenix, Arizona, that begins with the proposition that any player must believe that she/he can shoot 54—a birdie on every hole. Pia has served as senior head coach for the Swedish National Golf Teams and on the LPGA National Education and Research Advisory Board. In 1998 she was captain of the European Solheim Cup Team, and has also served as vice captain for the team. Pia has received many awards in her career, including the five-star professional award from the PGA of Europe as well as designation as one of *Golf Digest*'s Top 50 Teachers and one of *Golf for Women* magazine's Top 50 Teachers. In 1998, she received the king of Sweden's Medal of the Eighth Dimension with Royal Blue Ribbon. She is the author of several books, including *Coaching*, *Vision 54*, and *Be Your Own Best Coach*, in addition to hundreds of articles for golf publications in Sweden, Japan, and the United States. *Every Shot Must Have a Purpose*, coauthored with Lynn Marriot, will be released in October 2005 from Gotham Books.

If You Go

▶ **Getting There:** Torekov is located on the southwestern coast of Sweden, roughly 350 miles from Stockholm. Most golfing travelers will fly to Stockholm and take a few days to drive west to the Strait of Kattegat, experiencing some of the noteworthy courses along the way. Stockholm is served by most major international carriers. While golf can be played in southern Sweden throughout the year (some years), the most reliable months to play are May through October; early June and late August tend to be the least crowded times.

▶ **Course Information:** Torekov Golf Club plays 6,244 yards from the back tees.

218

Greens fees range from $45 to $60. It's advisable to arrange a tee time in advance; you can do so by calling +46 431 44 98 4. As noted, Sweden is a golfing treasure largely unexplored by Americans. There are five other fine courses near Torekov, including Båstad Golf Club, considered one of Sweden's best. Many Swedes speak English, and they are generally extremely friendly; consider yourself lucky if you are paired up with some local linksters!

▶ **Accommodations:** The fishing village of Torekov (population 1,200) is utterly charming and is a popular vacation spot for Swedes. Pia recommends two hotels for visitors: Hotel Kattegat (+46 431 2630 02; www.kattegat.com) and Claerencegarden Hotel (+46 431 738 40; www.claerencegarden.com). In addition to fine lodging, Kattegat boasts an award-winning restaurant.

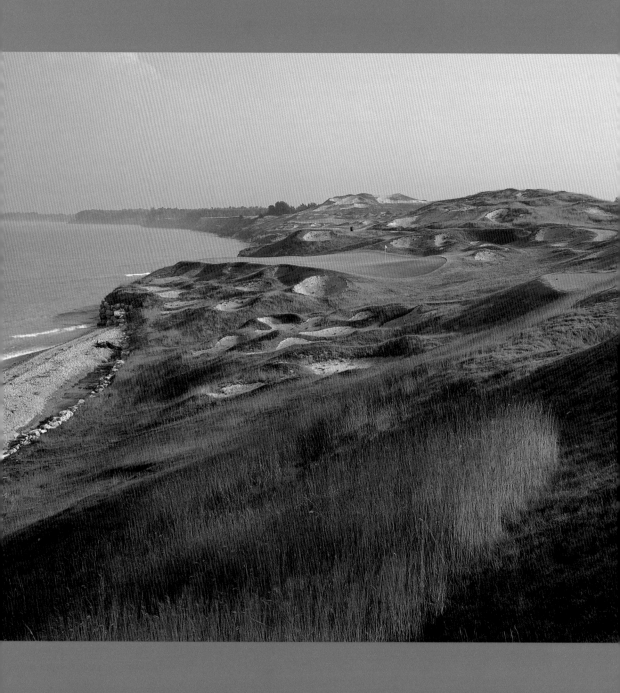

WHISTLING STRAITS,
STRAITS COURSE

RECOMMENDED BY **Peter Jacobsen**

When you step up to the first tee at the Straits course at Whistling Straits, you may think that your golf partners have shanghaied you in the night, deposited your sleeping figure on a plane, and dropped you on the west coast of Ireland—say, near Ballybunion. There are immense sand dunes, towering to 80 feet. There's the blue expanse of Lake Michigan (might as well be an ocean). And there's a fabulous golf links that looks as though it has been here for generations, since before Wisconsin joined the union.

Now go to your kitchen or bathroom and check the sink. Chances are pretty good that it says "Kohler" on it somewhere. For golfers, this is a boon. For without Herb Kohler's money—and Pete Dye's genius (critics would say madness)—there would be no Whistling Straits.

By the time Herb Kohler and Pete Dye began conceptualizing Whistling Straits, they'd already successfully collaborated on the 36 holes at nearby Blackwolf Run. Demand at Kohler's resort was outstripping the resources at Blackwolf, and he wanted another course . . . and he wanted Dye. Dye envisioned a links course, and after a trip to Ireland with Dye, Kohler was sold on the idea. Two miles of land along the bluffs of Lake Michigan—the site of an abandoned army base that at one point was slated to house a nuclear power plant—was purchased. And then the transformation began. The rather flat, unspectacular land was cajoled—no, pounded—into a wildly undulating, dune-ridden, dyed-in-the-green Irish links. To accomplish this feat, 13,126 truckloads (that's about 800,000 cubic yards!) of sand were brought in, the angles of the bluffs were altered to control erosion, and sensitive wetlands were relocated to meet environmental regulations.

And if someone hadn't told you, you'd never know it!

OPPOSITE: On the par 3 third hole at Whistling Straits, one can barely count the bunkers; over 500 grace the course, helping to make it one of America's most challenging tracks.

DESTINATION

50

"I've always loved courses that incorporate the coastline into their design," Peter Jacobsen said. "The great meeting of land and sea, as they say in reference to Pebble Beach. For the design to be successful, the course has to be playable in all types of weather—hot, cold, windy, rainy. I think that many architects don't design for variances in conditions. Instead they design as if every round were going to be played when the temperature is eighty degrees and there's a light wind. Whistling Straits is a classic links layout. It has the bump-and-run aspects you associate with the links experience. I also think that it accommodates the potential weather conditions—and there is weather on Lake Michigan—very nicely. The holes that hang over Lake Michigan are truly spectacular."

A total of eight holes rest right against the shore, and the other ten holes all offer views of the lake. Golfers must walk on the Straits, a gentle nod to the course's Irish/Scottish gestalt; caddies are mandatory until twilight. Players may encounter the Straits' unofficial greenkeeping force, a flock of Scottish Blackface sheep, nibbling on the fescue as they wander the links. They step gingerly to avoid being enveloped by one of the five hundred plus bunkers; you would do well to do the same.

Given its fabulous lakeside setting, it's no surprise that Whistling Straits offers up a number of memorable holes. On the 455-yard par 4 fourth, dubbed Glory by Pete Dye, intimidating mounding on the right side of the fairway prompts most players to favor the left. However, the narrow fairway slants in that direction, sending most shots too far left, toward fairway bunkers, dunes, and a largish water hazard known as Lake Michigan. The green extends out on the edge of the bluff, giving golfers with a tendency to hook their long irons—especially while bearing down on a critical shot when there's potential to hook their long irons—a second chance to test the waters.

Shipwreck, the 214-yard par 3 seventh hole, graces all of Kohler's promotional materials, and rightly so. The hole snuggles up against the lake on the right, where a series of bunkers will protect any short shots from the drink; mercifully, the hole plays just 165 yards from the whites. On the left, there's an imposing hillside festooned with bunkers; again, it's hard to believe that the hillside is a recent, man-made creation. The green, which is narrow and 40 yards deep, can frustrate club selection and make for some very trying putts. Imagine the pain of knocking your tee shot on, only to four-putt!

While the long carries over pot bunkers, sand dunes, and other Dye devilry that are required from the back tees will prove overwhelming for the average player, the middle

tees are more forgiving . . . at least on the drive. That being said, players of all skill levels should pause as they approach the 462-yard par 4 eighth hole, as Kiel Christianson points out in a story for TravelGolf.com, "On the way to the appropriate tees, just take a moment to stand on the championship tees, from which there is absolutely no view of the fairway, hiding some 20 feet above and 100 yards away from these back tees. There are times one is happy *not* to be a scratch golfer."

PETER JACOBSEN is a thirty-year veteran of the PGA Tour and has established himself as golf's unofficial ambassador. In March 2004, Peter turned fifty years old and was welcomed to the Champions Tour; a few months later, he won the 2004 U.S. Senior Open. Peter was a member of the 1985 and 1995 U.S. Ryder Cup teams and has seven other Tour victories to date: 1980 Buick-Goodwrench Open; 1984 Colonial National Invitation Tournament; 1984 Sammy Davis, Jr.–Greater Hartford Open; 1990 Bob Hope Chrysler Classic; 1995 AT&T Pebble Beach National Pro-Am; 1995 Buick Invitational of California; and 2003 Greater Hartford Open. A successful entrepreneur, Peter owns an event management company that conducts activities ranging from PGA tourneys to the Cycle Oregon weeklong bike ride. He also co-owns Jacobsen Hardy Golf Design Co.

If You Go

▶ **Getting There:** Whistling Straits is located nine miles east of the village of Kohler, Wisconsin, one hour north of Milwaukee and two and a half hours north of Chicago.
▶ **Course Information:** Whistling Straits is 7,362 yards from the tips, with a slope rating of 151. Greens fees (with mandatory caddie) are $297. For tee times, call 866-847-4856. For a peek at the course, visit www.destinationkohler.com.
▶ **Accommodations:** There are several lodging options in the vicinity. The American Club is a AAA Five-Diamond Resort Hotel with 236 rooms that offers spa packages in addition to golf. Room rates begin at $275. The Inn on Woodlake has 121 rooms and is slightly less tony than the American Club, but still very inviting; rooms here begin at $178. Information on both hotels can be found by calling 800-344-2838 or visiting www.destinationkohler.com.There's plenty to do around Kohler for nongolfers, including a visit to the Kohler Design Center, where the company's bath and kitchen fixtures are on display.

DESTINATION

50

Editor: Jennifer Levesque
Designer: Paul G. Wagner
Production Manager: Kim Tyner

Library of Congress Cataloging-in-Publication Data
Santella, Chris.
Fifty places to play golf before you die : golf experts share the
world's greatest destinations / Chris Santella ;
foreword by Mark O'Meara.
p. cm.
ISBN 1-58479-474-7
1. Golf courses—Directories.
2. Golf resorts—Directories. I. Title.
GV975.S195 2005
796.352'068'025—dc22
2005011666

Published in 2005 by
Stewart, Tabori & Chang
An imprint of Harry N. Abrams, Inc.

Photograph credits:
Pages 2, 54, 114, 130, 194, 204, 220: photographs © Tony Roberts;
pages 10, 12, 22, 42, 62, 126, 178, 182: photographs © Evan Schiller;
page 16: photograph © Charles Seifried Photography;
pages 26, 30, 78, 104, 108, 118, 134, 150, 164: photographs © John and Jeannine Henebry;
page 34: photograph © Suzy Flood; pages 46, 100, 172: photographs © Mike Klemme/GOLFOTO;
pages 50, 96: photographs © John R. Johnson/golfphotos.com;
pages 58, 90: photographs © Brian D. Morgan;
pages 74, 190, 212: photographs © Matthew Harris/The Golf Picture Library;
pages 82, 138, 142, 146, 154: photographs © L.C. Lambrecht/Golfstock.net;
page 168: photograph © Per Ervik

Page 2: The Straits Course at Whistling Straits
sits above Lake Michigan in Wisconsin.

This book was composed in Interstate, Scala, and Village typefaces

Printed and bound in Thailand

10 9 8 7 6 5 4 3

HNA
harry n. abrams, inc.
a subsidiary of La Martinière Groupe

115 West 18th Street
New York, NY 10011
www.hnabooks.com